ALEXANDER MOFFAT RSA is an artist and teacher. Born in Dunfermline in 1943, he studied painting at Edinburgh College of Art. From 1968 to 1978 he was the Director of the New 57 Gallery in Edinburgh. In 1979 he joined the staff of The Glasgow School of Art where he was Head of Painting from 1992 until his retirement in 2005. His portraits of the major poets of the Scottish Renaissance movement now hang in the Scottish National Portrait Gallery and his paintings are represented in many public and private collections including the Yale Center for British Art, USA and the Pushkin Museum in Moscow.

ALAN RIACH is a poet and teacher. Born in Airdrie in 1957, he studied English literature at Cambridge University from 1976 to 1979. He completed his PhD in the Department of Scottish Literature at Glasgow University in 1986. His academic career has included positions as a post-doctoral research fellow, senior lecturer, Associate Professor and Pro-Dean in the Faculty of Arts, University of Waikato, Hamilton, New Zealand, 1986–2000. He returned to Scotland in January 2001 and is currently the Professor of Scottish Literature at the University of Glasgow. His poems are collected in *This Folding Map* (1990), *An Open Return* (1991), *First & Last Songs* (1995), *Clearances* (2001) and *Homecoming* (2009).

Luath Press is an independently owned and managed book publishing company based in Scotland, and is not aligned to any political party or grouping. *Viewpoints* is an occasional series exploring issues of current and future relevance.

By the same authors:

Arts of Resistance, Poets, Portraits and Landscapes of Modern Scotland,
Luath Press, 2008

Arts of Independence

*The Cultural Argument and Why It
Matters Most*

ALEXANDER MOFFAT and ALAN RIACH

Luath Press Limited

EDINBURGH

www.luath.co.uk

First published 2014

ISBN: 978-1-908373-75-5

The publishers acknowledge the support of

ALBA | CHRUTHACHAIL

towards the publication of this volume.

The paper used in this book is recyclable. It is made from
low chlorine pulps produced in a low energy, low emissions manner
from renewable forests.

Printed and bound by
Martins the Printer, Berwick upon Tweed

Typeset in 11 point Sabon
by 3btype.com

Contents

Acknowledgements

Our first thanks are to Gavin MacDougall, our publisher, who invited us to make this book, and has been wonderfully patient with our rate of progress and many revisions. The help we have been given through comments and suggestions made by Louise Hutcheson and Ceris Aston at Luath Press have been immensely valuable and we are grateful to them. We would like to thank Will Maclean, Ken Currie and Douglas Gordon for supplying images of their work, and the Fergusson Gallery, Perth and Kinross Council, for permission to reproduce J.D. Fergusson's 'Les Eus'. Thanks also to Stewart Sanderson for the index and Lydia Nowak for her patience with the proofs.

Preface: The Moment Before

ALL ARTS WORK for independence. They represent things, actions, relations of purpose and power. We learn from them and act, according to our deepest dispositions and our conscious choices, made in the air of wherever it is we inhabit, in observation only of whatever rules we choose and know that we wish to obey, or whatever it is we choose and know we should destroy. This learning is delight, these choices are a pleasure, these decisions made are taken no more lightly than the movements of a dance, that may appear as skip, turn, lift and buoyant motion, but like the actor's lines, may be learnt, acquired, focused and directed, powerfully, and to effect. Great work is hard work. Learning is pleasure. These are our premises, the promises we make, and the beliefs that have generated the arguments that occupy the pages of this book.

The cover depicts the red cliff of our previous collaboration, *Arts of Resistance*: the radical road by Salisbury Crags, next to Arthur's Seat, overlooking the capital city of Scotland, in front of which depicted are two figures, limbs stretched in the moment before contact, one, perhaps, acquisitive, the other defensive, claiming the ground. No simple conflict here: rather a sense of perennial contest, ignorance and knowledge, violence and art, foreclosure or elaboration challenging, extending possibilities. Which is which? Who's who? Wait there – hold on – there are things to be said, things to be talked about, and maybe after the conversation, after the depictions in art, after the work of the imagination is taken through to its possible conclusions, then we can come to our decisions without the failure of physical conflict. The long history of struggle for an independent Scotland from the 19th century to the 21st is characterised not by violence but by patience, poetry, argument, commitment to the process of democracy, commitment to education, belief in what the arts can do. These are not idealist claims, but simply the facts of the history here, which constitute a rare distinction.

Our argument is this:

Literature, painting, music, architecture – all the arts – are the most essential outward forms in which we make distinct our own humanity. They are what must be at the heart of all education. Education helps people make informed choices in a peaceful political structure called democracy.

Each thinking, feeling adult has a vote to cast for how she or he may thus be represented. The political representatives elected are responsible to people. The arts are there to help people to live. Therefore to argue for an independent Scotland must be to argue for the distinctive works of art that have arisen from the people of Scotland, throughout history, to find ways to make them and the values they embody more widely and deeply understood and enjoyed, in Scotland and internationally, and to create and develop new ways to further them, for future generations. This demands our engagement with the arts of other nations, throughout the world. These truths are distorted to the detriment and destruction of the well-being of people in the structure of state defined by the United Kingdom. We have an opportunity to change that here in Scotland. Our human potential would be more fully exercised in an independent Scotland.

From this argument, the further implications are clear: the United Kingdom is made of not only Scotland and England, but Wales and Northern Ireland also. In the third dialogue of the book, we talk about the variations of ethos, diversities of social identity, that are as present in England as in any other country, and we should acknowledge immediately that such diversity is within the character of any nation. Our argument is to oppose imperialism, to oppose the conformity of subjection pressed upon people by Empire, to reject the mortmain of the uniform identity that insists on any single story dominating others.

Perhaps at the heart of the question is the conflict of knowledge and ignorance. Knowledge may bring sympathy; yet also, it may prompt resistance. But ignorance only makes subjects of us all.

> It is a common sentence that Knowledge is power; but who hath duly considered or set forth the power of Ignorance? Knowledge slowly builds up what Ignorance in an hour pulls down. Knowledge, through patient and frugal centuries, enlarges discovery and makes record of it; Ignorance, wanting the day's dinner, lights a fire with the record, and gives a flavour to its one roast with the burnt souls of many generations. Knowledge, instructing the sense, refining and multiplying needs, transforms itself into skill and makes life various with a new six days' work; comes Ignorance drunk on the seventh, with a firkin of oil and creation is shriv-elled up in blackness. Of a truth, Knowledge is power, but it is a power reined in by scruple, having a conscience of what must be and what may be; whereas Ignorance is a blind giant who, let him but wax unbound,

would make it a sport to seize the pillars that hold up the long-wrought fabric of human good, and turn all the places of joy dark as a buried Babylon. And looking at life parcel-wise, in the growth of a single lot, who having a practised vision may not see that ignorance of the true bond between events, and the false conceit of means whereby sequences may be compelled – like that of falsity of eyesight which overlooks the gradations of distance, seeing that which is afar off as if it were within a step or a grasp – precipitates the mistaken soul on destruction?

It is salutary to consider that that passage was written by George Eliot, published as an epigraph to Chapter 21 of her novel, *Daniel Deronda* (1876). What we are committed to is the practised vision so described, a more accurate seeing, the true bonds between events, what must and what may be, in an independent Scotland.

Introduction

WE BELIEVE THAT Scotland should be an independent country. That belief is based on many years of practice as teachers, artists, a painter and a poet, both of us travellers in other lands, and both of us residents in Scotland.

Our proposition is that the arts in Scotland – literature, painting, music, sculpture, architecture, all the arts – are more than essential in the argument for an independent Scotland. They are pre-eminent. Economic, political and social questions need to be asked and answered but without the cultural argument, they are merely the mechanics. What gives Scotland and the people who live in Scotland the distinction of cultural identity is always more important than the number of chips in a fish supper, crucial as that must be for all of us. And this cultural identity has been suppressed and neglected, in the educational institutions, the mass media, the political deliberations and the ponderous pontifications of so many public balloons.

Cool, reasoned arguments are required but we want more than that. We want the passion and emotional investment that gives us the courage of our dispositions. We need to validate our prejudices, or abandon them. We want balanced consideration backed up and overtaken at times by marvellous conviction, expressions of faith and delight and good humour, open declarations that can be discussed freely. We want to consider how we feel about our country in comparison with other people and how they feel about their countries. We want to look at nationalism in all its facets – consider its overwhelming threat when it becomes what we might call uber-nationalism, or imperialism, the imposing authority of power over others and control through colonial occupation of one kind or another – but also to consider its value as resistance against such authority, its work in liberation, the opening of possibilities, the urge to critical self-exploration and its value in artistic practice.

This book arises from a lecture delivered by Alan Riach at the 'Changin' Scotland' gathering in Ullapool in November 2012. The theme was 'The Role of the Arts, Culture and Identity in Scotland'. The event was organised by Alexander Moffat, David Harding and Sam Ainsley, and the article based on the lecture was published in the newspaper *The Herald*

on 20 February 2013. The publisher of our previous collaborative book, *Arts of Resistance* (2009) invited us to build from that article and explore the questions it raised in another collaborative work. This is the result.

Arts of Independence follows from *Arts of Resistance*. The two books are intended to be complementary, this one following through and developing arguments and ideas that were implicit in the earlier one. *Arts of Resistance* was profusely illustrated, so that readers could see the works of the artists we were talking about. *Arts of Independence* is much more of a discussion – we want to focus on the words, the meanings of the words, what the ideas are that hold such sway over people in society generally. *Arts of Independence* is a more challenging book. Necessarily so.

We have structured the book in three sections, each with sub-sections and digressions, some data and factual documentation, arguments that take us along various avenues and side-tracks, before we return to the main emphasis and its elaborations. This structure is an affirmation of Friedrich Nietzsche's aphorism 154 from *Beyond Good and Evil* (1886): 'Objections, non-sequiturs, cheerful distrust, joyous mockery – all are signs of health. Everything absolute belongs to the realm of pathology.' We are mindful, too, of that book's subtitle, *Prelude to a Philosophy of the Future*. Our intention is that the arguments, examples and value of *Arts of Independence* should remain valid long after Scotland becomes an independent country once again.

The essential value and validity of the arts is the central theme of the book and a credo we would both stand for. Yet it is not a credo we would follow blindly. We would want to question and criticise all works of art and their contexts, who or what interests they serve. As the Nigerian Nobel laureate Wole Soyinka puts it, 'The greatest threat to freedom is the absence of criticism'. What is called a work of art does not always possess value and validity. It requires criticism and evaluation. And such criticism and evaluation must be convincing. For example, if Tracey Emin appears on television news and magazine programmes, this may be less to do with the quality of any of her works of art and more to do with the way media represents such an artist. That has more to do with the phenomenon of celebrity culture than with critical evaluation of works of art. Picasso was a great artist and a world celebrity. Emin is at best a minor artist and her celebrity status, such as it is, does not arise from critical or comparative evaluation. This understanding can be extended.

In the 18th century the fashionable priorities of gentility throughout Europe generated unquantified numbers of portraits of rich people: the nobility, dukes and duchesses, utter non-entities, humanly dull in their flattering representations in innumerable paintings of almost utter worthlessness.

John Berger once asked, 'has anyone ever tried to estimate how many framed oil paintings, dating from the 15th century to the 19th, there are in existence?' His argument is that what art historians talk about and we see in museums is in fact a tiny fraction of what was actually produced, and most of it worthless. He picks out the banality of 19th-century official portraits, 18th-century landscapes and 17th-century religious pictures as examples. He goes on:

> The art of any culture will show a wide differential of talent. But I doubt whether anywhere else the difference between the masterpieces and the average is as large as it is in the European tradition of the last five centuries. The difference is not only a question of skill and imagination, but also of morale. The average work – and increasingly after the 16th century – was produced cynically; that is to say its content, its message, the values it was nominally upholding, were less meaningful for the producer than the finishing of the commission. Hack-work is not the result of clumsiness or provincialism; it is the result of the market making more insistent demands than the job.

As such, even major artists can turn out work for the market that is less seriously valuable than other work they produce. This is certainly the case, for example, with the Glasgow Boys and the Scottish Colourists. If the critical value of appreciation is rendered invalid and the market is permitted to dictate the only value of a work of art, understanding what makes a work of art valuable in human, rather than commercial, terms, is made irrelevant.

In many places, that is precisely what is happening today.

The 18th century, the age of dictionaries, encyclopaedias and the codification of knowledge, was also the age of slavery and the era in Europe when the great tragedies of the preceding century – not to mention the tragic drama of ancient Greece, the plays of Aeschylus, Euripides and Sophocles – were unmentionable. *King Lear* could not be performed without a tacked-on happy ending. Yet emerging from this world were Mozart, Watteau, David, Fergusson, Burns, Scott, in a strong cultural reaction

against what had been happening in the half-century before them and in some cases was still happening around them. The achievements of the Enlightenment are manifold and various, but there is a liability in them. Gentlemen philosophers may take us deep into vital questions and there is much to learn from exploration of this kind. Scottish philosophers in this field are pre-eminent. Hume teaches us scepticism of the most essential kind. Hutton teaches us a sense of earth, of geological time, by which we must measure true human value. Smith teaches us that there emphatically is such a thing as society and in order to make money valuable and make an economy viable we must care for it, deeply and practically, and work for the benefit of all. However, the Enlightenment is not all there is. The wild imaginations of the wayward artists and writers, whose insights into humanity no Enlightenment man could encompass – Aeschylus, Shakespeare, Mahler, Sibelius, Flaubert, MacDiarmid – are needed to counterpoint and qualify more reasoning and rational minds. Laws of life, whatever they are, constant and changing, always produce their own men and women who make them, codify them, and give them to others – but they also generate outlaws.

Even the artists and writers and painters we might associate with the Enlightenment are not easily codified within a definition of Apollonian, classical, or neo-classical identity. Haydn, Mozart and Beethoven cross from Enlightenment to Romantic eras, but each foreshadows, arises from, or draws on, both. Likewise Gericault, Turner, Fuseli, and David. In the paintings of David there is a tension between the neo-classical and the proto-Romantic and that tension is not present in the Apollonian world of order. Each of these composers and painters knows intrinsically, physically, viscerally, intuitively and intellectually, the conflicting dynamics of chaos and order. Burns and Scott are of their company. And yet, we might generalise, the forces of law, the state and civilisation are always trying to impose order on the chaos of creative potential. And the forces that drive artists of whatever complexion or kind always arise from the depths of that chaos of human potential, resisting codification, commodification, order imposed from above, the laws of whatever market or state.

There have been periods in European history where the arts were little more than the toys of the rich. And if we really understand this, it is a vital warning. Compare the Turner prizewinners, fashionable art scenes, the salons and city sophisticates of the 20th and 21st centuries with the plays

of Bertolt Brecht or John McGrath, the paintings of Kathe Kollwitz or Joan Eardley, the poems of Sorley MacLean or Wole Soyinka or Ernesto Cardenal, or the novels of James Robertson or Thomas Mann. Consider art as a means by which we learn about the world. Then consider art as a power game, money-led. Consider the unmistakably commercial disposition in the transfer of artistic authority from Paris to New York in the immediate aftermath of the Second World War. And consider the role of the church. Great art has come from the church: Michelangelo, Velazquez, El Greco, just as great work has been done by commission. Not all portraits made for rich patrons are bad. But in any given period there is good and bad art and they are often differentiated by those works of art made for money and vanity, on the one hand, or on the other hand, those works of art made by critical outsiders. Often the distinction is evident between the work of commercial advertising and the work of art: adverts are made to take, to sell you things; works of art are made to give, to tell you things, if you want and are able to learn from them. Of course there is art in advertising and there is advertising in art but still, they are different. Their motives, purpose, ethos and practice are different. So in this analysis, what is the meaning of success? Financial or humanly lasting? In some cultures, success may be measured by the bank balance. In others by the love that surrounds you on your death-bed. And there is no guarantee, of course.

So where are the parameters for a sense of success? In what context does the work of art address itself to other people? Where do you begin from, as a writer, a painter, a sculptor, a composer? What do you draw on, who are you talking to?

Artists have frequently been committed to and engaged in nationalism. Many of the greatest artists were nation-builders like Verdi and Wagner, the French Impressionists, Grieg, Sibelius, Pushkin, Borodin and Balakirev, and many were deeply aware of how national cultures interact with one another. Consider Debussy's reaction to German music. And more generally, consider how art reflects and represents a nation's self-esteem. Artists present their nation's culture to the world. This is perfectly evident in Italian neo-realist cinema, in Satyajit Ray's *Apu* trilogy, in Bergman's film visions of Sweden, and Kurosawa's of Japan. And alongside these we might register the significance of the displaced artists of the 20th century, Stravinsky, Rachmaninov, Schoenberg, and Bartok remaining true to their

original cultures in all their travels and residences. *The Rite of Spring* may be a high-culture text, the paradigm of Modernism in music, internationally significant way beyond any concerns of 'narrow nationalism'. And yet Stravinsky chose to give it a subtitle, emphatically present in its universal interpretation: 'Pictures of Pagan Russia'. These artists and composers cannot simply be described as 'international' Modernists who came from nowhere in particular. It was important to return Bartok's remains to Hungary, for example, despite the fact that the name of the homeland he came from had long since disappeared. Is it going too far to claim that Poland would hardly exist were it not for Chopin? Perhaps. But Poland would certainly not be what it is without Chopin. And Chopin visiting Scotland, performing in Glasgow, prefigures the strong connections between the two countries that were realised when so many Polish people settled in Scotland in the aftermath of the Second World War. That is, national identity is strengthened and enriched by the recognition of difference, welcome and gratitude. It is not to be denied, in social or political or artistic terms. A recording of Stravinsky's 'Petrushka' exists transcribed for two accordions, which, far from making it sound banal and hackneyed, deepens and subtly emphasises the profoundly Russian nature of the music, and its popular character. Why should not Scotland be thus represented in the world?

Artists whose work really stands the test of time are as present in Scottish culture and history as in any other. More so, perhaps. We have had more than our fair share of them – from major Enlightenment figures such as Gavin Hamilton, Allan Ramsay, Henry Raeburn and David Wilkie, who remained hugely influential throughout the 19th century, to Charles Rennie Mackintosh and Patrick Geddes and so on. And long before the Unions of 1603 and 1707, there were John Barbour, Robert Henryson, William Dunbar, David Lyndsay and Alexander Montgomerie. And the composer Robert Carver – some would describe him as Scotland's greatest composer – at the court of James IV in the early 16th century. The idea that independence would narrow the parameters of the Scottish artistic imagination is utterly unfounded. Where does it come from, this idea?

In the aftermath of the Second World War, the exclusion of Scottish art from the Edinburgh International Festival resonated for decades with the implication that Scottish art had no international calibre. And the centralisation of the Arts Council in London with a Scottish regional

division also emphasised this idea that Scotland was no more than a region. Our institutional education system in Scotland neglected and oppressed literature in the Gaelic and Scots languages (with one glaring exception), not to mention works of art and music by Scottish artists and composers. Things changed radically in the second half of the 20th century, from the establishment of the Scottish Arts Council in 1967 to that of the National Theatre of Scotland in 2006, though there is no Scottish National Theatre building to house the company. Art galleries established in Stornoway, in Orkney, the new Shetland Museum in Lerwick – all these new initiatives since the Second World War herald new possibilities, new beginnings in particular localities far from the major cities. Yet the legacy of long-standing institutional neglect of, and hostility to, the full inheritance of the arts of Scotland is still with us. Perhaps it is the most difficult of all the obstacles we have to overcome to find the sense of value that would endorse and justify the validity of Scottish independence.

That is what this book sets out to do.

It begins with the cultural argument for Scottish independence set out boldly, as it was in the newspaper article and the conference lecture. This argument is followed by the first dialogue between us, prompted by Sandy Moffat's response to Alan Riach's essay. The first dialogue explores those questions not addressed by the cultural argument, disposing of some that are almost clichés in the public discussion, pausing on others that require further thought. Familiar lines everyone has heard about the economic argument and whether or not Scotland and England are 'Better Together' or 'Stronger Apart', and the paradox of self-suppression in Scotland's story, what some have termed 'inferiorism', compared to the political and cultural self-projection of the United States after 1945, the various forms of relationship between national governments, the arts and people generally, are all discussed, and we end Part One with an evocation of an exemplary day festival in the Scottish border town of Langholm.

Part Two looks at the Union, from the Union of the crowns in 1603, to the Union of the parliaments in 1707, to the fruits the Union brought, financially and culturally, through the 18th and 19th centuries, to the rise of the British Empire and the central significance of the Union to all that the British Empire means. We explore aspects of this significance through facts, details, anecdotes, personal experiences, and an overall picture of accumulated details giving an impression of what the relation between

money and culture in the story of the Union really is, what it means, and what it portends for the future. Central to the Union is the idea of Britishness, but what does that idea stand for? What does it mean? What role in it is there for the royal family and the government at Westminster, the armed forces, the differences of social and cultural character in Scotland and England? We talk about the idea of democracy under the crown, royalty as an inherited family position of privilege, and just how far education can go in this state system. Education democratises and democracy educates. That's our belief. But consider the state of the United Kingdom: what sort of democracy is it? How well-educated are its citizens? Or should we say, subjects?

Part Three closes in on the idea of democracy. How could the ideal of democracy work in an independent Scotland? How has it worked in the United Kingdom? The story of the last two centuries in the western world has been of the rise of democracy in the representation of otherwise silenced people, working class people, women, many of whom were not fully enfranchised until the 20th century. So where are we in the 21st century, with revolutionised technology and rampant managerialism? What might we achieve in an imaginary but perhaps not impossible future? Arising from our own knowledge and experience of many parts of Scotland, our work in the arts and in education, both in Scotland and internationally, what priorities would we endorse? And considering Scotland as it might be, looking at some of its worst aspects, shown in the violence associated with sport and religion, and the potential for some of its best aspects, in media, museums and libraries, what can we do to achieve these priorities? What might be made of Scotland, how much is there to build on, realistically, critically, sceptically and hopefully? If we are to make a new Scotland now, to enter a new modernity, what did the Modernism of a hundred years ago mean in terms of literature and the arts? What examples might we look at by considering the relation between Modernism and nationalism? And how should we think of nationalism, a word that seems to excite disdain or concern among some people, a word that some people almost automatically associate with fascism and dictatorship, and yet a word that is integral to many liberation movements, political struggles away from dictatorship and towards rejuvenation and redefining human potential within the borders of a national state? Was this not what Nelson Mandela aspired to in South Africa? Was

not his vision one of a nation reborn? The word nationalism itself needs to be examined in this light.

Each section of the book follows the same form: an essay offering a set of propositions and observations and a dialogue probing further ideas arising from them.

In Glasgow, in Lanarkshire, in Fife, and in many of the industrial or post-industrial areas of the central belt of Scotland, there remains a deep reluctance about independence, an opposition to the Scottish National Party and a loyalty of immensely constipated retention to the Labour Party, despite the fact that the Labour Party in 2014 bears almost no relation to the Labour Party that for a hundred years sought to represent working people, and has no connection whatever any more to what we would call the Labour Movement. The representatives of the Labour Movement remaining in the Labour Party must know that their ideals are most possible, would most closely be brought to reality, in an independent Scotland. The paradox is that the Conservative Party, if you believe there are virtues there, and even the Liberal Democrats, whose history in Scotland certainly has its values and nobilities at times, indeed all the major UK parties would warrant more serious and deeper evaluation by Scots within an independent Scotland. But the people of the Labour Party most of all must know the deepest roots of what they represent historically demand allegiance to the break-up of empire and delusions of imperialism, and that this is not only a matter of wages and welfare and homes, but a matter of dignity, self-realisation, doing the best for as many as we can. Culture demands leisure and leisure demands its fulfilment in work that yields life and brings life to its best articulation. The cultural visions this book presents might enable some people at least, to think about this once again.

The arts all deepen and sharpen our sense and understanding of reality.

And yet the pronouncements against independence we have heard are so astonishing in their flippancy, banality, insupportably portentous misery, that we have sometimes felt gloomy indeed. We must vote NO, we have heard, because: 'We must save Scotland from itself!' – 'There are no policies!' – 'We want to wipe that smug smile off Alex Salmond's face!' – 'We are much better off without the additional bureaucracy in Edinburgh – without the "wee pretendy parliament in Edinburgh"' – 'We are "better together" and stronger at the table of the world powers as part of the

United Kingdom!' – 'We couldn't go it alone economically, the figures don't add up' – 'The best people go to London' – 'We've been feeding at the same trough for far too long to do something different now' – 'Things are fine just now, don't try to fix it if it isn't broken' – 'We don't even want to talk about that – it's just ridiculous.'

Serious professional people we know have said these things or things very like them. What is going on? Why are people so afraid of even the prospect of change? If you don't want to talk about something so important, you should know that that in itself is a sign of the trouble you're in.

Then there is the question, 'How can we be certain about what the future will bring?' To which the only answer is, 'You can't.' But you can be pretty sure about the current state of things, and show what the likely prognosis is if we carry on as we are. And we can be very sure about what the arts can do, how they can help us to live, what and who they are for.

The question of independence is so important, so crucial in the self-determination of every life in Scotland, and the lives of all those people around the world now who care about it, and in future generations who will care, and indeed in the ways in which we now and those to come understand the lives of people of all the generations gone, that we insult them all and disgrace ourselves by refusing to talk about it openly. Or by offering such spurious statements and exclamations as those noted above.

What are the arguments in favour of remaining within the United Kingdom? We have yet to hear any. Alex Massie has said that the best possible case for the Union is the high Tory case, which is about the permanence of institutions – despite the fact that the high British institutions bought into not only by Tories and Liberals but also by Labour are all in a state of terminal decay. The nostalgic appeal made by unionists seems to evoke a fairytale Britain that never existed.

We have heard people talk of their feelings of uncertainty and disposition to be cautious, and we have seen and read the 'Better Together' representatives fostering fear, ignorance and eagerly spreading misinformation, but we have not encountered anywhere serious arguments convincing us in any way that voting to maintain the authority of the Westminster Government will be better for anyone, in Scotland, or in England.

When you are old and grey and your grandchildren ask you, 'How did you vote? What did you vote for?' what will you say?

Why should we even lift our own hands to try to write in such a way that these concerns are made more public? Why not just relax, go *laissez-faire*, and what will be will be what will be?

Hugh MacDiarmid wrote in a letter of 27 November 1970:

> I fear that so far as a very large part of our population is concerned the process of Anglicisation has gone so far that they are just utterly hopeless. However, as long as there are a hundred of us there is still hope.

There is still hope. There are far more than a hundred now. But the challenge is immense. Despite every attempt of our writers and artists to alert us to the distinctions of Scotland, our critical sense of their value has been under-nourished and worn down for 300 years and more. We have been ruled by authorities in London who care little or nothing for Scotland and the people of Scotland. Many of us have learned not to care or set value on our own, most vulnerable, arts. Our critical sense and self-esteem has thereby been insulted and betrayed.

This critical sense is precisely what all our best writers and artists help us not to betray. That is the liberty Scottish literature and the arts – like literature and the arts in any country – insists upon and exemplifies. It is with the arts that our hope resides and this is where it is to be renewed. Before, during and after the Union, in an independent Scotland, their work is never done.

PART ONE

The Cultural Argument

The Herald Manifesto

THERE IS ONLY one argument for Scottish independence: the cultural argument. It was there long before North Sea oil had been discovered, and it will be here long after the oil has run out.

It is the only distinction that matters. No-one denies the importance of economics – putting bread on the table, jobs, health – but they are all mere matters of material fact unless occupied and enlivened by imagination. The arts – music, painting, architecture, and, pre-eminently, literature – are the fuel and fire that makes imagination possible. Neglect them at your peril.

Why should literature be pre-eminent?

Apart from experience of life itself, it's our best way to understand other people most deeply. Everyone is alike: we all share desires, frustrations, needs, predilections, but every one of us carries the cultural significance of our individuality, upbringing, birth, geography, languages, skin colour, social preferences, habits and beliefs.

In Scotland, the cultural world is distinct. History, terrain, cityscapes, landscapes, economies and, above all, literature, give us this distinction. These things are as particular as in England, Ireland, Wales, America, France, Italy – anywhere. Our cultural identity is various, but distinct. The Borders are a long way from Shetland. Aberdeen is very different from Glasgow. Yet all share something that relates them to the identity we call Scotland.

This shared identity is mythic. It arises from historical fact but myth has a greater power than history. It is evident in the recurring themes of literature. In America, the myth of the American dream, from log cabin to White House, the myth of the frontier, have potent authority. The failure of the dream is the central theme of *The Great Gatsby* and more schoolchildren in Scotland will read that book than anything by Walter Scott. Why?

International scholars have worked hard to make our artistic heritage more widely available. Scotland's art, music, history and literature are much more familiar now than they were 50 years ago among the universities. Yet these things have not sufficiently permeated the broad spectrum of Scottish teaching or media institutions. This is the crucial point.

Independence is the best and most needed choice for Scotland's future because our arts should be a living conversation for all of us. Without them, people suffer from dullness and ignorance. The National Galleries still houses its wonderful collection of Scottish paintings in the basement. It is time to change that.

The 'spine' of Scottish literature has been regenerated at particular historical moments. Allan Ramsay in the 18th century and Hugh MacDiarmid in the early 20th century deliberately set out to re-introduce older traditions of Scottish literature to their contemporaries. The resurgence of creative work in the 1980s and 1990s in Scotland coincided with a comprehensive revaluation of literature, art and music. The purpose of having this depth of understanding is to provide something essential for 'vertebrate' identity – only by such understanding can the subject be compared and valued alongside other literatures.

Yet other than scholars and students, how many people in Scotland are confident about our literature and arts? On BBC2's *Newsnight* programme on 29 November 2011, I was asked, 'Is there such a thing as Scottish literature?' Stunned by the inanity, I was grateful when the novelist A.L. Kennedy leant forward and replied:

> Is there such a thing as English literature or Irish literature or American literature? You don't want to claim any literature for a country because it's international and has to do with the commonality of human experience, but Scotland exists, as a cultural entity, as an historical entity. I want somebody to be able to sit in a Scottish school and think, I can succeed, being myself from my country, using the language that I use, being the person that I am...

The great American critic Hugh Kenner began his study of modern literature in England, *A Sinking Island* (1987), by stating that the word 'English', until recently, 'implied the culture of an island called England'.

When you put your mark on the paper in the ballot box, that's what you must bear in mind. It is the essential reason why I shall vote YES for independence.

On 25 January 2012, the Scottish Government acted to end three centuries of institutional neglect in our education system by ensuring that works of Scottish literature must be in the school curriculum throughout Scotland.

A follow-up survey organised by the Scottish Qualifications Authority

demonstrated the extent of ignorance among schoolteachers of English in Scotland, most of whom still have to ask the question, 'What is Scottish literature?' Following from ignorance comes fear and negativity; nobody wants to be told to teach a subject about which they know nothing.

You can sympathise with someone studying English, getting a university degree, who will know not only Shakespeare, Austen and Dickens, but also some American, Irish, and post-colonial work. But most UK university English departments don't teach Scottish literature. Only one university in Scotland has an established Chair in the subject.

Those of us who argued for an exam question were opposed by the biggest teachers' union. The Educational Institute of Scotland said that an exam question on Scottish literature is not the best solution because exams put students off. So why have exam questions on Shakespeare?

As a professional teacher since 1986, teaching Scottish literature in New Zealand, China, India, France, Romania, Poland, Spain, Australia, Singapore, Ireland, the USA, and Scotland, where I hold the Chair of Scottish Literature at Glasgow University, I believe that teaching in courses over time is absolutely necessary. But so are exams. They test certain skills, capacities for knowledge and the application of knowledge under pressure, that are valuable. Not everyone likes what they're taught, but they will remember what they need.

I deplore the competition-mentality that skews teaching to produce league table results.

As for responses to the mandatory Scottish question, anecdotes are not evidence but some of the stories I have heard are appalling. At one headteachers' meeting, allegedly, the verdict was that there were no teachable plays by Scottish authors. At another, the opinion was that compared to English, Irish or American literature, no Scottish literature was of any quality.

These comments go well beyond, 'What is Scottish literature?' If they represent anyone's true opinions, they are based on ignorance, prejudice and political hostility – not only to me and the subject I profess, but to every generation of schoolchildren that comes under their care.

It is time to change that forever.

The First Dialogue:
The Unanswered Questions
Answered

ALEXANDER MOFFAT Your *Herald* Manifesto makes the cultural argument – and that's your argument, not one that the newspaper necessarily endorses – but what about the economic argument? You know that people will respond to what you've said by insisting that the facts of the economy are far more significant and that you're being elitist or irrelevant to the needs of people, with regard to jobs, health and social services, and the working economy. Most people, I suspect, would give priority to these questions over anything to do with poems or paintings. And for good reason.

We're living in an age of austerity, of economic crisis, not only in the UK but in the USA, Europe and Japan, the great motors of global economic growth. Of course it wasn't supposed to be like this. With the collapse of the Soviet Union we were told that capitalism had triumphed and that prosperity would grow accordingly, with ordinary folks benefitting from the ingenuity of the financial markets – the so called trickle-down effect. In reality, the rich got richer and the poor got poorer. It's impossible now to be optimistic about the future, especially when one looks at the situation in Spain and Greece. There is colossal debt everywhere that's not going to go away for years, and an awful lot of people are terribly worried and concerned. What do we say to them?

The Economic Argument

ALAN RIACH I won't go back on what I said. The cultural argument is the only one that really matters, in the end – but the second paragraph of my essay acknowledges what you're pointing out, and there's no denying that. Of course we have to find answers to many questions that arise now, but I think a lot of them will always be speculative. Whether or not we become an independent nation state sooner or later, there is no absolute prediction about what the future will bring, except to say it'll bring its own time and conditions. So how would you answer the question: How do we sustain a working economy?

SANDY There was a lecture on the economics of Scottish independence given by Professor John Kay of the London School of Economics, at Glasgow University on 21 February 2013, in which he said this:

> Small states in the modern world are not only viable in economic terms, but some are among the most successful in the global economy. That is, there are few economies of scale – as an economist would put it – in state size today, outside military expenditure; and armed strength is of reduced, perhaps negative, value. Arguably there were such economies in the 19th century and certainly that was believed then. But now being small is entirely consistent with very high levels of national prosperity. However, such prosperity is conditional on being an active and effective player in a global economic order.

And he went on:

> The result of independence could be a much more vibrant economic environment. It is hard to deny that devolution has led to some revival of Scottish identity and self-confidence, and independence might do more. Independence might also be characterised by a rather unattractive mixture of conservative municipal socialism. One which did so much damage to economic progress in Scotland with crony capitalism and produced such disastrous results in other small Western European countries, such as Ireland and Iceland. There are pluses and minuses in the ways independence might influence the climate of business behaviour and it is far from evident what the balance might prove to be. But this issue is the central economic question in the independence debate.

ALAN That seems a pretty fair account. I doubt if the early days of independence will be a stroll in the park.

SANDY And yet, in many ways the economic argument has already been won. There is general agreement between Nationalists and Unionists – even such as David Cameron – that Scotland can be a successful independent nation economically. The argument is now about *how* successful our economy can be, and whether it can be more or less successful in the Union or as an independent nation state. That argument can lead to a rather boring stalemate of claim and counter claim. Neither you nor I are professional economists but even if we were, would our opinion be any more trustworthy?

ALAN Economic theory is a highly subjective area. It's storytelling, in a different way. Economic facts and figures, within relatively secure but very broad limits, can be turned in different directions. But having read all I've

read on the subject, on both sides, it seems pretty clear that there is a deep agreement about the question of the economic viability of an independent Scotland. In terms of national resources, Scotland could sustain itself perfectly well, in the global market. That's not to be complacent, but we shouldn't be scared about it either. Sure, it's a rapidly changing world, there is violence and conflict and sometimes it seems to some people that violence is the only way they can bring about change. So the situation we're in here is very fortunate. How often do the people of a country get the opportunity, by democratic means, peacefully, by voting for it, to re-make their nation?

SANDY I agree with you that Scotland exists because of our culture and history, our literature and arts, but contrast this with the relative absence of considerations about art and culture in the political debate. The Scottish National Party is paying a price for its lack of interest in the arts.

ALAN There is an awful failure among the SNP people in Government to imbue their referendum campaign with either poetry or passion.

SANDY To be fair, it's not much in evidence among any of the other political parties.

Better Together?

ALAN In May 2012, it was reported in the press that Stirling Labour and Conservative city councillors, both in the minority, were forming a Unionist coalition to outnumber the majority of SNP councillors. This was described as a treacherous betrayal of the people of Stirling, who had voted either for the Tories or for Labour, believing that they represented different interests among their constituents. That they would get together to form the administration on Stirling Council, to ensure the SNP group were kept from power, was a shock for many people, but reports followed of another Labour/Tory alliance in Aberdeen.

SANDY A similar sense of betrayal followed a standing ovation given to Alistair Darling, former Labour chancellor, at the Scottish Conservative conference in July 2013. Appropriately, he looked rather embarrassed. He was speaking in his capacity as leader of 'Better Together', campaigning for the Union alongside Conservatives, Labour and Liberal Democrats. Former leader of the Conservative Party in Scotland, Annabel Goldie, recollected that Darling's great-uncle was the late Sir William Darling, the Conservative MP for Edinburgh South after the war. Darling said that while they may have their differences, both Labour and the Conservatives agreed that the

UK was the best option, appealing to British patriotism. The room full of Conservatives gave him lavish applause. And there's a further irony here. The 'Better Together' campaign is chiefly funded by wealthy Tory supporters, but mainly run by Labour activists who are using the opportunity to covertly shore up the Labour vote with an eye to the next UK General Election! Aye, it's hard to believe. Who would have thought that Scottish Labour would have taken over as the leading Unionist party?

ALAN The whole Unionist Alliance is a betrayal of the people each of these parties pretends to represent. And the biggest disappointment is the Labour Party. There is no representation of the ideals of the Labour movement there, the sense of social justice as something worth fighting for, something attainable, and something that can be brought about by breaking up the myth of the British Empire and realising the potential of all the nations and constituent parts of those nations.

SANDY There's a conspicuous lack of new ideas, or real vision, in the independence debate. The NO campaign people don't feel it's their job to offer anything of substance. After all, they are perfectly satisfied with the status quo. Their strategy of course, is to try to scare us, and it's worked in the past. A debate left to the political class and the media will be a restricted conversation with a limited agenda. Again this suits the NO campaign as the media are by and large on their side. That's why it's important to construct a wider context for debate than at present, with culture at its centre, because you're right: when cultural distinctiveness is given form in works of art, architecture, poetry, drama, film, and so on, we are presented with powerful and lasting statements of who we are and what we might be. But Scotland's cultural position is generally seen, when it's seen at all, within the overall British context. It's the old story, small versus large, therefore the mediocre versus the superior. That's even how many currently working in the cultural sector in Scotland see it, I'm afraid. The attitude is that Scotland is a region of Britain, has no national status in its arts or history or cultural production over centuries, and England, which is really what is meant by Britain, is the arbiter of all things. And there is a real hostility towards Scottish cultural achievement from within Scotland itself. What's called the Scottish cringe. That's why the arts are so crucial. A nation's art is part of its self-esteem. Not to exaggerate that stupidly, but to understand it as essential. For a long time we were bullied into thinking we had no art at all.

ALAN In September 2013, Labour peer Lord George Robertson, former Defence Secretary and NATO chief, gave a speech at the University of Abertay in Dundee, where he said this:

There's no linguistic differentiation, no great cultural discrimination that might argue for it, like it does in some other countries, you know. In Flanders in Belgium they say 'Why can't we become an independent state?', or Catalonia in Spain, where a million and a quarter people marched in the streets. They say they want to become an independent state but they've got language, and culture, and all these sort of things. We don't have any of that.

In other words, he's saying that Scots must not be allowed to believe that there is any distinction in our languages, arts and culture, because if we did believe that, we might demand to be governed in accordance with what we hold important. Scottish culture, therefore, must be denied and belittled at every turn.

SANDY Surely Robertson was misleading his audience? He must know hundreds of Labour people who identify strongly with their language and culture. Not only is he insulting them, but he is prepared to utter this nonsense in a university here in Scotland in the full knowledge that he's speaking to a highly sophisticated, educated audience, in order to attack the case for Scottish independence.

ALAN If he was, then he's stooping to a new low. The point is so unbelievably crass, it's a pity nobody leapt to their feet and told him what they thought of him.

Scotland's Self-Suppression

ALAN In some places, though, you might say that Scotland's major arts institutions are acting as if they believe Robertson. The National Galleries of Scotland still has its Scottish paintings in the basement, doesn't it?

SANDY It does, sending a message that this is second-rate stuff. There are plans to remedy the situation, but one wonders when and how this will happen. In 2012, the National Galleries mounted a major Edinburgh Festival exhibition, 'Symbolist Landscape in Europe, 1880–1910'. This was a co-production with museums in Amsterdam and Helsinki and showed yet again, in excluding the work of any Scottish artists, the failure of the National Galleries to represent Scotland in an international context. What were audiences in Helsinki and Amsterdam thinking of Scotland when they saw this exhibition? Our pre-eminent art historian, Duncan MacMillan, commented in *The Scotsman* (19 July 2012) under the headline: 'Scottish Art

has been ignored entirely in the Scottish National Gallery's major summer show':

> The National Galleries of Scotland exist to show the world to Scotland, but reciprocally to show Scotland to the world. Properly conducted, that exchange affects both parties. Scotland is enriched by the presence of great art from elsewhere, but the Scottish story, properly told, should in turn also enrich the wider European story. If our National Gallery cannot tell our story for us, who will?

MacMillan continues: 'If this were the National Gallery of Nowhere in Particular, the omission of Scots would be a serious criticism, but for the National Galleries of Scotland it is inexcusable.' Inexcusable indeed, with the National Galleries letting down both themselves and the people of Scotland. Professor Murdo Macdonald suggests the failure of the National Galleries of Scotland in this instance presents an intriguing set of opportunities for cultural analysis:

> It is as though something in the decision-making processes of such organisations stands in the way of treating Scotland as a normal culture. For these bureaucrats Scottish culture is still 'other'. It can be 'admired', even advocated, but only as a separate area, not submitted to ordinary processes of international comparison, such as those provided in a major exhibition of European work. Perhaps this attitude will eventually collapse under the weight of Scottish Turner Prize winners, but one should not assume even that. It is easy to justify contemporary work without any reference to a wider historical or geographical context.

Compare it to other National Galleries and what do we find? The Prado in Madrid first and foremost tells the story of Spanish art, and the Louvre in Paris acts as a beacon for the riches of French art and culture. All is not lost, however. Running concurrently with the 'Symbolist Landscape' exhibition was The National Museum of Scotland's 'Catherine the Great' exhibition where the considerable Scottish involvement with Catherine's Russia was highlighted. In this case the Scottish contribution to the cultural networks of Europe was made clear, not ignored. So we have two national institutions with two very different approaches. There hasn't been a Scottish Director of the National Galleries in Edinburgh since 1949.

ALAN That's shameful. I don't think it's xenophobic to say that. If you really believe you're appointing the best person for the job and in more than half a century that person, in charge of the National Galleries of a country, doesn't come from that country, that's a horrific indictment of that country's

education system. Is it really true that Scotland has produced no-one in all that time capable of filling that position?

SANDY It seems highly improbable. In the same time period we produced extremely capable Directors of the Tate and the National Galleries in London. And this leads on to another grand misconception concerning Scotland's place within cultural Britain.

How often do we hear that because Scottish candidates occasionally rise to top positions in the London museum world, the appointment of English directors to the Scottish National Galleries is wholly justified? This is always presented as a vindication of the cultural openness and equality of opportunity that distinguishes cultural life in contemporary Britain.

The purpose of the Scottish National Galleries is to represent Scottish artistic achievement within the wider historical context of European and international developments in the visual arts. We've noted the rather feeble attempts to do so over the past 60 years. This is hardly surprising, given that the English Directors in charge were unfamiliar with the history of Scottish art and in some cases openly hostile to an indigenous culture they regarded as provincial and therefore of no consequence. The purpose of the National Gallery in London is to represent a historical overview of European and British (English) art at the highest possible level and that aim has been consistently maintained, no matter who has been in charge, English or Scots. Any proposal to relegate the great English painters – Hogarth, Gainsborough, Turner, Constable – to inferior positions within the displays would be considered a sacking offence or worse. I've known several Scots – all absolutely outstanding in their fields of expertise – who made it to the top in London, but in order to get there, none of them played what we might call the Scottish card. That is, they never attempted to project Scottish ideas or Scottish art while in the job. That would have been suicide. They played an uber-British card first and foremost, adopting the mannerisms and attitudes of the English upper classes. Their assimilation was total. On occasions they may have been able to discretely promote an exhibition of Scottish art or an artist from Scotland, but their support had to be low-key, never drawing attention to itself. Those are the rules that govern the highest echelons of British art and culture and woe betide anyone who steps out of line. I read recently that for the parents of Duke Ellington who were middle-class black people at the turn of the century in Washington, DC, upward mobility depended on adopting the whitest mannerisms possible. Ellington's father, a butler, dressed and spoke in a high-flown fussy manner. Imagine an English toff, on applying for a senior arts post in Scotland, attempting to speak Scots in order to qualify for the job. Of course, the 'English toff' is a caricature.

The diversity of regional identities and representations of identity in England are often dominated by that caricature, just as much as they are in Scotland.

We'd like to think that in Scotland we're much less class obsessed and more democratically inclined than the English establishment. Are we? Boards of Trustees of Scottish cultural institutions are usually made up of bankers and business people committed to the standard view of British culture – and this is where our own special brand of inferiority kicks in. Instead of insisting that the main criteria for holding the post of Director of the National Galleries of Scotland is an all-encompassing knowledge of Scottish art, exactly the opposite seems to be the guiding principle. And this is all too readily accepted, as if the sporadic appointments of Scots-born arts bureaucrats to senior jobs in major London art institutions justifies the kind of British cultural orthodoxy that has continually relegated Scottish art to the backwoods.

It's different in other countries.

ALAN I was in Bucharest in 2012. The National Museum of Art of Romania in Revolution Square, in the city centre, is a massive building. It was formerly the royal palace, completed in 1937. Half of it is given to the great artists of the world, an international collection assembled by the Romanian royal family, now open to all the public; the other half is made up of work by the artists of Romania, from medieval to modern. There was no sense that this signified, 'We're better than all the rest'. It was simply a fair balance: this is where we are, this is our story, and we have to keep that in the critical context of the world, other nations, works of art from all around the world, celebrating our differences and distinctions, while at the same time, under-standing our commonality, our humanity. The museum had been damaged during the revolution in 1989, which brought about the fall of the tyrant dictator Nicolai Ceauşescu and it reopened in 2000, and in 2002, the medieval collection opened, including works salvaged from monasteries that had been destroyed during the Ceauşescu era. The modern Romanian collec-tion includes sculptures by Brancusi and paintings by Aman and Grigorescu. The international collection includes work by El Greco, van Eyck, Breughel, Rubens, Monet and Sisley. How's that for an example? The work hoarded by the privileged royals and the property of the dictatorship is now open and available to everyone.

SANDY This is a perfectly normal example of national galleries the world over. But then there are powerful vested interests for Scotland not to be normal. You can apply the cultural argument and see how it works in other countries. Your manifesto places particular emphasis upon the distinctive-

ness of Scotland's cultural world. If we were to make a journey from north to south Europe, from say Sweden through Norway, Denmark, Germany, Austria, Slovenia, Italy and on to Greece we would, I imagine, experience many different cultural worlds. How does this affect the work of artists and writers? Let's take as an example those two great film directors who died on the same day, 30 July 2007: Bergman and Antonioni. How does cultural difference reveal itself in their work and does it really matter? Isn't it best to simply regard them as great international film makers and leave it at that?

ALAN Yes and no. No, emphatically, because both draw so profoundly and effectively on their distinctive national contexts, by which I mean, most obviously, languages, landscapes, characters, traditional stories, questions and mysteries, the whole history of their countries and the different forms of modernity in each of them, different ways of approaching questions and phenomena and people. But yes too, because their work is international for sure, accessible to anyone who watches their films closely and sees in them what they're saying about what it is to be human. Their national distinctiveness doesn't cut them off from being international, and their international validity doesn't make them any less Swedish or Italian.

SANDY I'm sure many in Scotland would agree with what you say, but there remains a sizeable gap between thinking and doing. There seems to be a fear of action with regard to cultural matters, not helped by recent events at Creative Scotland. I'm told the biggest single objection theatre groups, art centres and so on had in their dealings with the ill-fated former directors of Creative Scotland was the attitude displayed towards them, which continually spoke of superiority, as if they were saying: 'We've come all the way from England to show you backward Scots how to do it!' Malcolm Maclean, former Creative Director of Proiseact Nan Ealan, wrote in the *West Highland Free Press* of his experience at the hands of Creative Scotland, in November 2012. Questioning Creative Scotland's capacity to understand Scotland's cultural landscape, Maclean refused to mince his words:

> The decision to end PNE's Foundation status was led by a very senior member of the Creative Scotland management team, Venu Dhupa, who was recently arrived in Scotland but had never visited a Gaelic-speaking community. She would rightly have been among the first to protest had I, as a Scot, been parachuted into another language community that I knew nothing about to determine the future of their key arts production company. The flaw in this analogy is the parachute as she did not even leave her aeroplane. This takes a high level of vanity and implies a view of Scottish culture as merely English culture in a kilt.

ALAN This sort of thing has been going on for a long time in Scotland, though. So long, in fact, that we might just take for granted that that's how it is, the natural thing. And if we raise any objections we can be shot down for racism, so-called 'narrow' nationalism, aggressive behaviour, over-simplifying the issue, and so on. That happened in December 2012, when Alasdair Gray published an essay entitled 'Settlers and Colonists' in a book edited by Scott Hames called *Unstated: Writers on Scottish Independence*. The essay title referred to the idea that many of the senior management of arts organisations might be described as either people who come to Scotland to settle and try to understand the different traditions, relationships, qualities and character of the arts in Scotland, while others take up their jobs with the ambition of getting out of Scotland as quickly as possible, and care little for the arts, history or inhabitants of the country. There is truth in this but the terms were provocative and predictably taken up by the press and sensationalised in mass media reporting. The Labour MP Margaret Curran hit out immediately and said, 'Talent and experience are all that matter – not where a person comes from'. It was all a bit too unthinking and declamatory. But it begs the question, are there no people from Scotland with the required talent and experience? In all the media hysteria, people had lost sight of one of the most important and suggestive paragraphs in Gray's essay. Gray was considering the phenomenon of Glasgow being awarded the title 'European Capital of Culture' in 1990, and what the city council and arts administrators chose to do in that year. He proposed an alternative which is immensely suggestive and helpful, that we should bear in mind:

> Glasgow had staged four great international exhibitions between 1880 and 1937 in which the city and Scottish culture were strongly represented, but in those years Scotland had not been thoroughly provincialised. For 1990 the Labour Council that had ruled Glasgow almost continuously for 60 years hired the best English arts administrators money could rent, and gave them control of Glasgow's main concert halls, theatres and galleries. They could have staged a drama festival of successful plays by Glasgow-area authors – Bridie's *Mr Bolfry*, McLellan's *Jamie the Saxt* and Ena Lamont Stewart's *Men Should Weep*. Archie Hind's Scottish version of *The Ragged Trousered Philanthropists* could have been staged with its original producer, David Hayman. They could have got an original stage play by commissioning John Byrne and Peter McDougall, successful stage and television authors, to co-operate with Billy Connolly to create something new, as the *Great Northern Welly Boot Show* was created. They could have arranged shows of paintings from those late 19th-century artists called the Glasgow Boys through the school

of colourists around J.D. Fergusson, taking in the best work of those 20th-century individuals John Quinton Pringle, James Cowie, Robert Colquhoun, Robert MacBryde and Joan Eardley. But these transient administrators knew or cared nothing for these local achievements and were employed by equally ignorant or careless town councillors. To both sorts the city's past was mainly rumours of gang violence and radical Socialism, both of which should be forgotten. New Labour wanted the City of Culture to attract foreign tourists and investors, so performances and shows were brought from outside Scotland. Hardly anything Glaswegian was presented in Glasgow's Year of Culture.

Alasdair Gray, 'Settlers and Colonists', in *Unstated: Scottish Writers on Independence*, ed. Scott Hames (2012)

Gray contrasts this with W.B. Yeats and Lady Gregory establishing the Abbey Theatre in Dublin in 1899 and fostering a tradition of Irish playwriting which continues to flourish, as opposed to staging plays by Oscar Wilde and George Bernard Shaw which were already doing well in London. When the Citizens' Theatre was started in Glasgow by James Bridie in 1943, the ideal was to follow the example of the Abbey and present plays by Scottish playwrights such as Bridie himself, McLellan, Joe Corrie and others, alongside plays by Shakespeare, Brecht, Ibsen, Frisch, Synge and O'Casey. After the appointment of Giles Havergal in 1969, however, a policy of exclusion of Scottish plays was adopted and maintained almost without interruption for 34 years.

SANDY We need to think about this very seriously. On the one hand, we want theatres and festivals to promote our own culture, and Alasdair's right, you would think that a Glasgow Festival would be responsible to the culture and history of Glasgow, but we also want them to be open to the world, to present the great masterpieces of world theatre and opera and music to our people, the people who live here. It's two-way traffic. Giles Havergal at the Citizens' Theatre did this with enormous commitment and tremendous verve, with productions of great plays that were of the standard you could find in the best theatres in the world. In the 1970s and 1980s there were Karl Kraus's *The Last Days of Mankind*, plays by Dario Fo, George Bernard Shaw, Cocteau, Racine, Sartre, Ibsen, *The Spanish Tragedy*, *The Seagull*, *The Caucasian Chalk Circle* – these were great productions of great plays and that same quality of international work was matched in the vision Alex Gibson had for Scottish Opera, first-class productions of a major art form

in Glasgow. So, aye, of course that has to be matched by work by Scottish playwrights or composers. That's the whole point. There was an extraordinary defence of Alasdair Gray after the stooshie about his essay from an unexpected quarter. This was by Bill Jamieson, a veteran *Scotsman* journalist who specialises in business and financial matters. In an article, 'Gray paints a fairer picture for us' (*The Scotsman*, 20 December 2012), Jamieson made a compelling case for the defence, and it's a defence that has been little commented upon, especially in the cultural world. Perhaps that's because no-one bothers to read financial journalists such as Bill Jamieson, suspecting that they are dyed-in-the-wool conservatives with nothing serious to say about the arts and culture. How wrong could they be! Or perhaps, what Jamieson is saying is what our arts administrators don't particularly want to hear. The fact that Jamieson came so quickly to Gray's defence is important and what he said deserves to be quoted:

> Mr Gray has set the cultural heather ablaze in recent days. In an essay he referred to English people appointed to top jobs north of the border as 'settlers' and 'colonists' who come here to advance their careers and move on. Progressive worthies in Scottish arts have recoiled in horror. 'Shocking'; 'odious'; 'ugly', 'bigoted', 'narrow-minded nationalism' – even apartheid South Africa has been invoked to describe Mr Gray's remarks. Leading composer James MacMillan strode into the blazing inferno this week, urging artists to be wary of 'fanning the flames of bigotry'.
>
> Let's all agree that there is no place for bigotry; that considerations of merit and appropriateness should be paramount in the selection of positions in Scottish life, and that these positions should never be closed to applications from outside Scotland. Let's also, this being the season of goodwill, spare comparison of Mr Gray's views with apartheid South Africa. He has not, to the best of my knowledge, proposed restricting the movement of English people into Special Areas, still less permanently herding them into bantustans.
>
> What he has done, is to remind us, if rather more bluntly than some of his admirers would wish, that Scotland is more than a place, it is an idea.
>
> Our writing, our language, our values, our history, our culture are not identical to those in the rest of the UK. There may be features that we share and enjoy in common. But Scotland is not England. To approach appointments in Scottish life and letters as if these were identical to and requiring no differentiation from appointments in the English regions is a misjudgement. And there are dangers in allowing appointments to our artistic and cultural institutions to be approached as if they were indeed

little more than short-term staging posts to something better elsewhere, an *en passant* opportunity to add another notch to that (hired) gun.

It is to the assertion of difference, this insistence on the distinctive, that our cultural institutions have a duty of care. Without this commitment the defining characteristics of our language, history and culture are put at risk. They will be at particular risk of being subsumed in that greater cause to which too many of Scotland's cultural elite are now indissolubly wedded, the promotion of universalism with its common values, shared beliefs and mantra of diversity that hides a darker truth, uniculturalism. This mind-set is now well-entrenched. Allowed free reign, it cannot but pose a present and direct threat to those very features that give our arts and literature distinctiveness on the world stage.

ALAN Jamieson says there's another reason why he I believes Alasdair Gray's critique did not deserve the scorn it received. He advises us that we should be more cautious than we are about the frequently-repeated notion that appointing someone from outside Scotland to important positions in the national cultural establishment is a good and effective way to do things. Sometimes, he happily admits, that's fine, when the candidate is really outstanding and the best person for the job. It would be crazy not to appoint the best person. And sometimes an outsider can come in and be a catalyst, shake things up in a good way. He tells us, however, that in his own experience, in newspapers, over a period of years, he has seen this happen and it has been a very unhappy experience, both for the person in question and the company as a whole.

Jamieson himself admits that he seriously underestimated the differences in Scottish life from life in England, when he returned to Scotland after working mainly in London. He had been based there for over three decades and was really out of touch with the politics and values of his native country. He had always been proud of being a Scot but he had lost sight of what Scottish really meant, what it was actually like to live here. Living in a place does make a difference. It seems obvious but it's easily overlooked by people who think they know about things they have never experienced. Jamieson says it took him years to redicover or reconnect with his own native identity, and maybe still isn't entirely sure he has done so. Maybe it's impossible.

But he is admirably honest in his perception of himself, and his observation that it must be even more difficult for someone arriving in Scotland for the first time, assuming in all innocence – or ignorance – that it is simply no more than another region of the United Kingdom. He goes on:

We are not some loft conversion or conservatory extension to England up north. We are different. We are something else. And we should recognise this in the public appointments that we make, not only to our arts and cultural institutions but across the board. That counsel should always be applied with thoughtfulness and an openness to exceptions. But we have a history to honour and a distinctive culture to respect. And it's in the defence of these that I say: *Vive Alasdair Gray! Vive la différence!*

SANDY Jamieson confronts the myth of the 'best person for the job' argument. If top jobs in the arts are handed out to those who have no understanding of Scotland's cultural distinctiveness that will inevitably prove to be, as so often has been the case, a recipe for disaster. None of the arts spokespeople, when asked by the media, dared to say this. I wonder why?

ALAN Of course, it's not that Scotland is not open to international settlers, new people coming to live here. We need to repopulate our depopulated places. Who was it who said that cultural hegemony breeds arrogance and that it also promotes intellectual enfeeblement? I think it was Irvine Welsh. What you've just described is a great example of how you need to be both national and international. The two complement each other. No country can afford to have its cultural authority devolved to another country. In Scotland, we have major figures who have made really important films, John Grierson, Bill Douglas, Bill Forsyth, and there are amateur film-makers like Enrico Cocozza, and experimental film-makers like Margaret Tait, but we have nothing that you could call a film industry. In fact, Scotland has been filmed more often by film-makers from outwith Scotland, creating versions of Scotland that really don't arise from any actual lived experience of Scotland. They're fabricated. Now, that's a fascinating history in itself, but it doesn't compare to the kind of work you see in Bergman or Antonioni. So we want an indigenous film industry that has learned from the indigenous visions of film-makers like Bergman and Antonioni. Not to copy them, but to learn from them.

SANDY Addressing the problems that seem to hold back our film-makers, Pete Martin, writing in *The Scotsman* (4 October 2013), made this point:

> The ready comparison is with Ireland, where the film industry is more robust than Scotland's. The real difference is that Ireland has an integrated screen industry based on national commitment. It's a virtuous circle which creates both critical mass, experienced personnel and a strong output. Yes, there are tax breaks, and support for film-makers, but more importantly, Ireland also has its own national broadcasters

who invest in home-grown talent. There's a healthy advertising scene too, where Irish clients are committed to Irish creative agencies who, in turn, are committed to Irish commercial production companies. So, there's a bedrock of work in which film folk can earn a crust and learn their craft. And then they make films that appeal to Irish people.

So, here's hoping the new slew of Scottish films will perform well financially (because with just £3 million in public support, Scottish film needs to attract investors). But money in itself won't create lasting success. To create an integrated national industry, only one thing will work. And that's 'Action'!

ALAN John Grierson himself said as much in 1968:

We, in Scotland, have a special reason to consider the relationship between the loss of public confidence and the lack of support for our national film-makers. To be short about it, support for our national film-makers barely exists, nor does the political power seem to care a whit whether support exists or not. We have a country of five million people, larger than many represented separately in the United Nations. We have a culture which we consider naively distinct and our own. We have certainly a concern for our self-esteem which we find proper and necessary. Those are, in effect, the important intangibles by which we live and move and have our being. Yet, to put it plainly, we are thwarted in the expression of these intangibles by which we live and move and have our being. We are denied access to the means of production by which we can give expression to our self-esteem and draw from it an inspiration for the present and the future.

John Grierson, 'The Relationship between the Political Power and the Cinema', Celebrity Lecture at the Edinburgh International Film Festival (24 August 1968), quoted in Forsyth Hardy, *Scotland in Film* (1990)

Given all that, which is symptomatic of a much larger context in which projected images and ideas about Scotland have held an international significance, people who don't see their own landscapes and languages and ways of life represented and questioned and celebrated, may well be more susceptible to uncertainty, caution, a lack of confidence in their own cultural validity. Is this not one of the reasons that might lead to people voting against independence?

SANDY People will certainly vote NO if they lack the self-confidence you've just described. And the kind of confidence that's needed is to all extents and purposes undermined on a daily basis when we switch on our TV sets. In

1970 Stuart Hood published an essay entitled 'The Backwardness of Scottish Television' where he lays out the criteria needed for us to judge the quality of a country's television.

> One is the range and variety of programmes offered to the viewer. Another is the degree of freedom it enjoys to show and speak the truth. A third is its success in revealing a society to itself: on a primitive level by showing its citizens how they speak, behave, live, and on another higher level by revealing to them the mechanics of their society, how it functions politically, economically and culturally. All three criteria are linked. For it is not possible to deal in the truth unless there is a sufficiently wide spectrum of programmes to include those which honestly explore the nature of society. No society can be explored unless its broadcasters are free to ask honest questions and answer them. Unless broadcasters are allowed this minimum of freedom, self-revelation is impossible. All over the world there are societies, ranging from great modern capitalist or socialist states to small, emergent, underdeveloped ones, which have not achieved self-awareness because the dominant instruments of mass culture do not provide a mirror in which their citizens can see themselves truthfully. In most countries television is now the main disseminator of mass culture. In many of them it has either failed in its duties or been prevented from performing them.

> Stuart Hood, 'The Backwardness of Scottish Television', *Memoirs of a Modern Scotland*, ed. Karl Miller (1970)

ALAN It's the old story, we see ourselves in one way, but we see ourselves rather differently if we imagine how we look in the eyes of others. That's a help. The accounts of visitors are a virtue. They help us see more objectively – which is, from a range of perspectives, not from any single one. To be objective, you need that sense of the relative, the relational. All things are partial, in relation to other things. Yet broadcasting in Scotland is not in the hands of the right people in Scotland. It isn't created by people with the sympathy and care, the critical perspectives you need to achieve self-awareness. The point to make is that London is in control, with BBC Scotland fulfilling only a regional role. There is no way BBC Scotland could ever be allowed to develop and broadcast what we might call a Scottish world-view. And this has deeply affected the way we see ourselves, literally.

SANDY Television is a medium that has to be used more effectively. Every year, on the morning of Remembrance Day, the culture minister of the new independent Scotland should appear and draw attention to the work

of the great Scottish artists, poets, writers, composers, who have taken their experiences of war and made their art to utilise those experiences in the service of peace. Ronald Center after Hiroshima and Nagasaki, Hugh MacDiarmid and William Gillies after the First World War, Edwin Morgan, Robert Garioch, Sorley MacLean, Hamish Henderson, Norman MacCaig, all with completely different experiences of war – as combatants, pacifists, prisoners, medical orderlies – must be part of the currency of reference. Remembrance Day has been commandeered by the military and religious orthodoxies – Generals and Bishops. We need to take things out of their hands and bring the concerns of the people back to the people. War poetry – the arts in times of war – do not glorify war, they deliver the assets of peace. We need to see these assets, hear about what they mean, see our politicians and representatives talking about them, with reference to the poets and artists who have articulated them clearly.

ALAN Fifty years from now, imagine a Scotland where there is no longer any need to talk about Scottish military achievement, and the cult of the Scottish regiments has become history.

SANDY We're in the 21st century now and Stuart Hood's analysis of the quality of Scottish television seems even more pertinent. Is Scottish television enabling the people of Scotland to achieve self-awareness?

ALAN Who has the power of persuasion? I've heard it said that we should vote for the Tories because they're rich, they're better off, and therefore they know how to make money, they would look after things better because they know how. Then there is the personal dislike of particular politicians, you know, 'I don't trust that man Salmond.' Then there are those who might say, 'Leave us alone – a distant government knows nothing about us so we can get away with more if we stay in that position and keep our heads down.' Then there is the Highlands versus Lowlands argument, or Gaelic versus Scots language speakers, and essentially it's a divide and rule argument. There is no coherent identity called Scotland, so we shouldn't have a single government in Scotland. Divide and rule is a policy that increases violence and sectarianism, leads to exaggerations of identity and a lowering of the eyes, and a population that is uneducated, miseducated, misled, ignorant, insistent on holding their own opinion and position but without argument, refusing to argue their position openly.

SANDY Isn't that what we've got? And what we've had for a long time now? If this is the case, then we have a problem, but it's our problem, no one else is to blame. You talk of a population that is uneducated, misled, but at least

we don't have a fascist party in our midst, a BNP or a UKIP. Let's set about tackling our problems. Independence can make a difference, self-government can change things. Let's argue our position openly. There's a great deal at stake here.

ALAN What would it take to convince people that what is at stake here is crucial? If people are not willing to stake their lives on the matter, can it really be so important? Scotland has taken 100 years longer than Ireland or Norway to reach a position where we can vote, peacefully, for our independence from the British state. Norway became an independent country in 1905, after a referendum when the Norwegian people chose to dissolve their political union with Sweden. And in Scotland, by taking our time, negotiating our position, calling all the arts and artists and everyone who cares about such things to consider these political questions carefully, we have achieved this position where the question of independence is right there in front of us, against the odds and without bloodshed. But in the end the only way to convince people that it can work is for people to vote for independence and allow it the chance to work. If you are still unconvinced, maybe the only way to be convinced is to vote YES.

SANDY There is a terrible passivity though, deeply ingrained in many folk, that they cannot possibly bring about change, that change is something you cannot make for yourself, in the big political world. There are large sections of the Scottish public who feel disempowered, who feel this is not the Referendum they would have wanted, had they been consulted. This makes it relatively easy for 'Project Fear' to connect with them, to discredit the independence case with scare stories.

ALAN 'Project Fear' is what the NO campaigners called their own enterprise. Honestly! It's a bad James Bond story.

SANDY And yet we have the evidence of opinion polls that tell us that most Scots remain unconvinced about independence. Fortunately, that's not the way artists and writers see things, because they're in the business of creation, of bringing about change through their art. Joan McAlpine, MSP and journalist, referred to a *Sunday Times* poll concluding that a majority of people involved in the arts and culture would approve independence.

ALAN We have a vested interest in it. Which calls to mind the larger context, another triumvirate: art, nature and science. Again, if you put those in isolated compartments you have a recipe for disaster. Nature has its defenders in the Green movement, and ecological concerns have been at the heart of so many Scottish writers – John Muir, Hugh MacDiarmid, Kathleen Jamie,

Ian Stephen – but the old 'Two Cultures' thing of C.P. Snow – the idea that this division between arts and sciences has grown so much – this puts the notion of scientific objectivity on a much higher plane of being desirable, and relegates nature to a position of being controlled by science, and art to a position of mere entertainment. This is at the core of error. So artists, ecologists, all of us, in whatever capacity, have an immediate intrinsic interest in independence, to correct that error. The scientists too, the really human ones, as opposed to the bankers, economists, the Treasury people, who think everything important can be attended to by numbers. Numerological thinking is necessary, of course. Quantitative understanding is essential in any society. But it is not the only way of understanding, and if you think it is, and you're in a position of power, then we're all in serious trouble.

SANDY There is, of course, a really human scientist who has lived and worked in Edinburgh for most of his long life, Peter Higgs. His theoretical discovery of a mechanism that contributes to our understanding of the origin of mass of subatomic particles, made in the 1960s and which now carries his name, the 'Higgs boson' (the most sought-after particle in modern physics) resulted in the award of a Nobel Prize for Physics in 2013. In a recent interview he was asked how he would feel when walking onto the platform of Stockholm's Concert Hall to receive the Nobel Prize from the King of Sweden. He answered by making reference to Ingmar Bergman's *Wild Strawberries* (1958). In Bergman's film, one of the truly great works of world cinema, an old man, a professor of medicine, sets off on a long journey by road to the University of Lund where he will receive an honorary degree. In

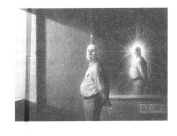

the course of the trip he relives many of the events of his life and though they are often troubled, and at times even bitter, he achieves serenity at the end. It's a difficult, demanding and deeply moving film. In this instance, the fact that Higgs should use the example of art, rather than science, to explain his feelings at such a defining moment in his life tells us much about what art is capable of.

ALAN Maybe you could say that the 'Higgs boson' particle is essential to the film? *Wild Strawberries* is set firmly in the context of Swedish life and culture, connecting with the plays of August Strindberg and the paintings of Edvard Munch. No wonder the insular movie critics in London and New York found it elusive and mystifying on first viewing.

SANDY Going back to Joan McAlpine for a moment, she further elaborates by stating that Scotland stands to gain major cultural benefits from self-rule

– and no one knows that better than the artists themselves. The poll revealed that 64 per cent of those asked thought Scotland's culture would benefit from independence, while only 9 per cent thought it would have a negative effect. Three times as many (59 per cent) say it would be good for Scottish confidence rather than bad (19 per cent). McAlpine goes on:

> Perhaps this is because they also believe that joining the family of nations will boost our self-esteem and a thousand flowers will bloom. Significantly, many of the most outspoken supporters of Scotland resuming its place in the family of nations are global players who know what success looks like – it comes from self-esteem and knowing who you are. A long list of prominent cultural figures – including Sean Connery, Gerald Butler, Liz Lochhead, Alasdair Gray, Iain Banks, Peter Mullen, David Grieg and Alison Kennedy – have made positive noises about the benefits independence would bring. And many also recognise the importance of the diaspora in the modern world. The concept of national identity is no longer confined to its borders – and here Scotland is at a considerable advantage because of the millions of people around the world who have an affinity with us. We live in an interdependent world, in which cultural institutions span borders. But to shine we need to participate as equals. One only has to think of the Venice Biennale where Scotland has had its own pavilion in recent years, giving a prestigious international platform to our most challenging contemporary artists. Does anyone believe Scotland's reputation as a vibrant centre for visual art would be enhanced without an independent platform in Venice? Now imagine what we could achieve if that model was the norm right across the creative sector, as it will be when Scotland votes YES. Independence itself is an act of collective creativity, an assertion of hope.

ALAN So our central concern is the arts and education. If democracy is defined in terms of the size of the population, in Scotland we're crippled before we even begin. Five million people in Scotland, 50 million in the England. But even if it was democracy at work in an independent Scotland, what proportion of the population would have any idea why Titian was a major artist, someone we could all learn valuable things from? The greatness of art is not democratic. A great work of art is not made out of democratic structures. But education is. Our means of understanding things arrive through education. Without education, there is no democracy. To act democratically is to act in a context of choices, and to understand what those choices really are. Without knowledge of the arts, literature, painting, sculpture, architecture, music, we have no chance of understanding what the

choices really mean. A culture should be a reflection and a representation of and a dialogue with democracy.

SANDY So what do we mean by this word 'culture'?

ALAN Culture can mean works of art. It can also mean the sophisticated way people interact familiarly with works of art. Thus a 'cultured' person might know about and enjoy certain works of art in appropriate ways but if you connect this with a privileged education you're straight into snobbery, class division, elitist disdain and pretentiousness. This is why certain people might approve works of literature in 'Oxford English' but disdain anything in Scots or Gaelic. But the word 'culture' has another meaning. It simply means *everything*, everything you do and encounter, from an opera to how you hold your fork and knife, from your language to your habits of drinking and sense of humour. So culture in Scotland is, let's say, David Hume and Byron and Walter Scott and Duncan Ban MacIntyre, but it's also football, sectarianism, slums, alcoholism, deep fried food habits, all of that too. So why is Scottish culture so abysmally awful, with soaring scales of early mortality, alcoholism, violence, and so on? The answer is that we who live here have not dealt with these problems directly.

SANDY That's not quite the full answer. Yes, there are serious social problems embedded within Scotland that we have failed to resolve – not that they can be fixed at the drop of a hat. But the main case for the Union is that we all benefit from sharing our great wealth and expertise, that we pool our resources and tackle poverty, ill-health and unemployment together, as one nation. But that has not happened. We have to ask why Labour after 1945 and through the 1950s and '60s and onwards, when they were in control of Scotland as well as the industrial cities of England, failed to deliver anything like that. One million Scots felt the need to emigrate during the 20th century. That's hardly a vote of confidence in the Union.

> 'I dinna ken muckle about the law,' answered Mrs Howden; 'but I ken, when we had a king, and a chancellor, and parliament-men o' our ain, we could aye peeble them wi' stanes when they werena gude bairns – But naebody's nails can reach the length o' Lunnon.'
>
> Walter Scott, *The Heart of Midlothian* (1818)

ALAN What happened in 1707 was that the Scots retained their rights to organise their own religion, education and law, but sent all political responsibility to London. It's taken 300 years for us to understand that it doesn't work. Politics keeps coming back in. It affects everyone. Trying to do without it is like living without water or sunlight. And in that respect, the

word 'independence' is really misleading. What's required is self-government. Any state is going to have to deal with the world as it is, which means capitalism in its latest stages. So any notion of an independent Scotland is going to have to be practical in its way forward. And that means understanding that the most extreme form of absolute independence – isolationism – is neither possible nor desirable. But self-government is, and it has been demonstrated for a long time now that such a state of self-government in Scotland would be far better than leaving things to Westminster as they are. It is not only the Scots who are thinking this way but people in Wales and Northern Ireland too. George Kerevan in a newspaper article, 'Lifting the gold medal for hypocrisy' (*The Scotsman*, 8 February 2014) wrote this:

> Every nation that composes the UK has a vested interest in dismantling the existing status quo, starting with England. As each morsel of devolution in Scotland, Wales and Northern Ireland has been wrestled from Westminster, the people of England have become increasingly disenfranchised and subject to policies decided by the the votes of backbench MPs from the Celtic fringes. The metropolitan elite – scornful of what they see as the racism of the English hinterland – steadfastly refuse an elected English Parliament, thereby creating the very conditions for such a populist groundswell. There is growing support in Northern Ireland for more powers to be transferred to Stormont, especially over tax – aka devo-max. Indeed a new political party – NI21 – has just been formed in the North to campaign for income tax powers. A Yes vote in Scotland will add pressure to give Stormont control over Northern Ireland's finances. In Wales, with its own Celtic social democracy, the tide towards re-shaping the creaking UK state is also gathering pace. Polls show a majority want more powers for the Welsh Assembly, including control over borrowing (59 per cent) and welfare (51 per cent). An independent Scotland, sitting in a Council of the Isles, will only add to the political clout of Wales in its quest for greater autonomy. Scottish independence also tips the tide against the remorseless economic pull of London – a change that is bound to help the Welsh economy too. Scottish independence is not the end of the partnership between the peoples of the British Isles, as David Cameron infers. Rather it is the door to returning sovereignty to each and all of the nations of the UK, allowing them to participate in a new, confederal arrangement as equal partners. Unfurl the flags – all of them together.

SANDY What would be Scotland's place in the world? We know that creating a successful small nation will take time and hard work. You're right, it's

definitely not about isolation. A new state needs to become a member of as many international organisations as possible. And smallness is no barrier to thinking big, to punching above our weight. Take the example of Costa Rica which uses the phrase: 'No army since 1948'. That's non-threatening and shows Costa Rica as a good place to do business and that it can act as an honest broker. Switzerland too, follows this line. There are many others we can learn from. All of the Nordic states for a start. Make no mistake, there's a role for an independent Scotland to play in foreign affairs.

Regarding the future economy, a country's name is a badge of quality. Scotland is already doing this with food, whisky, university education, aerospace maintenance and oil industry support. We need to streamline the model, making 'Scottish' globally synonymous with top quality products and move quickly towards standing on our own two feet, to embrace responsibility and entrepreneurship.

ALAN Let's return again to John Kay:

> What competitive advantages does Scotland have, or might have, that would enable Scottish businesses to compete as effectively as Swiss businesses or Finnish businesses or Danish businesses; firstly within the European Union and then in a world-wide market? If one identifies areas in which Scotland has potential competitive advantages we can come up with about four or five.

Kay lists those as (1) Financial Services: 'the role of Edinburgh as Britain's second financial centre – and as far as asset management and insurance are concerned – a reputation for conservatism and competence remains largely intact'. (2) Tourism. (3) Premium food and drink products. (4) Energy Services developed around the growth of North Sea Oil production. (5) Life Sciences and medical related activities. He sums up by saying:

> But a great deal has to be done in order to realise this potential. And what we need to do is to create a climate of enterprise and entrepreneurship within Scotland, which would lead to the growth of the kind of businesses that exploit these sorts of sectors.

SANDY I doubt if this is simply a response to the extreme free market ideology that currently dominates. After all, the small Nordic nations remain much more social democratic than the UK, but they are geared to compete globally, their industrial bases up to speed. Kay is being realistic with his advice. Why should that be difficult? We've done it before.

ALAN And that takes us back to the cultural argument. Artists, after all, take responsibility for their work and develop entrepreneurial skills to promote

it. They have no choice in the matter. Perhaps that's another reason a large majority of artists support independence.

SANDY Joyce McMillan, writing in *The Scotsman*, suggests that artists will vote YES because they know Scotland has the creative capacity to face up to its problems. She says the NO campaign's aim to convince people that independence would be a disaster, was always likely to anger those who spend their lives in Scotland's creative sector, and to drive them towards the alternative. Why? Because Scotland's creative community is now a tremendously confident body of men and women, who, in the everyday detail of their work, know and understand the world-class achievement of Scottish writers, artists and musicians, especially over the last half-century, in re-imaging their own culture, and in taking their place on the world stage. If they vote YES it will be because they know that Scotland has the creative ability to come to terms with its history, to deal with its conflicts, and to create a future worth having.

ALAN There's a lot to be done. There always is. But come at it that way and you realise just how much of what we take for granted doesn't have to be the way it is. So how do other people in other countries tackle this question?

The USA: Cultural Self-Projection

SANDY Let's start with America. Most of us around the world have seen movies all made in Hollywood. It's the great national art form of America. But we don't think of it as the pre-eminent American national art form because we don't think in terms of national art. We've been brought up in a world where US cultural hegemony is taken for granted. It's a superpower, the only one left standing. But its role as a mighty military, industrial and cultural giant is relatively short-lived, only assuming such a status after 1945. Apart from its contribution to the cinema and to popular music in the 1920s and 1930s, no-one took its art and artists very seriously, least of all in America itself. As Milton W. Brown says in his introduction to *The Modern Spirit: American Painting 1908–1935* shown at the Edinburgh Festival in 1977:

> It is fairly clear by now that in the field of art, the United States has during the 20th century moved from provincialism to world dominance. This is not stated with any particular pride, or conviction that there is an inherent virtue in such dominance, or that the quality of the product is therefore superior. It does mean that American art has assumed leadership, at least in the Western World, and that other countries now look to the United States and New York as they once looked to France and Paris.

True enough, names like Andy Warhol and Jackson Pollock are now common currency the world over. Yet up until the 1940s, American artists were considered less advanced than their European contemporaries. American collectors travelled to Paris to buy work, American orchestras hired European conductors. Pioneering 'national' composers such as Charles Ives struggled to have their music performed.

Here's Milton W. Brown again:

> Nationalism in art had been on a constant increase during the 1920s. Actually, the position of American art was bolstered by the founding of the Museum of Modern Art in 1929 and the opening of the Whitney Museum in 1931. Further, a national cultural consciousness was fostered inadvertently and on an unprecedented scale by emergency governmental support of the arts under a series of agencies, as part of the Roosevelt administration's effort to cope with unemployment and economic stagnation.

I think we should draw attention to the impact that Mexican Modernism had on the Americans with the great muralists – Rivera, Orozco, and Siqueiros – all accepting contracts from Roosevelt's New Deal programme. In the USA, they stimulated a national school whose work is still described and routinely disparaged as 'socialistic'. Jackson Pollock worked in the mural division of the Works Progress Administration and believed like Siqueiros that the easel picture was a 'dying form' and 'the tendency of modern feeling was towards the wall picture or mural'. He was also a great admirer of Orozco whose influence is evident in Pollock's aggressive, dark brushstrokes of that period. That the Mexicans had produced such a distinctive brand of modern art was both a model and a challenge to American artists.

ALAN So the whole idea of modern art in America was heavily influenced by Mexico. I hadn't quite thought of it that way. The Mexican art movement was exemplary and it prompted many American artists to think nationally about their own work.

SANDY After 1945, a concentrated effort by artists, museum directors and government to promote and disseminate American art and culture began, taking on an extra urgency because of the Cold War. For a left-leaning liberal such as the composer/conductor Leonard Bernstein – who became the first native-born principal conductor of the New York Philharmonic in 1958 – the issue was about American music and not primarily the defeat of communism.

As well as placing a large portrait of George Washington in the foyer of

Lincoln Centre, Bernstein programmed a work by an American composer in every concert during his first season. 'My job is an educational mission', he told the *New York Times* a few weeks after his appointment and described the coming season as 'a general survey of American music from the earliest generation of American composers to the present'. That opening season 1958–59, will always be seen as a turning point in the musical and cultural life of America.

I remember when I first saw the New York Philharmonic in concert in the early 1970s after Pierre Boulez had taken over from Bernstein, an American Flag was placed on the stage beside the orchestra. It was as if the very presence was saying: 'We're an American orchestra! We represent American music and American culture! This is it!' There are some who would recoil in horror at such chauvinism, but there are times when it's right and proper to make such a point in terms of cultural identity and self-confidence. Think of it! The British Unionists would love that of course – if it was a Union Jack!

ALAN They pretty much do that, on the last night of the Proms. Poor old Elgar, hijacked that way!

SANDY But what if it was a big national celebration, fireworks and festivities, no guilt or jingoist superiorism – not one that invokes the imperial legacy, but a real celebration of all that culture can bring to people of all kinds, and the flag that was flying was the Saltire? It could be a festive occasion that would encourage the country to celebrate itself, in its variety, rather than in any uniformity. The whole thing could be great fun too, as we recently witnessed with those great young musicians from Venezuela, the Simon Bolivar Youth Orchestra, unashamedly wearing their nation's colours just like a football team.

ALAN I understand that James MacMillan, despite his hostility towards Scottish independence, is committed to a project similar to the Simon Bolivar Youth Orchestra and the Big Noise orchestra programme in Raploch, by Stirling, working with the Scottish national charity Sistema Scotland, based on the methods and practices of Venezuela's El Sistema movement. This involves school children having fun and getting involved in performing and learning about classical orchestral music. But in Scotland, this needs complementary work in concert programmes and adult exposure to classical music by Scottish composers of a wide range across centuries. A lot of great Scottish music simply isn't in the repertoire. Imagine Creative Scotland taking the initiative here, and a Scottish conductor/composer, a Scottish professional orchestra, getting together to do what Bernstein did in America! Wow! A general survey of Scottish music – let's say, classical music, for want of a

better term, because so much traditional Scottish music is so very familiar – but composers whose work is not, really has not been, in the orchestral or choral repertoire here – Robert Carver, John Clerk, Thomas Erskine, John Blackwood McEwan, Alexander Campbell Mackenzie, William Wallace, Erik Chisholm, Ronald Center – so many of them – since 'the earliest generation' – now that's a long way – but instead, it's the occasional, 'Land of the Mountain and the Flood' and now, thanks to a touch of enlightened programming, perhaps Mackenzie's 'Benedictus' – but an overall, comprehensive programme for a long season – say, three years – just imagine it!

> We are apt to look on art and music as a commodity and a luxury commodity at that; but music is something more – it is a spiritual necessity... [It] cannot be treated like cigars or wine, as a mere commodity. It has its spiritual value as well. It shares in preserving the identity of soul of the individual and of the nation.

> Ralph Vaughan Williams, *National Music and Other Essays* (1963)

SANDY We do have a great champion of Scotland's music in John Purser. He really broke open new ground, whole territories of enquiry, for the widest possible range of people, with his radio programmes, books and his encouragement of new recordings of Scotland's music – from Bronze Age horns to full-scale major orchestral work from the 19th and 20th centuries, particularly.

ALAN I remember in 1992 the first series of radio programmes, each one an hour and a half long, broadcast every Sunday afternoon, with a double CD set of a selection from it and an illustrated book with an extensive discography. There was a revised series of 50 half-hour programmes and a revised edition of the book with an extended discography in 2007. And yet, so much of the material there has still to be brought into the orchestral repertoire generally. Much of it, I imagine, is simply written off as negligible – because it's Scottish. Perhaps this is the reason why some Scottish composers and writers and artists want to avoid being called 'Scottish' – because of how the label brands them. Even though most of our best writers have all been distinctively Scottish and produced work that could have arisen from nowhere but Scotland, there are still those who would wish to deny that.

SANDY They aren't the only ones. There are a lot of artists out there desperately trying to distance themselves from any kind of label. The successful contemporary artist must adopt a kind of purity free from brands of any type, especially national or cultural, so they say. The American Indian artist and poet Jimmie Durham had this to say about posturing of this kind:

In New York I am often asked the question, 'Do you consider yourself an Indian artist or simply an artist?' The implication is that the work of an Indian artist is somehow more restricted, narrow, and perhaps even less serious, while that of an artist is more universal, more sophisticated, and conceivably of lasting importance. Oddly, it is only the art of white men that ever achieves such culture-less, cosmic universality. My answer to that arrogantly misinformed question is: 'I am a traditional Cherokee artist. My work is not less universal than some other. I demand that it be approached with the expectation of universal responses. We want to be participants in all of art's discourses. We expect that these discourses will allow more voices. To be an American Indian artist is possibly more sophisticated and universal than many white artists can manage, for what should be obvious reasons.'

And yet we continually hear there is no such thing as American art, or Mexican art, or Cuban art – there is only art. It's as if the unique and special properties of art are somehow or other unconnected to the mundane surroundings of the artist's day to day existence. That's a wonderful proposition, but it hardly scratches the surface of what art and artists do, where they come from, who they make work for, who they want to communicate with and how. We've just been discussing American music, so here's a succinct account of its distinctiveness by the German musicologist, Wolfgang Rathert:

> Compared to European national music styles, North American art music has its own unmistakeable shape. Notwithstanding the enormous European impact, American composers from the late 19th century onward have created an astounding scope of heterogeneous stylistic and technical idioms. This process has been launched by a dialectical approach to the European idea of tradition. The American point of view thus implies both absolute rejection and eclectic appropriation of existing musical styles. The key to this ambiguity is inherent in the American composer's identity, rooted in the rather short history of American art music and its mainly foreign origins. American music never could create such an impressive and sometimes threatening system of musical rules which has characterised European music for centuries. On the other hand, this deficiency has led to an experimental and free musical style and to a unique co-existence of the 'amateur' and 'academic' type of composer. As long ago as 1900, Charles Ives, sometimes titled 'the father' of modern American music, moulded musical works in this spirit. His music set an important example for composers like Carl Ruggles, Harry Partch, and, especially, John Cage, who transformed the European

idea of a musical work into a completely new conception of aesthetic variety and equality.

ALAN I've read that at its premiere, Ives's 'Ukelele Serenade' prompted scornful laughter and calls of contempt from the self-styled cultural elite who were looking to Europe for cultural legitimacy. In his biography of the poet William Carlos Williams, Herbert Leibowitz says that like Ives, Williams simply refused to be intimidated by such critics and persevered 'in his quest for a bold, essentially American synthesis of high and popular arts.' Of course there are problems with an 'approved' national programme or one that has the official government 'stamp'. I love that observation made by Jean Dubuffet:

> Art does not come and lie down in the beds that have been made for it; it runs away as soon as anyone utters its name: what it likes is being incognito. Its best moments are when it forgets what it is called.

SANDY No artist should ever feel press-ganged into contributing towards any 'narrow' form of national art. Pressure to create a national art often proves a straightjacket for the artists involved resulting in the most banal types of work. There's a glaring example of this hanging on a wall of the First Minister's residence in Charlotte Square, and seen by millions on TV – and that kind of art, sad to say, is not an unusual occurrence in the offices of senior politicians of all nations.

The Australian novelist Meaghan Delahunt, who has lived in Edinburgh since 1992, gets it right:

> The nationality of the artist – that accident of history – that place she was born and the cultural, linguistic, political, religious, landscape which formed her – will of course influence the artwork on a conscious or unconscious level. But the relationship between the two terms is complex. Nationality is one aspect of a person's, an artist's identity – that fluid, mutable term – but it is certainly not the only one.

She goes on to make a very important point: 'What I would say is that artists who live and work outwith the centre of artistic production – London or New York – or what is seen in global capitalist terms as the centre – are forced to think about their nationality, it cannot be taken for granted'. And that's something that artists working in Scotland have to think about.

ALAN And sometimes that would lead artists to serious commitment about their nationality and the place of their art in that context.

SANDY As Erich Fried pointed out at the Writer's Conference in Edinburgh in 1962, there are historical moments when such a commitment becomes a priority.

ALAN And the commitment can come from government, with enlightened ministers taking an active role, and it can come from individual artists or groups, writing a manifesto for their work and in their specific time. It's always exciting when the gauntlet is thrown on the floor like that. We need more manifestos, from artists of all kinds. We need more declarations of intent, of intervention. We don't want silent artists.

SANDY Aye, it's not about committees and faceless bureaucrats. As an example of an enlightened minister taking an active role, step forward José Vasconcelos, Mexico's Minister of Public Education from 1920 to 1924, a liberal intellectual who had advocated ideological and educational reform as early as 1910, and who saw education as fundamental to future success. As minister he introduced a far-reaching public arts programme sponsored by

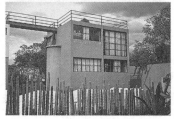

the government and which positioned the visual arts in the mainstream, making them theoretically accessible to everyone. Artists were given wall space on which to paint murals and Vasconcelos believed the murals would help to unite the nation behind the government's political objectives and celebrate the achievements of the Revolution. He also shrewdly realised that the scheme would only succeed if Mexico's leading artists were involved. As a result Diego Rivera was called back from Paris to become the artistic 'leader' of the campaign. As they say, the rest is history, with the murals widely regarded as one of the most remarkable contributions to the development of modern art.

ALAN What we're really talking about is the way nations, large and small, strive to project their cultural agendas globally – America, France, Germany, Japan, Australia – and England as well.

SANDY Think of the way the British Council exported Henry Moore to all corners of the world in the 1950s. And think of the way the Dutch promote Van Gogh, the Finns Alvar Aalto, the Norwegians Edvard Munch. There's a certain ruthlessness of approach in these 'cultural wars' we'll have to adopt if we want to compete internationally. It would be naive to think

otherwise. We've got a lot to learn. Have we ever seriously attempted to export Raeburn, Ramsay, Wilkie, Dyce, the pioneer photographers Hill and Adamson, William Gillies, William Johnstone, Ian Hamilton Finlay, Bellany, the Colourists, as great artists in a great *national* culture – rather than as isolated phenomena? Any other nation would be delighted to show their work internationally. These are not minor artists of a minor regional identity but significant artists in world terms – but they must be understood in the context of their nationality.

ALAN But how many people care? If you'd like to encourage people to care more, invest in it. But if you do that, you better start from a position of knowing what it is you're investing in, and why. The American poet Robert Creeley told me that the poet George Barker once said, in the 1930s or 1940s, 'American poetry is a very simple subject to discuss, simply because it does not exist.' Creeley said that he felt:

> ... as a so-called American poet, particularly as one recognised one's elders who were facing it, there was an immensely, either condescending or else dismissing disposition. I mean, here, we thought, here's this various and substantial place with all its factually remarkable artists, writers, and we have apparently no communal or collective authority whatsoever. It was like, we just, we aren't there, we're invisible, we just don't count.

I was talking with him when he visited us in New Zealand in 1995: the conversation was recorded and it's available on his author home page. It's important because he highlights this relation between money and power and the recognition of the arts. He said this of his time in post-war Europe:

> I remember being in Paris and finding that one recognised in all the spectrum of the arts that there was, not a war on, but, there was an attempt clearly from an American situation, as a fact of the results of the war, to claim international significance as an authority, as a fact, in the arts. The contest was particularly active vis-a-vis painting and the visual arts. When the school of Paris collapses, and the New York school takes over, it was almost as though they were sold. There was a lot of commercial disposition in that for damn sure.

So there you have a state investment, as it were, prioritising the arts in a way that must seem very suspect in some respects, but has clearly brought many rewards. Of course we can recognise the values of American art and poetry and music now in a way that was less possible in, say, the early 1950s. So apply that to Scotland.

Apply That to Scotland

SANDY Let's apply that to England, first of all. In a recent essay entitled
'Re-thinking "Provincialism": Scotland's visual culture in the 1960s',
Tom Normand focuses on an address given by the eminent art historian
and connoisseur Kenneth Clark to the English Association in 1962. His
subject, as Normand explains:

> … was the qualities, positive and negative of English art in respect of the
> relative dislocation from metropolitan centres in Europe and the United
> States. He was chiefly concerned with the historic distinction of Paris
> as a centre for art… but also… with the emergence of America, chiefly
> New York, as a metropolitan centre dominating the cultural landscape
> of the post-war period. Against this background his reflections on
> 'provincial' English art were melancholy. He recommended that English
> artists might be 'accepting of the provincial virtues and relating them
> to the dominant style'. Clark's unease in this address was shaped by his
> unchallenged metropolitan bias… In this frame the cultural dominance
> of the metropolis was fashioned by its focused energy and creative
> innovation, for the metropolis was where 'standards of skill are higher
> and patrons more exacting'. Within this construct Clark declaimed
> that no open-minded historian of art would deny that English painting
> is 'provincial' and, given that by English painting he meant art from
> the capital city of London, this placed Scottish art in an impossible
> situation; a periphery on the edge of a periphery, an outland to an already
> provincial hub.
>
> Tom Normand, 'Re-thinking "Provincialism": Scotland's visual culture
> in the 1960s', in Eleanor Bell and Linda Gunn, eds., *The Scottish Sixties.
> Reading, Rebellion, Revolution* (2013)

I remember this period well. As students we realised that notions of the centre
and the periphery, of cosmopolitanism versus provincialism, and a bogus
internationalism, had condemned us to the status of backwoodsmen. Some
accepted this state of affairs, others didn't. And it was in 1962 that Hugh
MacDiarmid – celebrating his 70th birthday – became a huge influence on
myself, John Bellany and Alan Bold. We quickly grasped that the ideals of
the Scottish Renaissance instigated by MacDiarmid in the 1920s were not
'things of the past' but had an immediate relevance to the art we might make
ourselves. That Scottish culture could engage with a 'local vision' while
projecting an art that was international and universal. It was also around this
time, in 1963, that we first heard Edwin Morgan read his poetry. Morgan

was an intellectual like MacDiarmid, but spoke in a more modern voice, unapologetically addressing the local – Glasgow in his case – but fusing it with a range of styles and ideas which reflected a world-view that was anything but provincial.

ALAN Go back to Milton Brown's point that in the field of art, the USA moved from provincialism to internationalism. In some ways Scotland travelled in the opposite direction. In the 18th century the influence of Scottish ideas resounded around Europe and even further afield in the emerging American nation. Our artists were major players in the birth of the European classical and romantic movements. By the end of the 19th century, however, the effect of the Union on our art was one of severe modification. The superiority of the larger, dominant culture and the efforts made to fit in produced a profound change of attitude and direction. The temptation of London promising wealth and influence had been apparent long before, but our cultural distinctiveness had remained intact. By the end of the 19th century things were different.

SANDY In the absence of our own politics, we embraced the cult of tartan and wallowed in nostalgia. Many educated Scots had become embarrassed that Burns wrote in Scots and there was the example of the wholesale defection of the Glasgow Boys to the Royal Academy in London, decried by J.D. Fergusson in the following words:

> I feel really depressed as I think of it... Here were 25 men who were not conscious of the tremendous contribution they had made in founding a first-class tradition of Scottish painting. Twenty-five men who mostly preferred academic honours and success to the Wallace and Bruce example of patriotism, of fighting to the last for Scottish Independence.

The Union had come to mean that within an overall British context, Scottish artists would have to give up or water down their independence. In many ways this is the heart of the matter, what William Boyd referred to in his introduction to Alasdair Gray's *Lanark* as 'the thorny – the thistly – question of *Lanark*'s Scottishness'. This is not something the English want to deal with just as they don't really want to deal with German expressionism or for that matter the Scottish Colourists, denounced in a *Daily Telegraph* review in 1923 as '"Scottish Extremists" whose harsh outlines and garish colour are anything but pleasant to look at'. Well, that particular tune has fallen out of favour, but there are many others mostly along the lines of: 'It's just stuff from an unsophisticated northern region, of no real interest to us.' The problem was, we began to believe that when it came to cultural matters, we were nothing more than a bunch of uncouth jocks.

So, in a sense, we had to think about how we could overcome the built-in bias that the Union had brought about. Become more like the 'British'? Well, it has to be said many chose that route. But there were alternatives. A Scottish Modernist revolution did happen. Let's just go back to where we were at the beginning of the 20th century with the Colourists rubbing shoulders with Picasso and Matisse, not to mention Lenin and Trotsky who were drinking in the café-bar *La Rotonde*, just around the corner from J.D. Fergusson's studio. It's strange how the radical nature of much of the work of Scottish artists is never fully acknowledged. Why? We're not used to speaking about Scottish artists in terms of their radicalism, their politics, their nationalism. Instead we concentrate on aesthetic issues, formal values, with art as a neatly contained entity in itself, quite separate from real life. It's almost as if we did talk about their radicalism we would become aware of our self-suppression, our lack of politics, our lack of independence. There's a different story to be told here, one that needs to be discussed and talked about, perhaps for the first time.

ALAN Scottish artists, the Colourists for example, at the turn of the 19th and 20th centuries, all went to Paris, as did the Americans, at that time –

SANDY Aye, the Colourists went to Paris because it was where the revolution in painting was taking place. They valued their independence, and had no intention of trimming their art so it would appeal to English taste. Most importantly, they took Scotland back into Europe, beyond London. And it was in France where they found themselves as both artists and Scots. And they had a point to prove about their 'Scottishness'. They were as good as anyone. In a letter to his future wife, Margaret MacKay in 1907, S.J. Peploe wrote:

> I do like the French people, they always remind me of the Gaelic, so frank and open. They enjoy life, largely in an animal way. There you have camaraderie – good talk, enthusiasm. You are among people who are in sympathy with you.

For J.D. Fergusson:

> Paris is simply a place of freedom. Geographically central, it has always been a centre of light and learning and research. It is a place that has always been difficult to dominate by mere dead-weight of stupidity. It will be very difficult for anyone to show that it is not still the home of freedom for ideas... After going there over 30 years ago I have some right to speak – *Salut!* to Paris. It has allowed me to become Scots as I under-stand it... And what do I mean by Scottish? They were Scottish because they wanted liberty.

ALAN Unusually for a Scottish artist, Fergusson wrote a book, *Modern Scottish Painting* (1943), a declaration of his practice, of painting as national intent. For him independence is the key, both in art and in politics. He recognises the long history of Scottish literature as empowering, and what he refers to as the Arbroath manifesto – the foundational document of 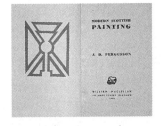 Scottish national identity, declaring the principle of liberty and freedom and self-determination – as an inspiration for his art and ideas. For Fergusson, cultural and political independence are complimentary. 'A free art should naturally be produced in a free nation.'

His theoretical approach to painting is similarly straightforward:

The modern movement in art was an attempt to get down to truths, to fundamentals, and start afresh to create a free art, or an art freed from academic imbecilities which at that time dominated the world... Progressive painting would be a better title, for progressive should mean liberating, liberating by a persistent attempt to find the fundamentals, the essentials or truths, instead of adding clever gadgets, or by using fashionable stunts.

SANDY Duncan MacMillan has noted that for Fergusson, 'women were his real subject, his life-long preoccupation'. His greatest painting 'Les Eus' (1913) depicts a pagan-like dance with both naked women and men participating. It's now considered likely that a visit to the Ballets Russes to see Stravinsky's 'Le Sacre du Printemps' provoked the great vigour and physicality of the figures in the painting. 'Les Eus' reveals Fergusson as a radical painter of female emancipation, especially given that the liberating, social and moral implications of dance had inspired women such as Isadora Duncan, Mary Wigman and Margaret Morris (Fergusson's life-long partner) to create dynamic new forms of modern dance. The female nude, sensuality, sexuality – but no guilt. As Fergusson himself puts it, 'Calvinism drives the best Scots away... to benefit other countries'.

It's worth recounting that Fergusson, Peploe and Cadell never really experienced the kind of financial success many of today's artists take for granted. Their popularity came later. They were out in the cold for a long, long time. Cadell was stony-broke in his last years, desperate at times. There were no arts councils in those days. Appreciation in Scotland was slow to develop and as always the great British art institutions, true to form, were supremely uninterested in art from Scotland. The Colourists were alien to the London view of art.

ALAN The consequences of the Union are quite clear on this point: Scottish art will not be promoted at home or abroad ahead of any English equivalent or worse. As we know, Scots-born directors of the great British Institutions such as the National Gallery and the Tate have been powerless to help.

SANDY In his chapter on 'Scotland and Colour', Fergusson contrasts the gaiety and exuberance of tartan with the traditional sombre black suit and says it is the duty of artists, architects, and designers to give a lead to make a brighter Scotland. There can be no question that Fergusson and his fellow Colourists set in motion a process of transformation that resonates more strongly than ever before in our socially liberal and more tolerant society. Their vision has changed our idea of Scotland. And for many around the world it will be their only idea of Scotland. Not a bad idea at all, I would suggest. Once again they show us that great artists can be both national and international. In a sense, that's one explanation of what the arts are for in society, their true value, the good of the arts.

ALAN The good of the arts has been there across centuries, exemplified in

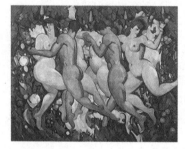

the specific instances we've mentioned. 'The Rite of Spring' and 'Les Eus' are very precisely 1913, but what they're saying, what they're about was just as true in the 13th or 14th century as it is in the 21st. It links to the core-ideas we're talking about here, the idea of affinity across differences, the idea of freedom that predates the myth of freedom in the Scottish Wars of Independence, the myth of kinship, family connection, and respect for difference, that you see in the story of Columba coming from Ireland to Scotland, and arriving in Iona. These have specific reference in Scotland but they are also, equally, universal themes. And that last one I mentioned is a central theme for the greatest of all modern Scottish painters, William McTaggart, just before and alongside Fergusson's work.

SANDY Iona assumes a special prominence during this period, not just as a pretty, sun-drenched island that reminded painters such as Peploe and Cadell of their visits to the South of France, but as the distinctive foundation for Scotland's political and religious identity. We need to reconsider the relationship of the two great Scottish Colourists, Peploe and Cadell to Iona in terms of modern Scotland's potential. The beginnings of our understanding of Scottish national identity are to be found here. For all those thinkers, painters and poets connected with Celtic art in the regeneration of Scotland, from the pioneering work of Patrick Geddes in the late 19th century to the Scottish

Literary Renaissance of the 1920s, Iona was the mythic co-ordinate point, the place from which artists of different kinds began to take their bearings. Indeed, Geddes had a line carved on a stone door frame in the Outlook Tower in Edinburgh pointing in the direction of Iona.

Peploe and Cadell's paintings constitute a statement about Scotland: this is the birthplace of Celtic Christianity, where Columba, arriving from Ireland, bringing not only religion but also other distinctive forms of culture, began to establish a national identity based on ideas of connection and kinship across differences. Here, the *Book of Kells* was created, and from here the nation called Scotland began to emerge over the next 500 years.

ALAN William McTaggart (1835–1910) was the first great modern painter drawn to the subject of Iona and the Columba story which he depicted in two big canvases, 'The Coming of St Columba' and 'The Preaching of St Columba'. The two paintings are directly linked to the anniversary celebrations of the saint which took place on Iona in 1897. Interestingly, the episode depicted in 'The Coming of St Columba' is not Columba's landing in Iona, but his first reaching Scotland from Ireland directly to Kintyre, then part of the Scottish Kingdom of Dalriada. McTaggart's chosen setting was Gauldrons Bay, a short walk along the coast from Machrihanish which he knew well and often painted. The specifics of place, so important to all of our great poets, were equally important to McTaggart.

SANDY Establishing a new understanding of the work of McTaggart demands urgent attention. More often than not he is presented simply as a landscapist, a painter of light and colour who like the French Impressionists liked to paint outdoors. He did indeed paint many beautiful landscapes or more correctly seascapes, and his early work was somewhat respectable and conventional in a Pre-Raphaelite manner.

ALAN But McTaggart was much more than that.

SANDY The son of a crofter and a Gaelic speaker from Kintyre, he understood what he was painting from a socially engaged perspective. He thus integrated his Highland background into his work, making no distinction between his modern self as an artist and the traditions of his folk. Mistakenly, The Glasgow Boys came to be regarded as the first Scottish Moderns. J.D. Fergusson begged to differ:

> At the same time McTaggart, not the Glasgow School, was producing without official recognition work that is thoroughly Scottish. I find it

65

difficult to believe that anyone has painted the sea better than McTaggart. I've seen lots of paintings. I've never seen any as good.

For Fergusson and his fellow Colourists, McTaggart was *the* representative modern Scottish painter. During the 1890s, McTaggart was occupied with two major themes, in fact. You're right to emphasise the Columba paintings but there was another theme too: the departure of the Scottish emigrants to America. These profound and complex themes were inter-related and were entirely personal to the artist. The 'Emigrant Ship' paintings are in a sense historical, showing a period that can be roughly equated with the artist's boyhood in Kintyre during the 1840s. So they are personal, historical – and also mythic.

Alan, didn't you say that myth has a more potent authority than history?

ALAN Yes, in *The Herald* Manifesto, I said that myth has a greater power than history. There is a history of the Highland Clearances and there's a mythology of the Highland Clearances. The mythology carries the heart of the event while the history holds the facts. The myth of the Clearances had a powerful impact especially for artists and poets and writers of all kinds, and that impact continued to have its effect for generations, indeed into the present day.

SANDY What we see in these 'Emigrant Ship' paintings is the landscape of memory and loss anticipating the kind of 'political' painting which would emerge in the late 20th century. Think of Anslem Kiefer, who almost a century later would embark upon a great series of historical landscapes dealing with German cultural identity. In the aftermath of World War Two, where was a German identity to be found? Had the roots been burned? Could ashes render the land fertile? Kiefer shares with certain 19th-century painters such as Turner and Caspar David Friedrich – and McTaggart – a belief that painting, and in particular landscape painting, can be a means of presenting fundamental human emotions. 'The Sailing of the Emigrant Ship' (1895) bears this out. Avoiding both the sentimentality and the story-telling aspects of his late Victorian English counterparts, McTaggart's expressive brush binds the painting's meaning with the music of a lament. In fact, the painting itself is a lament, a pibroch. In her masterly book, Lindsay Errington points out:

All McTaggart's strong feelings and Celtic inheritance, so often noted by critics – James Bone called him the 'greatest Highland poet since Ossian' – went into the making of The Emigrants and the St Columba pictures. Thereafter he painted large pictures and important ones, but never again did he attempt anything with such profound or complex themes.

ALAN It is unimaginable coming from anywhere else but Scotland. And it is deeply historical, in the context of empire and colonisation.

SANDY And yet how is this represented in the official British version of art history? If you would like an example of the Tate's version of Scottish art, their William McTaggart exhibition in 1935 proved, in the words of the current Tate catalogue, 'a revelation to those who had been inclined to regard his northern reputation as a matter of regional patriotism'. Their categorisation of McTaggart as 'regional patriot' remains at the root of their idea of Scottish art. And that historical relegation of McTaggart and Scottish art comes right into the present. Carry this story through in terms of Highland Art. McTaggart is crucial for a contemporary Highland artist such as Will Maclean but are the Highland Clearances ever discussed in terms of British History in England?

ALAN Imagine a class of children studying history in a school in Surrey or Kent, and the history teacher comes in and says, 'Today we're going to discuss the history of the Highland Clearances in Scotland, and we're going to do this by a close examination of the paintings of William McTaggart.' Do you think that's happening or has ever happened? Does it happen in Scotland?

SANDY When I was a student at Edinburgh College of Art in the early 1960s, it was Scottish painting we practised in the studios – not English painting. This was handed down by our teachers and explained to us as such. We admired above all Alan Davie – an artist who brought passion and painterly exuberance to his work, unmatched by his polite English contemporaries.

All of that was perfectly clear – what wasn't clear was the history of Scottish painting. There was no systematic study of the subject on offer at the art college and there were few if any books worth consulting. By that time John Tonge's The Arts of Scotland (1938) and J.D. Fergusson's Modern Scottish Painting (1943) had all but vanished from circulation.

Finding out about the story of Scottish art and artists was a slow process lasting many, many years. In those days, the idea that there was a Highland Art would have seemed absurd. But Scotland has moved on and we're no longer prepared to neglect our art and culture. Murdo Macdonald, Professor

of the History of Scottish Art at the University of Dundee, has played a leading role in re-claiming the forgotten past of Scottish art and he takes us straight to the heart of the matter:

> Highland Art is one of the defining currents of Scottish art. This is true whether one looks back to prehistoric rock art – which has inspired so many contemporary artists – or to major works of the Scottish *Gàidhealtachd* such as the *Book of Kells* and the great crosses of Iona and Islay, or to the work of William McTaggart, the Gaelic speaker who pioneered modern art in Scotland. How are memory and history represented visually? How do artists respond to geography? How does visual culture develop through periods of demographic change?

ALAN These questions are addressed in Murdo's book, *Rethinking Highland Art: The Visual Significance of Gaelic Culture* (2013). A stereotype of the Highlands as a land of mountain and mist, as a romantic spectacle, was created by artists in the 19th century. This was further replicated in images of tartan-clad Highlanders and kilted warriors. On the other hand there's little in art about the land rights of the Gaels, the suppression of the *Gàidhealtachd* and consequent emigration, until McTaggart.

SANDY And then later, it was those particular issues that provided a rich source for Will Maclean, who was born in 1941, and whose body of work, made over a long career, is of the greatest importance. Maclean draws on his personal Highland heritage – his family were involved in the Clearances (his paternal family were cleared from Coigach and his maternal great grand aunt was the Portree post-mistress who defied Sheriff Ivory during the Battle of the Braes in Skye) – and also the myths, legends and beliefs of his forbears. In the mid-1990s Maclean collaborated with a number of local craftsmen to erect three large memorial cairns on Lewis, commemorating episodes in the struggle between crofters and landlords a century ago. As he says:

> It was a privilege to be part of the Lewis Land struggle memorials project *Cuimhneachain nan Gaisgeach*. I was introduced to the chairman and driving force of the project Angus MacLeod MBE, to the local historian and stonemason James Crawford, and to John Norgrove, civil engineer, who made sense of my initial drawings. Just as the history of the raids was researched by Angus and Joni Buchanan in her book *Na Gaisgich*, so Jim's knowledge of archaeology and building techniques informed and gave substance to the sculptures. The communities of Ballallan, Gress/Coll and Aignish each came together for the opening days, three of the most memorable days of my life as an artist. The opening celebrations were an

integral part of a project that gave continuity to the history of the island and its people.

A further fourth cairn has just been completed at Reef on the west of Lewis (2013) celebrating the return of the land to the people of Uig.

ALAN I said once that the most essential character of Scotland is do with its variety, its variations of language and place. It's about wholeness made up of diversity. This is a different thing from the idea of a single, imperial story. In a way Maclean's memorial cairns exemplify this, especially if we think of them as part of the poetic traditions of the Highlands alongside the writings of Neil Gunn and Sorley MacLean. And if we widen the context to include the growing number of artists who work in the land with the landscape (Ian Hamilton Finlay's legendary garden 'Little Sparta' in the foothills of the Pentlands near Dunsyre comes to mind) we begin to glimpse how a new generation of Scottish artists might show us ways in which we may go on, what we might value in difference, and how things might be otherwise than they are.

SANDY So can you give me an example, a concrete example, from literature, from Scottish literature, of something that demonstrates that value?

ALAN Liz Lochhead has a poem called 'Something I'm Not' which describes a young woman encountering her neighbour and her neighbour's child, coming down the stairwell in the tenement flat where they live. The title marks a decided and absolute sense of difference but it suddenly becomes the first line of the poem as the sentence goes on:

> Something I'm not
> familiar with,
> the tune of their talking
> comes tumbling before them...

It is as if the hesitant, faltering line-breaks suggest that tumble-down music which you begin to make sense from, when you start to listen closely. It's a kind of onomatopoeia – the line breaks are slightly awkward, like the sounds coming down the stairwell as the two people are coming down the stairs. In the middle of the poem, the poet asks herself the question: 'How does she feel?' And as soon as you ask that question, you're beginning the work of literature.

SANDY You're finding a common cause, a common purpose, while noting and respecting a difference. There is both pathos and humour in that, the sad fact of being lonely and apart, and the warm acknowledgement of common humanity. How does that represent Scotland, particularly?

ALAN Maybe it's just a cliché to say that Scotland is a land of contrasts – every country is, of course – but I do think that the most essential element of Scotland is its diversity. That's the best way I've found of understanding it. You could turn it around and say it's all about dividedness, sectarianism and so on. But the positive potential is to understand its diversity as an advantage. Scottish literature is various in time and place, language and tone, ways of understanding the world and attitudes towards our experience of it, the ways and wiles of others. And also, sometimes, Scottish literature, like the country itself, delivers things that are truly profound, deeply necessary and replenishing. Sometimes the shock of new perception is followed by the warmth of recognition. It has to be fun to read it and teach it, and always has been for me. The pleasure it gives illuminates and opens questions, asks us to consider things from points of view we might not have thought of before, and in forms of language so diverse they may seem very unfamiliar and strange. That is the virtue of its invitation: try the words out, in your own voice. See how they apply, what they mean, what they sound like when you bring them from your throat, what they look like when you study them on the page. We always need this, to get through life: to make some kind of sense from the chaos of the world. The quest is to take us beyond ourselves, to find something else – something we're not, but perhaps something we are related to, something that connects.

SANDY Isn't that what all the arts should do?

ALAN It is what all literature does. Every single poem, song, play, story, novel, gives us a way of looking at the world. It embodies an attitude to experience. It takes us to other places, to meet other people, to understand other ways of life, politics, religions, women and men, children and old folks, animals, geology, landscapes, economies and ways of seeing how things work. Everything is open to our enquiry: not only the good and the bad but the ugly as well. We begin from where we are, in whatever part of Scotland we find ourselves, city or village, island archipelago or farmland or small town, to ask questions. Who has written about this place? What languages did they use? When did they write and how have things changed here, since then? What are the good things around us? What are the bad things that need to be changed? This is what literature helps us to do. It has to be a pleasure in itself, but it also opens up the world to all of us, anyone who cares enough to read deeply. For you have to care about something to read it deeply. As Herman Melville

says, 'Any fish can swim near the surface, but it takes a great whale to go down stairs five miles or more'. Or as Hugh MacDiarmid puts it in Scots:

> Like staundin' water in a pocket o'
> Impervious clay I pray I'll never be,
> Cut-aff and self-sufficient, but let reenge
> Heichts o' the lift and benmaist deeps o' sea.

One other thing. If someone likes a poem, song or story, I'd advise them to memorise it. It's more fun that way. Actors learn their lines. We all have stories to tell. Learning a poem by heart can help get words into your mind most deeply, and the words themselves help sharpen your perception. They keep thinking clear and senses keen. Flowers and fruit have better colour and taste when you put them in words. Identify trees, cloud forms, structures of economy, specific aspects of people, in words, and you start to under-stand them more precisely and more deeply. And one more thing, especially in Scotland – people are so often shy of saying what they think. Don't be! All art, literature especially, is a living conversation. My best advice is speak about these things to other people.

SANDY I think we might be giving a false impression, that art, poetry, novels, songs are simply there to give pleasure and we can all join in and have fun. Most folk regard art as 'difficult'. Getting to grips with a poem like 'The Waste Land' or a Mozart opera involves a great deal of thinking and listening. It's a time-consuming process. A deeper understanding of all art forms demands commitment on the part of the reader, viewer, listener, and so on. I very much approve of the words carved above the auditorium of the Leipzig Gewandhaus: *Res severa est verum gaudier* – in other words, 'True pleasure is a serious business'. If it was really so pleasurable then surely many more people would read poetry and go to art galleries, but instead they much prefer to go to rock and pop concerts, musicals, and all of the other offerings of the entertainment world.

ALAN I think that's true. Good work and great work is often hard work, sometimes very hard work indeed. There is no short cut, not if you want the full thing. *King Lear* is not easy. *Medea* or *The Oresteiea* are not easy. There is that famous speech by Duke Theseus in *A Midsummer Night's Dream*, where he says that 'the lunatic, the lover and the poet / are of imagination all compact'. But he continues:

> One sees more devils than vast hell can hold,
> That is the madman. The lover, all as frantic,
> Sees Helen's beauty in a brow of Egypt.

The poet's eye, in a fine frenzy rolling,
Doth glance from heaven to earth, from earth to heaven;
And as imagination bodies forth
The forms of things unknown, the poet's pen
Turns them to shapes, and gives to airy nothing
A local habitation and a name.

People are more or less familiar with the lover and the poet, but the madman brings the dangers and risks of art more forcefully close. The arts are the gift of Prometheus, fire stolen from the gods, something of the divine, so to speak, that brings spirit and vitality to human beings, without which we are merely clods of clay. But there is a risk. And that's part of the problem. There is a minority in any population willing to make the commitment the arts demand, to do that work. It isn't what everyone would choose to do, because it entails a sacrifice of their own comfort. But then, the rewards are great, and lasting. And the work is there, available to all. Great art is not cordoned off. All great art has its life in the languages people use every day. All people. The visual, the aural, the vocal, what we see and hear and speak and take into our intellectual and sensual apprehension – these languages belong to everyone. Great art is not cordoned off, it's available to all.

SANDY Yes, up to a point, and that point is related as always to education. Does a broad cultural education really exist for everyone in Scotland, or is culture only for the 'better educated' with all that implies?

Let's imagine that one day opera will be as popular as football. And before everyone bursts out laughing let's consider the case of ballet in Cuba. An elitist art form before the revolution, now a truly popular art form that has helped to transform the lives of thousands from the poorest sections of Cuban society. It's a wonderful story. In 1958, Fidel Castro sent a telegram from his hide-out in the Sierra Maestra mountains to Alicia Olonso, the legendary Cuban ballerina who had been working abroad for most of the 1950s, telling her of his wish to support all Cuban cultural programmes. Olonso returned immediately after the revolution in March 1959 and founded the Ballet Nacional de Cuba which she still leads today at the age of 92. Unwavering in her support for the revolution she explains:

Due to deep personal convictions, I felt and still feel obliged to contribute to the development of the culture of the country where I was born. It is a moral principle, to be aware at all times, of what your moral duty is.

That's a great artist speaking. The doubters will argue that this kind of action can only happen in a communist society, where cultural programmes are

either fully supported or forbidden by the government, but I see no reason to think that something similar couldn't be implemented here. Think of the Raploch programme we mentioned, for example. Imagine a Scotland where everyone sways to the rhythm of 'The Rite of Spring'.

The Languages of Scotland

SANDY So if the arts have their deepest roots in the languages of Scotland, let's take stock of those languages and ask ourselves how we might change their status actively? What could be done to help here? It's the most essential question to begin with, because it is simply about how people speak to each other, confident, sensitive self-expression. How many people speak to each other in Scots?

ALAN Probably most of the population of Scotland. We all speak English of course, and a number of people speak Gaelic, but I suspect that most Scots, from Shetland to the Borders, speak varieties of the language we call Scots, and are perfectly confident about that. In formal situations, job interviews and so on, many middle-class people will choose to speak English, but skilled people speak Scots with no self-conscious embarrassment. Garage mechanics, taxi drivers, shopkeepers, tradespeople of all kinds, speak Scots. In the 18th century, lawyers and judges spoke Scots fluently and vigorously. You remember that gruesome line from Lord Braxfield, in the 1790s, when he sentenced Thomas Muir, the radical reformer, to be transported to Australia, and Muir pointed out that even our good lord Jesus Christ was a reformer, and Braxfield replied from the bench, 'Aye, and muckle guid it did him – he wis hangit!'

SANDY Nowadays few lawyers and judges speak Scots in their professional lives, so what went wrong with them? It was only in 2011 that Scots appeared in a national census, alongside Gaelic and English, as one of the languages people speak in Scotland. Which begs the question, how many of the many, many people who speak it, know that they're speaking a language, and not simply 'bad English' or 'slang'?

ALAN Scottish literature, which is where you find the languages working most effectively in writing, has mainly been produced in Gaelic, Scots and English. Roderick Watson's great anthology of Scottish Poetry has the subtitle: 'Gaelic, Scots and English' and includes translations from Gaelic and glossaries for less familiar Scots words. If this were taken as the normal thing, so that in audio representation, translations were commonplace for English-

speakers and Gaelic and Scots were more widely represented, confidently, from nurseries, in family life, through to universities and places of work, especially highly-skilled professional work, that would form a much more secure foundation for everything. Our institutional education system has been of no help at all, for generations, about this. The precarious state of our self-knowledge of the languages of Scotland – the diminishment of Gaelic, the denigration of Scots, the ascendancy of English – leads directly to uncertainty. The novelist Fionn Mac Colla tells a story about the headmaster of a school he was teaching in taking him to confront an unruly boy, whom the headmaster described as illiterate. Mac Colla asked him to read Burns's 'Tam o' Shanter' and the child read it fluently, easily, confidently, with pleasure. The moral is that the imposition of English on this boy's language idiom resulted in his bad behaviour, frustration expressing itself in inarticulate anger, when the answer was there all along. The really unruly element there was the prevailing educational ethos, the imposition of a mistaken English superiority. This is ingrained in Scotland's story, with the rise of Enlightenment English and the ascendancy of the English language after the Jacobite risings, after the Clearances, after the Anglocentric Empire really got underway. Gaelic and Scots were deemed less important in the context of contemporary conditions and there was a corresponding and increasing gulf between social aspiration and 'high' literature, and popular stories, poems and songs (most crucially, songs).

SANDY We mentioned that in 2011, the census conducted in Scotland included a question about the use of the Scots language alongside Gaelic and English.

ALAN: Yes. This is from the official document summarising the results:

> In 2011, the proportion of the population aged three and over in Scotland who reported they could speak, read, write or understand Scots was 38 per cent (1.9 million). For Scotland as a whole, 30 per cent (1.5 million) of the population aged three and over reported they were able to speak Scots. The council areas with the highest proportions able to speak Scots were Aberdeenshire and Shetland Islands (49 per cent each), Moray (45 per cent) and Orkney Islands (41 per cent). The lowest proportions reported were in Eilean Siar (7 per cent), City of Edinburgh (21 per cent), Highland and Argyll & Bute (22 per cent each).

That's important because it was the first time Scots had been recognised and named in such an official document as the census as a language of equal standing with English and Gaelic, and nearly two million people recognised

this. So any description of Scots as 'a dialect of English' – in other words, something subordinate or less valid – has to be stamped out completely, and that requires teachers, government people, media people, everyone, to sharpen up. The writers, of course, have known this for centuries. But even the census report was cautious. It noted that:

> The census data on language skills in Scots needs to be carefully qualified... Research carried out prior to the census also suggests that people vary considerably in their interpretation of what is meant by 'Scots' as a language, resulting in the potential for inconsistencies in the data collected.

But put that alongside Gaelic and English. The proportion of the population in Scotland who could speak, read, write or understand Gaelic was 1.7 per cent (87,000), while nearly all (98 per cent) of the population of Scotland reported they could speak, read, write or understand English. So after 300 years of Union, English is overwhelmingly the dominant language in Scotland.

SANDY Unquestionably. The statistics show that clearly. In order to increase the wealth of the British Empire it was of benefit to have an English-speaking civil service in India and Africa, and to neglect or ignore or suppress the native languages. In Scotland, English became the language of social aspiration. So what are we doing about this awful history now? In terms of class, Scots is still the preserve of working class and rural communities, polarised between middle-class aspirations and their caricatures of the lower orders as vandals and brutes. From great 18th-century philosophers to tawdry 21st-century businessmen and women, arts administrators and senior management of all kinds, English-language superiorism means hostility to Scots and Gaelic, both as speech and as literary languages. The Unionists say the English language has helped us internationally, and it has – but it's not an unmixed blessing.

ALAN But things change. It's not impossible to imagine change happening. Maybe it's utopian and we have to acknowledge that English is indeed essential in the international business world. So if the economy depends on how we work with the Chinese, the rising eastern economies, and so on, we need English, of course. But when great literature has been written in Scots and Gaelic, we're not going to deny or neglect that, are we? And in social terms, the stigma that has attached to Scots and Gaelic has got to be challenged – and destroyed. I think this situation is similar in some respects to that of the class bias of the Russian upper classes speaking French in Tolstoy's time. We might think about Finland's decision to make Finnish the

national language, not Swedish, when the time came for its self-determination to be put into effect. Language is crucial. It's not the economic priority of the viability of the languages – Scots and Gaelic – but the cultural viability of the languages, and that cultural viability is absolutely crucial in any business developments, internationally.

Government, Arts and People

ALAN The national distinctiveness of Scotland in the whole long trajectory of its historical achievements has got to be seen in the context of Europe as a whole, and alongside the USA, China, India and so on. In Scotland, the huge contributions of our great artists, their sheer distinctiveness, their mythic power, from pre-Christian Celtic times onwards, has often not been recognised in our own national institutions. So the question is – and we have to keep coming back to this – how do we promote our art and culture most effectively? Who can we learn from?

SANDY We've discussed the shortcomings of the National Galleries in Edinburgh in promoting Scottish art, but what about the Scottish National Theatre?

ALAN There is no such thing, unfortunately. There was a deliberate choice to call it the National Theatre of Scotland, just in case it would seem a bit too national. Honestly! The establishment of The National Theatre of Scotland in 2006 confirmed an identity many people for more than a century had been campaigning for. It was argued that the distinction of the NTS was that it would be a theatre 'without walls' – that is, without an actual building. This was deeply unsatisfying to those who had been pushing for a substantial actual theatre, perhaps to be situated in the capital city, which would be recognised internationally as a cultural statement of self-possession and political self-determination. However, the argument for a theatre committed to productions that would be visible in different parts of Scotland, across the variety of the nation's terrain, addressing different audiences, was also recognised as valid and freshening. A number of NTS productions have indeed delivered impressive work and won appropriate praise.

SANDY Yet questions remain.

ALAN Indeed they do. A National Theatre, given that title, might be expected to fulfil three essential functions: resourced to the full extent it should be able (1) to mount productions of professional international companies from anywhere in the world; (2) to have an experimental space, where new

plays by living Scottish authors might be tried out, and encouragement directed explicitly to bring such work into the public arena; (3) to review, reappraise and perform new productions of plays from the entire history of Scottish literature. What could be done with the archive? David Lyndsay, Allan Ramsay, Joanna Baillie, Robert Louis Stevenson, J.M. Barrie, James Bridie, Robert McLellan, Donald Campbell, C.P. Taylor, Liz Lochhead, Sue Glover, Rona Munro, Edwin Morgan, and many more? And what of the plays in Gaelic, from those by Donald Sinclair to those written since? And what of the all but invisible plays obscured in history, like *Hubble-Shue* (*c.*1786) by Christian Carstaires, a governess in Fife who may have written the play for a family in a big house to perform? Edwin Morgan said it was 'a bizarre, anarchic comedy, more like Jarry or Ionesco than *Douglas* or *The Gentle Shepherd.*' Or Joan Ure, whose real name was Elizabeth Thoms Clark (1918–78), whose first play, *Cendrillon*, was written in French for a fourth-year school class performance, who worked with Ian Hamilton Finlay at the Falcon Theatre in 1962, and whose two short plays *Something in it for Cordelia* and *Something in it for Ophelia* are about sexuality, national identity and potential unfulfilled? Surely all these plays demand revival? And what about *The Lesbians* by Catherine Birrell, published in Glasgow in 1914? There is so much there, in the archive, to be unearthed and dusted off and tried out.

SANDY Not all of them are going to work – it might be difficult to address a 21st-century audience with George Buchanan's plays in Latin.

ALAN Agreed. But a National Theatre ought to be trying such things out. Buchanan (1506–82) was one of the most significant literary and political figures of the 16th century: poet, playwright, historian, intellectual humanist scholar, teacher of the great French essayist Michel de Montaigne, Mary Queen of Scots and later of her son, the boy who was to become King James VI of Scotland and I of the United Kingdom. He was a native Gaelic speaker from near lower Loch Lomond, a Catholic who committed himself to the Reformation and joined the Reformed Protestant church in the 1560s and published *De Jure Regni apud Scotos* in 1579. Here Buchanan says that all political power resides in the people, and that it is lawful and necessary to resist kings if they become tyrants. He was basing his argument at least partly on his understanding of the clan system. There were numerous attempts to suppress this work in the century following its publication but you can see how it's in a tradition of thinking that goes back to the foundational document of Scotland, and one of the greatest pieces of political writing in world history, the Declaration of Arbroath of 1320.

Now, if the National Theatre means what it says, there is all that work to get into, and there is another requirement for national reappraisal and regeneration of the theatrical traditions: a fluent understanding of the languages of Scotland – Gaelic, Scots and English – in which Scottish literature has been predominantly written. And another requirement would be the collaboration between professionals in theatre and professional scholars and literary historians, to identify and help select work of both literary and theatrical vitality. Theatrical vivacity becomes thin and irrelevant the further it is removed from literary substance. And literary drama becomes stodgy and dull the further it is removed from theatrical performance, presence and movement. But to get all this to work, there has to be an evident respect for the nation, and an enquiry into what the nation means and has meant, how to present it, to the world and to ourselves. And that is not easy.

SANDY As we said earlier, we can learn a lot from the disastrous history of Creative Scotland, the agency set up to replace the Scottish Arts Council. We shouldn't forget that story. All our major artists rejected the bureaucratic jargon Creative Scotland used. But turn the whole sorry saga around, and ask this question: What sort of difference could be made by a truly enlightened Minister for the Arts? We could learn a lot by considering the examples in France of André Malraux (1901–76), and Jack Lang (b.1939). Malraux was an art theorist and novelist, famous for the novels *La Condition Humaine* (*Man's Fate*) (1933) and *Le Temps du Mépris* (*Days of Wrath*) (1936) and the art books *La Psychologie de l'Art* (*The Psychology of Art*) (1947–49), *Le Musée imaginaire de la sculpture mondiale* (*The Imaginary Museum of World Sculpture* (1952–54), *Les Voix du Silence* (1951) (*The Voices of Silence*, 1953) and *La Métamorphose des dieux* (*The Metamorphosis of the Gods*) (three volumes, 1957, 1974 and 1976). Charles de Gaulle appointed him to the position of Minister of Information, which he held from 1945 to 1946, and then he became France's first Minister of Cultural Affairs during de Gaulle's presidency (1959–69). He started the process of cleaning the blackened facades of notable French buildings, revealing the natural stone underneath and he also set up a number of *maisons de la culture* in provincial cities, working to preserve and promote France's national heritage. We could be doing with someone with that kind of initiative in Scotland.

ALAN And Jack Lang?

SANDY Jack Lang was a Socialist member of the French National Assembly, and is probably best known for his work as Minister of Culture through the 1980s and early 1990s and as Minister of Education from 1992 to 1993 and 2000–02. In 1981, he set up a *Fête de Musique*, a massive celebration of

music held on 21 June each year, where many amateur musicians give free open-air performances. He was the co-founder and president of the Union of the Theatres of Europe. In August 1981, he created the Lang Law, allowing publishers to enforce a minimum sale price for books. These are serious interventions for the benefit of all and they are opposed to the general tendency to elevate entertainment and celebrity culture above serious art.

ALAN The future of social democracy in Scotland demands good political leadership but there is a built-in unionist bias in the media. The BBC and the Scottish Press, most of them, are establishment fixtures, and support the status quo, despite the fact that there are a number of excellent individuals, writers and broadcasters not afraid to say what they think.

SANDY But this all takes place in the context of the politics of fear. Lies and distortion are commonplace. Institutional fence-sitting is the normal thing. So how do we reach people with a positive message of hope? Can artists help to do this?

ALAN Yes, of course. Cultural development is linked to political development, past and present. So the question of political independence is also a question about cultural independence. It is not a romantic 19th-century notion but a living reality.

SANDY Tom Nairn quotes the French political philosopher Jacques Attali, who talks about 'the history of the future' and predicts that 'more than 100 new nations could be born in this century' in reaction to what he sees as the 'shockwave' of capitalist-led globalisation. How do we resist that globalising uniformity? The answer has to be a cultural one as well as a political one. We need a vision that matches cultural and political resistance, and make sure it's a vision that everyone can share.

Langholm Common Riding

ALAN We have the basis for that here in Scotland, but it needs real work and commitment to get down to it, to the very foundations from which all cultural expression arises, from which all life arises, actually. And we experienced that when we were in Langholm in 2012, at the Common Riding, a genuine 'People's Festival' where young and old, physically fit or impaired, the well-off and the less well-off, different groups of different politics and religious belief and convention and habit, all got together for a day of great festivity and celebration. It was a day marked by the riding of

the marches, an absolute confirmation of borders, the territory within which the people of Langholm have their identity, secure.

SANDY It doesn't mean you're isolationist or bound to conformity – the diversity of people throughout the day was striking. You can cross borders, of course. But here is the evidence that it helps to know that they're there. And what borders were being crossed by the marching bands – pipe bands, flute bands, fiddlers, drummers, the whole range of performers were marching together! Now, that was evidence of diversity in unity. Normally, you would associate particular musical instruments with religious identities – and there were certainly different religious groups present – but they were all there together, enjoying the party. And aware of the physicality of being human, not taken up by any fictional idea of superiority, but sustained by the knowledge that we are here and now.

ALAN That's why the riding itself, the speeches and the relations between the town councillors, the civic people, and the farmers, the farmers' workers, the shopkeepers and small businessmen, that's why they were together in this. There was a common recognition that the commerce, the marketing, the farming and harvesting, the whole working economy of the area, was dependent upon the well-being of all the people working in it. So when the man of the day, the Cornet, has to stand up on the saddle on his horse's back and make his speech, deliver his pledge to the assembled crowds and the mayor and so on, he's in a very precarious position, supported by his helpers but physically vulnerable, even so. And then when he leads the hundreds of riders and horses up the hill from the main square at full tilt, riding at the gallop, and the hundreds or maybe thousands of onlookers are lining the road, sitting on walls, standing up on the hillside, watching, they're literally inches away from these great galloping horses.

SANDY That's where we were standing, so close to these great galloping horses as they rode by. So it was physically a sense of presence that reminds

 you forcefully and deeply of the nature of the whole thing, the history we rise from, the sense of what has to be maintained and kept in good working order, in good health, for the future generations and the flourishing of the cultural lives of everyone.

ALAN Langholm shows the way!

PART TWO

The Union: Before, During and After

The Union Means Money

IN 1707, THE UNION meant money, for some. It still does. But it does not mean prosperity for all, and it never did.

Important things are on the far side of 1707, and important things lie behind its construction and legitimisation, and of course, there is a legacy that's still with us. The question is, though: what comes after?

The Union of the Crowns in 1603 had been foreshadowed by the marriage in 1503 of James IV and Margaret Tudor, the daughter of Henry VII of England. That ended in 1513 at Flodden. Ninety years later, King James VI of Scotland ascended the throne in London in 1603 and became James I, attempting to merge the institutions and identities of the two nations. One result of the Union of 1603 was a hostile reaction to Scots who followed James to London, with English courtiers resenting the favours James showed to his own countrymen at court. While Shakespeare famously welcomed James in *Macbeth*, performed before the king, legitimising his authority in the pageant of monarchs that forms part of the play, other playwrights were satirising the London Scots. The urbane cynicism of Ben Jonson, John Marston and George Chapman, in their co-authored play *Eastward Ho!* (1605), led to Chapman and Jonson being imprisoned.

After the Union of 1707, certain important Scottish institutions remained under Scottish control: the Church, the legal system, education and local government. Scotland continued to develop its distinctive intellectual, artistic and cultural life. But Scottish national politics became the provenance of England. And Scottish opposition to the Union persisted. The Jacobite risings of 1715 and 1745 were not purely Scottish nationalist but they represented a serious threat to the economy of the newly-created United Kingdom. When Bonnie Prince Charlie's soldiers approached London, the value of the British pound dropped to sixpence. Such a threat to the union prompted violent response. Reprisals against the Highlanders were brutal. For a time, the bagpipes, the kilt and the Gaelic language itself were intensely oppressed. If you were a Gael, you might be punished for playing music, wearing normal clothes or simply speaking your own language.

So a strange thing happened: bagpipes, Highland dress and Gaelic

became symbols of an oppressed culture. But since they were actually *expressions* of that culture, you might say that they became *symbols of themselves*. This helped give them a tremendously potent force in later years. One exaggeration of that is the extent to which they became clichés of Scottish identity, instantly recognisable throughout the world. The deepening force of these symbols, surviving as it has done through centuries of caricature, can be heard most keenly in the classical music of the Highland bagpipe, the pibroch. In his poem, 'Bagpipe Music', Hugh MacDiarmid described this brilliantly:

> The bagpipes – they are screaming and they are sorrowful.
> There is a wail in their merriment and cruelty in their triumph.
> They rise and fall like a weight swung in the air at the end of a string.

He says that they are 'like a human voice' – then he corrects himself:

> No! for the human voice lies!
> They are like human life that flows under the words.

The paradox was that while Highland identity was subject to colonial oppression, the long tradition began of successful Scots – including Highlanders – engaging in the developing British Empire and identifying themselves with it. In the 19th century, Scotland was widely known as North Britain. Scottish identity was internationally recognised in the images known even today all over the world: not only bagpipes and tartan but whisky, heather, haggis, wild mountain scenery, Highlands and Islands. While these images largely derive from exaggerations and caricatures of Highland, rural and pastoral life, Scotland's people in the 19th century were overwhelmingly moving to live in the big industrial cities of Glasgow, Dundee and the towns of the Central Belt. They brought the ideals of community and family life into new conditions of urban deprivation.

To many Scottish writers and artists, the First World War was the ultimate culmination of imperialism.

Two other contemporary events inspired many of them: the Irish rising of Easter 1916 and the Russian socialist revolution of 1917. A Celtic nation asserting its independence from the British state and an assertion of aggressively idealist communism to break down the social divisiveness of the class system were both, for many of Scotland's people, inspirational acts. MacDiarmid, who had enlisted in the British Army for the war, eager

like a whole generation of young men to march into the apocalypse and be part of what seemed like Armageddon, said that when he heard of the Irish rebellion he wished it had been possible to get out of British uniform and join the Irish fighting imperialism.

In the 1920s a literary and cultural movement renewed the drive towards political, as well as cultural, self-determination. The National Party of Scotland was formed in 1928 and the Scottish National Party in 1934. In 1979, a referendum was held for the population of Scotland to vote for or against devolved political power. A majority of voters in Scotland were in favour of devolution but the referendum was declared invalid by the London government because, it was decided, not enough people had turned out to vote. In 1997 another referendum was held, in which voters in Scotland conclusively declared their preference for devolved self-determination and tax-raising powers. The Scottish parliament was reconvened in 1999.

When the Scottish National Party was returned as a majority government to Edinburgh in 2011, they pledged their commitment to holding a referendum on Scotland's independence, and the question of the value of the Union was brought suddenly and centrally fully into public scrutiny.

This is a very singular story. It does not conform to any general theory of nationalism or national history.

Compare it with what you might call other national psychologies. The establishment and rise of nations and empires in the 19th century is only part of the story, confirming the tension between ideals of uniformity and diversity. New nations come into existence but the rise of uber-nations and empires leading to conflict and competition and ultimately violent contest in the slaughtering of the First World War show you just how emphatic were the priorities of uniformity, not diversity. But the diversity of nations in trade, rather than at war, with each other is surely a good thing. If you're a football fan, you will have noticed that in the World Cup, in the European section alone, there are seventeen or eighteen new nations since 1991, nations like Slovenia, Bosnia, Latvia, Estonia, Ukraine. A large number of 'new nations' have come into statehood in the last few decades and none of them seem to want to surrender their national identity. Even in Ireland, or even in Iceland, in the worst of recent financial crises, no-one was clamouring to surrender their sovereignty. But it goes beyond that to cultural preference.

The writer and actor-producer Gerda Stevenson tells a story about taking part in a literary festival in Ireland and going to the checkout counter in a local supermarket. When the checkout lady noticed her accent, she asked what she was doing there and Gerda told her she was giving a reading, she was a poet. 'You're a poet!' exclaims the checkout lady. 'That's wonderful!' and she leans over and gives Gerda a hug. Now, here's the question: could you imagine that happening at a checkout in any supermarket in Scotland?

We could go further. Alan Riach offers these stories:

When I was trying to explain a little of the history of Scotland to my brother-in-law in New Zealand, a man of some wisdom and insight, who knew nothing at all about Scottish history, he listened silently, thought carefully, and said, 'Scotland must be full of a sense of resentment.'

When I was holding forth at a conference in Poland in 2012, I was strongly impressed at how very seriously the people there were listening and paying attention. They wanted to know what was going on in Scotland, and wanted to discuss the situation and the possible futures for Scotland and Britain very seriously – more seriously than some of the British press do, more seriously than some of the people I've met here in Scotland do. And their comments and opinions were varied. There were a number of perspectives and thoughtful comments. 'Be careful what you wish for,' said one person. 'We wish you all the best, and hope the best might happen,' said another. 'It's astonishing that Westminster has allowed it to get this far,' commented another. 'Spain would never allow the Basques to get to the stage that Scotland is at now.' That sort of speculation is very welcome, very curious. Put it against conditions of prejudice or ignorance or attitudes of assumption that you can find all over the place in Scotland and in England too.

I was going with a friend a few years ago to pick up his daughter from her pal's parents' house, where the kids had been in the swimming pool all that Saturday afternoon. When we arrived at the house – this was in Warwickshire, in England – the whole building was covered with bunting and strings of little plastic Union Jack flags, put up for the sake of a football match that was on that afternoon, England versus somebody, I can't remember who. When we went in and waited for my friend's daughter to get out of the pool and get ready to come with us, we were invited to sit down, have a glass of chilled lemonade, and watch the game with the

family and friends who had gathered there. When I sat down and thanked the woman who gave me the glass of lemonade, I immediately sensed everyone bristling and furtively glancing at me. After a little while, she leant over to me and said, 'Are – are you – are you – ehm – Scottish?'

It was as if I had been beamed down from outer space.

The Second Dialogue: What do we do with the Union?

ALAN Essentially, the question is just this: Would you rather have your political representatives in Edinburgh or in London? Would you, someone living in Scotland, be better represented by people in a government based in Westminster, or by people in a government based in Holyrood?

London or Edinburgh?

SANDY Which central government might devolve power further to self-governing regions or island-archipelagos? Which one seeks to further its own power-base and economic authority at the expense of all the other territories of its constituent parts?

ALAN: Once again, would you rather have your elected representatives in government in Scotland, or in England? Who cares about Scotland or the people of Scotland? Do those people in London really care about us? Do they know anything about us? Do those people in Edinburgh really care or know anything about us? Do they care and know about the range of different identities that make up Scotland, linguistically, geographically, economically? Do the people in Edinburgh know and care more or less than the people in London? What chance do we have of making them listen? An equal chance, in Edinburgh or London? A greater chance to be heard by the people in Westminster or by the people in Holyrood? Who would they listen to, these people? Whose interests are they serving?

And of your children, or your children's children: who among them might go to work as a member of parliament, and would they go to London or Edinburgh, and what responsibility would they feel and carry with them?

SANDY The Westminster people claim to be serving all of us in the UK and their message is that this is as good as it gets. They want us to believe that Britain can be great again and that there's no need for any kind of change in the way the UK is governed. The Scottish situation is an irritation that will eventually be squashed and common sense will prevail. And it seems that a lot of Scots think that way as well. They don't want to be part of a wee country. They'd much rather have the trappings of real power, whatever they think that might mean. So they stick with London rather than Edinburgh.

There's no question about the concentration of political power in London and the extent to which the three main British political parties have carved up that power between themselves. They are each of them, on their own, coming out of their own singular histories, but also collectively, as Unionist British political parties, almost interchangeable, for example in their engagements with Iraq or Afghanistan. They are helplessly committed to continue their imperial posturing.

ALAN It's shameful, the way in which Labour and the Liberals have retreated so far from their formerly strong Home Rule positions in the early 20th century. Andrew Marr, in his book *The Battle for Scotland* (1992; revised edition 2013), points out that in the early 1900s, Scottish constituencies were basically cosy little havens for ambitious English Liberal politicians such as the Prime Minister, Asquith, and later on, Winston Churchill:

> At the beginning of the century, when the Liberal MP Augustine Birrell was standing on top of a hill overlooking Fife and East Lothian, he was able to exclaim cheerily (to Asquith among others): 'What a grateful thought that there is not an acre in this vast and varied landscape which is not represented at Westminster by a London barrister!' By 1906 the vast bulk of Scottish MPs lived in England; many were English.

But that came to an end with the split between the Home Rulers and the Unionists. Labour's 1918 Scottish manifesto made an Edinburgh parliament a priority, and Home Rule had been a pre-war Liberal demand too:

> In 1919 a Speaker's Conference at Westminster did some preliminary work on the creation of national assemblies for Scotland, Ireland, England and Wales. It recommended a Scottish parliament the following year, but there was little interest at Westminster, and, not surprisingly, the 1920 Government of Ireland Act dominated the constitutional debate.

SANDY Yes, it's a great pity that Labour gave up on Home Rule. Marr again tells us that:

> The Clydeside MPs of the Independent Labour Party who were elected in 1922 had gone to London, from Glasgow's St Enoch Station, with 'The Red Flag' echoing in their ears. One of them, Tom Henderson, protested to the crowd that he wished he was going to the Parliament in Edinburgh. The rest would have agreed: almost all the 29 Labour MPs elected in Scotland that year were committed to an Edinburgh Parliament. There was, of course, the issue of emphasis: socialist first or nationalist first? To start with it hardly seemed a problem: Robert Burns, a poet of occasional nationalist views and internationalist sentiment,

was routinely claimed as an early socialist. The Glasgow MPs considered their Scottishness and their socialism to be richly and sentimentally inter-woven. Jimmie Maxton had promised the St Enoch's crowds that they would see 'the atmosphere of the Clyde getting the better of the House of Commons'.

But Maxton's attitudes to Scotland epitomised the difficulty faced by any Labour Home Ruler. After a year he returned to Glasgow to tell a meeting of Scottish teachers that he found it humiliating to be working for a 'a policy of fundamental change for the benefit of the Scottish people and to find the Scottish majority (at Westminster) steadily voted down by the votes of the English members pledged to a policy of social stagnation.'

Old history maybe, but political parties have roots, traditions. It's not a good idea to abandon them. I suspect there are many Labour supporters who would prefer independence and are deeply troubled by their party's Unionist alliance with the Conservatives and Liberals. William McIlvanney for one:

I really believed that when we got the (Scottish) parliament that a lot of socialist principles would surface in Scotland. But the truth is the Labour Party's now dead in the water. We voted Labour for generations. Now we've got the parliament there is no Labour Party.

ALAN Labour has always sold Scotland down the river. Don't forget that wonderful essay by Lewis Grassic Gibbon on Ramsay MacDonald, the first Labour Prime Minister in Westminster in the 1920s and early 1930s. It was published in the book which Gibbon co-authored with Hugh MacDiarmid, *Scottish Scene*, in 1934. It was called 'The Wrecker – James Ramsay MacDonald'. Already, back in 1934, Gibbon was saying that MacDonald had wrecked the Labour Movement by following the small-minded creed of his Dominie, Kailyard culture, and that while it might regain some virtue, the spirit, the faith and the hope had gone from it. It's even more crushingly true now, in the 'New Labour' era.

SANDY It is a different story in Scotland than it is in England.

ALAN The experience of Devolution itself and the work of the Scottish Parliament show the differences to be real and important. Ours is a cultural argument and the role culture played via the extraordinary work of many artists and writers in the 1980s and 1990s has been widely recognised.

SANDY The New Image painters from Glasgow – with Steven Campbell conquering New York – gave Scottish art a kind of confidence it had never

had before, and the publication of Alasdair Gray's *Lanark* (1981) was more than just a literary event. His motto, derived from the Canadian poet Dennis Lee, 'Work as if you were living in the early days of a better nation' – had

a galvanising effect. Many said: this is us. All of this was driven by Scottish nationalism. This was the engine behind the creation of the Scottish Parliament. But Devolution could only become a fact if Westminster said so, and it was eventually delivered from Westminster by the Labour Party, after their great victory in the 1997 General Election and the message the Labour Party wanted to deliver was that Scottish politics was a small part of British politics and had to fit in with British political machinery. London would always hold the upper hand.

ALAN And that was made utterly clear in the revelations about London deliberately hiding information from the people of Scotland with regard to the money that came to London from the oil in the North Sea. The financial value of the oil revenues was known to London in 1975 and they kept quiet about it. Stephen Maxwell, in *Arguing for Independence* (2012), quotes Gavin McCrone, Chief Economic Adviser to the Scottish Office, whose report, *The Economics of Nationalism Re-examined* (1975), was circulated only to a small number of senior politicians and civil servants and not made public till 2005: 'The advent of North Sea oil has completely overturned the traditional economic argument used against Scottish nationalism.' In other words, they lied to us.

SANDY If that's what they were holding back in 1975, what do you think they're holding back from us today?

ALAN Well, there's more. In the *Daily Record* of 3 January 2014, it was reported that: 'Secret documents released under the 30-year rule yesterday sparked fury after they revealed a Thatcher plot to fiddle Scotland out of £500 million.' Plans for huge cuts on spending in Scotland were drawn up by Downing Street advisers John Redwood and David Willets in 1984 and Thatcher wanted the scale of the cuts kept secret in case it boosted support for the SNP. She said, 'There should be no attempt to publicise the figures.' The Scottish Secretary at the time, George Younger, agreed to the cuts if it could be done 'invisibly'. In January 2014, three decades later, Willets is a British Conservative Party politician and the Minister of State for Universities and Science and Redwood is a British Conservative Party politician and Member of Parliament for Wokingham in Berkshire. Redwood famously was Secretary of State for Wales in 1993 when he was caught on film at the

Welsh Conservative Party conference trying to mime the words to the Welsh national anthem, which he clearly had no idea about. Apparently he learned them by heart after that. What an embarrassment! What a disgrace.

SANDY McCrone proposed back in the 1970s that the UK should set up an oil fund, but successive Labour and Tory governments refused to do so. If they had, the early 21st-century recession could have been greatly ameliorated.

ALAN That's where we are. In England, or shall we say, the United Kingdom with the seat of government at Westminster, we have three major political parties: Labour, Tory, Liberals (Lib/Dems). That's it. But in Scotland, there are the SNP, the Greens, and behind the 'New Labour' people there is a palpable sense of the Labour movement, which goes back to the very beginnings of the idea of democracy in Britain, with the Scottish Labour Party, founded in 1888 by R.B. Cunninghame Graham, who was also the first socialist MP in the London parliament and the first president of the Scottish National Party, and Keir Hardie, another Scot, first leader of the UK Labour Party; and then there was the Independent Labour Party, founded in 1893 by Keir Hardie again, and others; and only then was there the Labour Party, founded in 1900. Things have gone a long way since then. It was only after the 1945 General Election that the Labour Party became so centred in London, and it was in London that we've seen the rise of 'New Labour'.

SANDY Margaret Thatcher in 2002 was in Hampshire to speak at a dinner and at the reception one of the guests asked her what was her greatest achievement. She replied, 'Tony Blair and New Labour.' Blair courted popular culture, as opposed to the difficult arts and the value of the arts in a general sense of human education. And this endorsed the role of the arts in the context of the UK government as trivial, superficial, and utterly commercial. But there are other examples of democratic structures of government, different relations between government and the arts, rather than those that have arisen through the imperial legacy of London as the economic and cultural centre.

ALAN It's still going on with the 'Better Together' people claiming that the singing of Scottish songs in schools is 'propaganda'. This was reported in the *Scottish Express* (12 October 2013) that Scottish schoolchildren were being taught to sing pro-independence and anti-nuclear songs, and someone from 'Better Together' commented: 'This is an outrageous example of tax-funded political propaganda. It is a deeply cynical ploy aimed at presenting a distorted view of history...'

SANDY Distorted history, indeed!

ALAN Maybe it's not just Westminster, or politicians or civil servants. There are active aggressors, but maybe the most active aggression is in the culture like a disease, in the media – again, there are individuals who have power and do make decisions about what will be broadcast, what will be discussed, and what will be the tone and weight and balance of any discussion, but it's almost as if thinking differently itself is forbidden, they can't countenance a different way of doing things. I'm reminded of the great American poet Edward Dorn and his magisterial attack on the whole big parcel of those political and cultural habits. In an interview from around 1993, Dorn came straight out with it. He said that history has basically dropped right out of consideration:

> It has no meaning, and is part and parcel with an intense anti-intellectualism that now rules. So you can't follow history, you can't get a sense of history, you can't seek to understand the whole transmission of human life without an intellectual distinction. And that, of course, is totally forbidden.

He was asked if that's just 'cultural relativism' and this is what he says:

> No, I think it's programmed ignorance. And like religion of any kind, and like the intention of the state, all states, its function is to enslave, capture and enslave. Once that's even partially successful economically, it's easier to run a kind of blind consumerism which is the engine then of a further economic reality that seeks to manipulate on a global level. This, of course, is the meaning of the new 'corporate world, corporate globe.' And its aim is total control and its outward manifestation is consumerism and its mechanism is ignorance.
>
> Ed Dorn, *Ed Dorn Live: Lectures, Interviews and Outtakes*, ed. Joseph Richey (2007)

He also has something really important to say about scorn and satire. 'I spew scorn everywhere I can,' he says. 'Humour is aggressive and humour is an attack, of course. You can't attack anything with sadness. And increasingly you can't attack anything with seriousness.' But, he says, laughter can blow things to rags, if you get people laughing at what's so crazy, absurd, contemptible, laughable. We need more of that.

SANDY Contemptible and laughable? Well, how about this. The Albanian Government has proudly announced that it has recruited Tony Blair as an adviser in its attempt to join the European Union. At a briefing in Tirana, Blair said joining the EU was 'right and proper' for Albania and added: 'The orientation towards Europe is immensely important, and personally,

I'd love to see this country join the family of European nations.' There's an echo here of all those Labour people who used to support self-determination for every country in the world except their own. Does this suggest we should hire Blair after independence to make sure Scotland remains in Europe?

ALAN I don't think so.

SANDY London is what it is now because of the imperial story. And in Scotland, for 300 years, many Scots were part of that imperial story. So many Scots loved the British Empire. We were up to our necks in it. The whole legacy, the imperial authority of being British, commanding the whole world, being self-disciplined, hardy, all that makes another potent myth that's based in a past reality but has become fictitious posturing, a ridiculous facade, in the shadow of America. We sometimes forget how mythical it is. And London was essential to that myth, and remains so, a sizeable and influential Scottish community in its midst. The London Scots are, by and large, unsure of what to say about independence. No longer in contact with the new Scottish political and cultural landscape, they fail to understand that the Scotland they left 20 or 30 years ago is now a very different country. As a result their opinions are uninformed and come across as quaintly old fashioned: 'Our heart says Yes, but our head says No' is an oft-repeated mantra. They also don't want to say anything that might upset or offend their English colleagues who tend to look upon the idea of Scottish independence as an act of treachery. I believe Indian independence just after the war evoked similar feelings amongst many in England who thought that it was perfectly accept-able that the entire sub-continent of India be governed from London. That kind of thinking dies hard.

ALAN So where are we with London, now? There are twice as many people living there than the entire population of Scotland. I wonder how they feel about us.

> The ten million people within the M25 are increasingly living in a different world from the rest of us in the 'provinces'. Britain has become a grossly unequal country in which the top one per cent of the popula-tion have seen their wealth soar over the last 30 years of low taxes and rampant property inflation. And the recession barely put a dent in it. It is a matter of simple geography, that most of those super-rich live in London…

This is Iain Macwhirter, writing in *The Herald*. He tells us that Barclay's wealth map shows 287,000 millionaires in London. There are apparently 40,000 in all of Scotland. London is characterised by the wealth of these

millionaires. In the City, bankers make their huge fortunes then go and invest them in property. The property increases in value. The wealth accumulates. But not for everyone, and certainly not for us. The whole situation is an economy not of manufacturing, not of literally making things, but, as Macwhirter puts it, 'of speculation and rent'. He says: 'It sucks value out of the rest of the UK, through bank bail-outs and loan interest charges, denuding the provinces of investment capital...' And he goes on:

> London hoovers up the bulk of national wealth, and then complains that it isn't getting enough back in public spending... It's one long party at the nation's expense... Boris Johnson's London Finance Commission has even talked about London declaring UDI from Britain, seizing its entire property tax base and using it to pile up revenue. The M25 would become a kind of international tax haven, run by and for bankers... However, London doesn't really need to leave the UK. It has captured the UK Government, Whitehall, the Bank of England, the BBC and most cultural organisations... The London financial establishment was responsible, through its greed and irresponsibility, for a financial crash that has impoverished many of Britain's citizens and made us all – outside London – poorer. But cocooned in their media bubble, and intoxicated by house prices, few in London's élite seem to care what happens outside the M25... Many Londoners no longer regard themselves as citizens of Britain, but as citizens of the world. They move between international capital cities and expensive playgrounds, and have no real concept of the nation state and its social obligations... And this matters for the fate of the United Kingdom... The Scottish Parliament has begun, in a small way, to pull economic activity north through the promotion of green energy and life sciences, but the work has barely begun. There is a real danger that a No in the Scottish referendum next year will bring it to a dead stop... It will be up to all parties in Scotland to ensure that whatever the outcome, Scotland does not revert to what it became in the last century: a tartan theme park for the southern upper classes.
> Iain Macwhirter, *The Herald*, 14 August 2013

SANDY London is what it is because of the Union. When Scotland becomes an independent country, the meaning of London will change. Or will it? The casino capitalism that Macwhirter identifies and was taken to extremes by the two big Scottish Banks has barely altered the way London sees itself and its future. The British political elite (Tory, Labour and Liberal) have done everything they can to establish London as the 'capital of capitalism' and will continue to do so. The idea that they might regulate the banks and the City of

London, and get tough on financial malpractice – well, forget it. As Mervyn King, former Governor of the Bank of England put it: 'They're too big to fail, too big to jail.' Barely a week goes by without a UK bank having to pay another huge fine for a breach of regulations. The sums involved are colossal. Through 2013, RBS agreed to pay US regulators a fine of £61 million to settle sanctions-busting dealings in Iran. This follows a £324 million fine for manipulating European and Japanese interest rates and in February, a similar Libor breach cost RBS another £390 million in penalties imposed by UK and US authorities. Although we own 81 per cent of RBS nothing seems to happen in terms of criminal investigations or individuals accepting responsibility for their actions.

ALAN But in Iceland, criminal bankers have been sent to jail. Lesley Riddoch reported in *The Scotsman* (16 December 2013):

> As President Olafur Grimsson put it: 'We bailed out the people and imprisoned the banksters – the opposite of America and Europe.' Indeed, there's a new joke doing the rounds – the new prison planned for Reykjavik is actually a retirement home for bankers, accountants and lawyers.

She continued, noting:

> Iceland has bounced back – thanks to a little luck and a lot of independent-mindedness, hard work, quick thinking and bold capital investment. The new centrepiece of the Reykjavik skyline is Harpa, a magnificent concert hall which opened in 2011 – against all the odds. In 2008 it was part of a waterfront redevelopment including a 400-room hotel, luxury flats, shops, restaurants and new bank headquarters. The whole project went on hold when the financial crisis hit, until the government decided to fund construction of the half-built venue. The result is a home for the Icelandic Symphony Orchestra and Opera and an awe-inspiringly beautiful, shimmering glass cathedral – a tribute to Iceland's new economy built on what's real, not leveraged or illusory.
>
> Creativity in Iceland is very real. There are 7,000 creative arts businesses in this population of 320,000 people – famous names like Bjork, and aspiring names like Dogma (the makers of those provocative T-shirts). Two of the three offending banks, Glitnir and Kaupthing, have gone.

And Iceland has less than one-tenth of the population we have in Scotland, so in fact you can be most effective on that scale of

things. Meanwhile in Britain, the bankers are bailed out and ordinary people are crucified. And it seems that there is a lack of resistance, and the extent of malaise generated by so much institutional restructuring has depressed public morale. The culture of managerialism, the corrupt MPs, the bank managers, all of this is being represented as simply the way the world is. This is not good enough. We should follow Iceland's example. In an independent Scotland, we could.

SANDY And we should have plays and TV shows about this, commissioned by our broadcasting corporations from our best writers.

ALAN I love that song from towards the end of *The Beggar's Opera* (1728) by John Gay, when the hero-villain Macheath is on the way to the gallows, that goes:

> Since laws were made for every degree,
> To curb vice in others, as well as me,
> I wonder we ha'n't better company
> Upon Tyburn tree.
> But gold from law can take out the sting;
> And if rich men, like us, were to swing,
> 'Twould thin the land, such numbers to string
> Upon Tyburn tree.

And of course that play was the source for Bertolt Brecht and Kurt Weill's *Threepenny Opera* (1928) from Germany and Wole Soyinka's *Opera Wonyosi* (1977), set in modern Nigeria. The events of our time are crying out for contemporary satire. There's no shortage of material. It occurs to me that Scotland Yard, the London headquarters of the metropolitan police, is called Scotland Yard because it was the site of the execution of William Wallace. Or to be more precise, his judicial murder. In Scotland, you know, there is only one lake, the Lake of Menteith. All other expanses of water are lochs. Smaller ones are lochans. The reason why this one is a lake is to keep alive the shameful memory of the Earl of Menteith, the man who betrayed Wallace. Those facts will change their meaning after the end of the supremacy of the Union, after independence.

The Union and Democracy

ALAN Walter Scott saw all this. He saw the commercial attraction of the Union and how imperialism, colonisation, and foreign trade would appeal to

the merchants. In *Rob Roy*, Bailie Nicol Jarvie defends the Union in terms of its economic advantage to Glasgow.

> 'Now, since St Mungo catched herrings in the Clyde, what was ever like to gar us [cause us to] flourish like the sugar and tobacco trade? Will onybody tell me that, and grumble at a treaty that opened us a road west-awa' [westward] yonder?'
>
> Walter Scott, *Rob Roy* (1817)

So slavery was all right according to the good Glasgow Bailie, so long as we were getting the money. Isn't that what the Union was all about? And the Empire?

SANDY Many people will tell you that the Union brought peace and prosperity and ensured the survival of Scotland. It brought new opportunities, and improvements followed, leading to the Enlightenment and Scotland's key role in developing the Empire. So why is the United Kingdom no longer necessary? At what point does it become irrelevant? The idea of Britishness is not alien to many Scots, and often enough you'll hear people say, 'I'm British and Scottish, proud to be both! And I see no contradiction in that!'

ALAN That seems like protesting a bit too much. Why would you want to deny a contradiction if there isn't one? There is a contradiction, if the interests of Britain, so-called, are evidently working against the interests of the people of Scotland. And they have been, so clearly, for many generations. The words 'British' and 'Scottish' do mean different things, historically. So to be 'British' or 'Scottish' means something different. The reprisals against the Highlanders, after Culloden, the Clearances, Highland and Lowland, mass emigration in the 20th century, the hugely disproportionate killing of young men from Scottish islands and towns and villages as well as the cities in war after war. All in the service of the wealth and greatness of Britain and the British Empire. And the central authority of London. That's what 'Queen and Country' means, isn't it? Not entirely something to be unequivocally proud of, I'd have thought.

 A friend of mine remarked about the opening festivities of the Olympic Games in London in 2012 that it was terrifically entertaining, a real spectacle, magnificent choreography, fireworks, dancing multitudes, and all kinds of representations of working people, the National Health Service held up as an exemplary ideal, wonderful – just a pity it all had to be wrapped up in the Butcher's Apron.

SANDY That's ancient history or foreign history to a lot of people though, sour grapes and useless resentment. They'll tell you it's a bad idea to break

up the Union, to bring about an emphatic separation in the United Kingdom. They will say, 'Why change a successful 300 year-old partnership? Why change when we can be Scottish, British, European and a member of the Commonwealth?' Of course, the English don't want to be European or members of the Commonwealth. They're even proposing to opt out of the European Convention on Human Rights. They simply use the word British to mean themselves, the English, and the rest of the world is different and unimportant by comparison.

ALAN I know what you mean, and yet the word 'English' means more than one thing too. Maybe it's just as wrong to generalise about 'the English' as it would be to generalise about 'the Scots' – except for the sense that England and the English are terms that are caught up centrally, gravitationally, so to speak, in the whole trajectory of the British Empire. Now, you could say the same thing about Scotland and the Scots or Wales and the Welsh, but different dimensions come into play. General complicity in the Empire is obvious enough, but I think we have to note something else here. There is a very different ethos in the Lake District, for example, to that which I know from experience of living in Kent. Cumbria, Northumbria, Yorkshire, all have a long legacy of forms of identity, a social ethos, a feeling you experience in the villages and towns, which is different from those in the home counties. In the Lake District, for example, you have a long history of local communities, small towns and villages, simply a sense of locality that's shared in communal life, that's much closer perhaps to Orkney than anywhere else in Scotland. There is no sense of social injustice comparable to the history of the Clearances, felt in many parts of Scotland. Of course, there was industrialisation and exploitation and poverty and class differences in the Lake District – its history is not idyllic – but there is a sense of a continuity of human well-being that seems deeply to do with what Wordsworth called 'the still, sad music of humanity' and that's a very different thing from the legacy of history as it is experienced in Scotland. There are big houses that were owned by rich families in the Lake District, but they're not always or automatically synonymous with dominating class power, as Dunrobin Castle is, in Sutherland, for example. When Bonnie Prince Charlie and the Jacobites marched south in 1745, and retreated north in 1746 followed by Butcher Cumberland and his Hanoverian troops, they had no real presence in the Lake District at all. So you get a fine poet like Norman Nicholson (1914–87), in many ways a counterpart to George Mackay Brown (1921–96) in his small-'c' conservatism, not taken up by the great movements of history but rather attending to the local business of being

human. To generalise about 'English attitudes' to national identity without acknowledging this might be dangerous, I think.

SANDY There is more than one 'England' to set against the vortex of the idea of the British Empire, so an independent Scotland might actually help the return of England.

ALAN Exactly. Dick Gaughan has a wonderful song, 'Both Sides the Tweed', where he says that spring, summer, the splendours of all the seasons mean precisely nothing if you've 'bartered your freedom for gain': 'Let friendship and honour unite / And flourish on both sides the Tweed.' The Tweed is the river running along part of the border of Scotland and England. In the song, it signifies, as Gaughan says, 'both the need for independence and the need for friendship and co-existence.' It is not the United Kingdom, but rather friendship, honour, decency, freedom, that are the right things. The only way to let them flourish is independence. These are the last two verses:

No sweetness the senses can cheer
Which corruption and bribery bind
No brightness that gloom can e'er clear
For honour's the sum of the mind

Let virtue distinguish the brave
Place riches in lowest degree
Think them poorest who can be a slave
Them richest who dare to be free

Gaughan wrote the song in 1979, not long after the referendum in which Scots returned a majority in favour of a separate Scottish Parliament but had their majority torpedoed by the UK Parliament, who decided that it was invalid because fewer than 40 per cent of all eligible voters turned out. Gaughan himself noted that the verses call for the recognition of Scotland's right to sovereignty and the choruses argue against prejudice between our peoples. That's the ideal, to aim for. But there is also what happened in history. There are some things we can generalise about accurately. Remember Ezra Pound, in his *ABC of Reading* (1934), suggesting four periods of England in history: (1) when England was part of Europe (Chaucer); (2) when England was England, containing her own best writers (Shakespeare); (3) when England no longer welcomed her own best writers (Keats, Shelley, Browning travelling abroad, and Tennyson the official poet laureate); and (4) when exotic injection was required, from different European and American sources, from the pre-Raphalites, Fitzgerald's *Rubaiyat*, the Celtic Revival and new American writing. Maybe, in the aftermath of independence,

there's much more to be made of the sense of the native place, the grounded, earthed traditions you find in work such as the poetry of the Welsh-London modernist David Jones (1895–1974), *In Parenthesis* (1937) or *The Sleeping Lord* (1974), or the London-centred, anti-imperialist writing of Iain Sinclair (b.1943).

SANDY Even so, even taking that into account, we can generalise a bit more, I think. We Scots see ourselves as one people amongst many. The English see themselves as the only people who count. We take an absurd pride in believing we can take on any of these identities, especially bending over backwards to assume the desired dual identity of being both Scottish and British. It seems that the English don't bother with any of that. They rattle their sabres and threaten military action, and send soldiers from the dole queues of Scotland out to die. They seem not to be interested in the independence debate at all. There is a glaring absence of discussion about the possible end of the Union south of the border. The issue hardly rates a mention on BBC news bulletins or in the pages of *The Times* or *The Telegraph*. Is this arrogance or simply a lack of interest in what they regard as a rebellious periphery? Should they crush it or simply leave it alone? But many Scots still think we can use these multiple identities to our advantage.

Royalty, the British Army and Brute Force

ALAN Is that why the SNP seems anxious to hold on to the authority of the Queen and the royal family?

SANDY You met her recently, didn't you?

ALAN I met her at Buckingham Palace on Tuesday 19 November 2013. I shook her carefully gloved hand and I said, 'Best wishes from Scotland!' She said, 'Think yo. It's rether cold up theah, isn't it?' I said, 'It's rather cold down here, actually.' And she said, 'It is, rether.' The Duke was good too. Shook hands. He leans down like a tree in the wind and looks at the badge, and says, 'Glasgowe Universitah? And what do you teach theah?' And I say, 'Scottish literature!' And he says, 'Including powetrah?' And I looked puzzled for a moment, thinking, what sort of question is that, and answered, 'Including poetry!'

SANDY So you were perfectly happy to use your dual identity as British and Scottish on that occasion?

ALAN No. Republican and Royalist. Both.

SANDY You're going to have to explain that.

ALAN I'm all for a Republic of Scotland. So let's say we have that and the Royal family happily continue in England. Now, in that situation, I wouldn't have any argument against a neighbouring nation having a royalist constitution. Why should I? It wouldn't be any business of mine, as a citizen of a different nation and a different state. So when the Queen or King invite you to a reception, what's the problem?

SANDY Well, there are problems, because that isn't the way things are in the British state.

ALAN I know. But it's worth dwelling on this for a minute. What does the word 'British' really mean? I've been trying to tease this one out and it's more complex than it appears. There are different meanings of the word. The most familiar thing is the elision of the word 'British' with the meaning 'English'. But even so, 'British' seems to mean at least three different things.

First, it just means English. There is a total elision, 'an island called England' as Hugh Kenner puts it. Scotland is merely part of England. That's if it's noticed at all.

But then it can mean predominantly and overwhelmingly English but also including the other nations, proportionately, according to their population, which is to say, democratically according to demography, but a long way away from equally according to cultural authority. Thus a new proposed book on *Modern British Poetry* is all about English poets with the odd chapter on 'the other nations'. Of course this leaves aside Scots Gaelic, Irish Gaelic, Welsh and so on, so there is a crucial implication about the dominance of the English language here. This use of the word 'British' can sometimes feel even more insidious and insulting to the sense of different national cultural identities than the first one, above.

But there is also a third meaning. 'British' can mean the collected constituent nations and their complex cultural hinterlands, of (potentially) equal status, the British archipelago of nations, so to speak. Though of course this begs the question of Northern Ireland as a constituent identity in the British state and also in the historical island-nation of Ireland. Nevertheless, at the Reception for Contemporary British Poetry at Buckingham Palace that I attended, the main event was a reading by the poets laureate of Northern Ireland, Sinead Morrissey, of Wales, Gillian Clarke, of Scotland, the Scots Makar, Liz Lochhead, and the unofficial Black British poet laureate, John Agard, and the initiator, the poet laureate of the UK, Carol Ann Duffy, which of course implies that if you believe they all have equal status, then the poet laureate of the UK was essentially the poet laureate of England.

There is another ambiguity here, though. If you accept that she initiated the whole thing and the Royal Household and the Queen agreed, then the poet laureate of the UK has a somewhat greater status than the others. Although, if we were to imagine independent nations, and an event where the Scots Makar or poet laureate of an independent Republic of Scotland organised with the Scottish Government a reception for her neighbouring poets laureate, and they all attended a party and reading at Holyrood in Edinburgh, they would be doing so as guests of their colleague whose status was only different as hostess. Seen in that light, Carol Ann Duffy's status was not greater than that of the others, but the responsibility of the hostess was hers, while that of the guests was theirs.

SANDY But the real hostess was the Queen of Great Britain and Northern Ireland. Essentially, the ambiguity resides in the current status of the nations in two perspectives: one, constituents of the British state, and two, autonomous cultural identities.

ALAN Maybe the Queen, by inviting these national poets as representatives of their own national cultural dominions, was ahead of the game. Maybe she was thinking ahead to a Britain in which all of the nations are independent.

SANDY In that case, could you in fact be both British and Scottish?

ALAN That would give the word 'British' a different meaning again. There is another way of thinking about government and democracy, though. I was examining an excellent PhD thesis recently by a student named Henry King on the English poet and civil servant C.H. Sisson, entitled 'Out from Under the Body Politic': Poetry and Government in the Work of C.H. Sisson (1937–1980). I want to acknowledge Henry King here gratefully because he got me thinking about this more deeply than I had before. What I'm going to say is what I understand from a part of the thesis. We're familiar with the idea that in a democracy, governments are voted into authority and are responsible to the people, but the other side of the story is that governments are there not to enable the people but to control them. The Victorian essayist Walter Bagehot suggested that the so-called 'dignified' components of society, headed by the monarch, were there to make sure the people held them in reverence, partly through their theatricality and class distinction, because most people in society were scarcely more civilised than they were thousands of years ago. They were badly educated and riddled by illusions. The government's job was to rule them. We might think royalty an expensive sham, but when you see the crowds at a royal jubilee or wedding, you wonder if Bagehot didn't have a point. The idea is that the Queen rules through the government, so there

is a theological idea that the monarchy rules by divine right and that runs through the whole economy, top down.

SANDY Bagehot was writing in the 19th century, not that long after the French Revolution, so there is a real threat to the British ruling class there that his ideas are responding to.

ALAN Yes, he's responding to French Revolutionary Republicanism. Burke did the same in Ireland.

SANDY He's trying to establish a firewall.

ALAN But the result over the last two centuries is basically the English ethos. It is absolutely foreign to the Scottish ethos that you might argue begins in prehistory, is evident in the story of Columba that we talked about earlier, is fought for in the Wars of Independence and clearly set out in the *Declaration of Arbroath*, and that we've been under pressure to give up ever since.

For England, or let's say the British state, the character of the monarchy is ultimately religious and government in Westminster is there not to represent the people but to constrain them. The mandate to govern is not given by the people but by the monarch. You see this happening at every election. Most people don't vote. The Queen approves the government. The glory is in the possession of the Queen, not the people – that's why they look up to her. And the monarch appoints the poet laureate and supports the arts – there is the Master of the Queen's Music and the Queen's Limner – in recent years, all Scots of one kind or another – while there is a general reluctance and suspicion of the arts in government. As Henry King points out, the argument is that administrators in government are not, and should not be, concerned with aesthetics. The artist makes things through his or her engagement, arising from the world, coming out of it into the work of art created. The government looks on all that and sees over it, world and works of art both, with royal, that is divine, imperious authority. Their purpose is not to learn from art but to control it and exploit it. That's the meaning of the ambiguity in the Reception for Contemporary British Poetry at Buckingham Palace I was at. You were made welcome, but you knew who was supposed to be in charge. I asked a young equerry with a tray of canapés if he was armed and he replied very openly, no, sir, he wasn't and hadn't come out of the military services, but there was one person in the room who was. He didn't look around.

SANDY One of Westminster's leading politicians, the current Chancellor, George Osborne, says it's best when we try to shape the world with our values. Does he mean by peaceful means or by war-like means? I would

guess the latter, given that for every single year of my life, the British Army has been fighting wars with the single exception of either 1966 or 1967. Many sincerely believe this is right and proper. The United Kingdom is big and powerful and respected throughout the world. Nobody messes with us, or else! The British army is continually active in supporting and defending democracy across the globe. 'Brute force' is what other nations respect. This is also used as an argument to maintain the so-called 'nuclear deterrent' in the waters near Glasgow. Criticism of the military is now unthinkable.

ALAN Our military interventions in Iraq and Afghanistan are part and parcel of this ethos, but in reality, you have to ask what have they actually achieved? Or to go back from that, what were they actually responding to?

SANDY In global terms, there has been a rise of fanatic religions and to an increasing extent, the motivations that drive men and women into these commitments of extreme, sometimes suicidal, conflict, have become public and visible in mass media. And that is being responded to by military means in the west. Both politicians and the military use this for their own ends. And this is taken up in the media to such an extent that it's difficult to analyse it in a cool and constructive way. The media fan the flames of hysteria. It seems that there is only one possible response to what is called 'terror' and that is what is called 'the war on terror' – but these words and phrases are being used to manipulate feelings about what's going on. So the politicians and military personnel react in the way they do, with the military demanding more and better equipment and pleading to be given more time to finish the job, and many people simply accept the case for this. One argument is that we don't need nations anymore, because we have globalisation. But one reason why western interventions have so badly failed is that there was no understanding of what people like Gaddafi and Saddam Hussein had done. They had created their own states that were self-affirming, that could protect themselves against the incursions of religious fanaticism. These dictators were able to keep the overwhelming potential of religious fanaticism at bay.

ALAN This is summed up by Patrick Cockburn in an essay entitled 'The Hazards of Revolution' (*London Review of Books*, January 2014), where he says:

> What is the glue that is meant to hold these new post-revolutionary states together? Nationalism isn't much in favour in the West, where it is seen as a mask for racism or militarism, supposedly outmoded in an era of globalisation and humanitarian intervention. But intervention in

Iraq in 2003 and Libya in 2011 turned out to be very similar to imperial takeover in the 19th century. There was absurd talk of 'nation-building' to be carried out or assisted by foreign powers, who clearly have their own interests in mind just as Britain did when Lloyd George orchestrated the carve-up of the Ottoman Empire. A justification for the Arab leaders who seized power in the late 1960s was that they would create powerful states capable, finally, of giving reality to national independence. They didn't wholly fail: Gaddafi played a crucial role in raising the price of oil in 1973 and Hafez al-Assad created a state that could hold its own in a protracted struggle with Israel for predominance in Lebanon. But to opponents of these regimes nationalism was simply a propaganda ploy on the part of ruthless dictatorships concerned to justify their hold on power. But without nationalism – even where the unity of the nation is something of a historic fiction – states lack an ideology that would enable them to compete as a focus of loyalty with religious sects or ethnic groups.

SANDY And there's also the idea that the UK is an economic powerhouse. All citizens benefit and share in its great wealth. Scottish nationalism is small-minded and backward looking. British nationalism is forward-looking with an international dimension. An independent Scotland would struggle economically and a 'narrow nationalism' would then prevail, or worse, there would be an adherence to an outmoded socialist ideology that would turn Scotland into a failed state, a kind of North Korea.

ALAN Oh, come on!

SANDY I know, I know! But that's what we're told again and again by some of the most eminent London-based Scots like Andrew Neil, who in the BBC programme *Sunday Politics*, just before the 2011 Scottish Parliament elections, described Scotland as 'the land of the big state' and went on to claim that in Scotland, 'the state was more important than in any other country in the world, bar Cuba, North Korea, or Iraq'. Of course, all of that is a veiled attack on what could be termed the legacy of Labour Scotland, a legacy of paternalism and dependency, but what is not so widely broadcast is the obvious truth that Britishness is an artificial construct and the Union signifies old values. Unionism is always about what has happened in the past. It brings all things down to that harness of historical structures that are no longer useful or helpful to anyone. The Union was a financial pact, a means of allowing traders access to global money, and it went hand-in-hand with military imperialism. The high point of Britishness also exposes the limits of Britishness, and it is essentially about Empire. Scots have been collaborators in the eclipse of Scotland in their contributions to building the British Empire.

They rushed off to build the Empire and ignored the Scotland they left behind. We could still affirm Scotland decisively, especially on Burns Night and Hogmanay, but then we would leave it behind and the people who lived in Scotland would be left far behind, while so many others went south, capitulating with an eagerness and appetite second to none to the high priorities of the BBC, Oxbridge, Westminster rule and Standard English. But today, looking back on all that, what would we wish to preserve?

What are our feelings today when we read *The Glasgow Herald* for Wednesday 9 May 1945, printed a few hours after the official cessation of hostilities with Germany? It reports VE celebrations in Moscow, salutes war efforts by the USA, Canada, New Zealand and South Africa, briefly mentions involvement by the C-in-C Scottish Command in surrender proceedings in Norway and allocates a short column to Scottish DFCs. Sixty thousand people cheer Mr Churchill giving the victory sign from the balcony of the Ministry of Health building in Whitehall. The King's 'Broadcast to Nation and Empire' begins with God, Empire and London:

> Today we give thanks to God for a great deliverance. Speaking from our Empire's oldest capital city, war-battered but never for one moment daunted or dismayed – speaking from London, I ask you to join with me in that act of thanksgiving.

About a sixth of page four announces that there will be a 'Scottish Festival of Thanksgiving' in Edinburgh's Usher Hall, and describes 'Glasgow's Crowded Scenes of Revelry' during which:

> A sailor of the Royal Netherlands Navy burlesqued Hitler from the top of the Duke of Wellington statue in Exchange Square. An admiring crowd applauded his buffoonery. It was equally responsive when the Dutchman, changing his mood from gay to serious, made a short speech in broken English, and thanked 'the Scots for the brave part they had played in the liberation of his country'.

That's the best recognition we get. Equal space on the page is taken by an advertisement by Lewis's department store for 'Feminine Fantasies': 'an exceptionally lovely collection of Model Millinery, designed for June Weddings – Summer Garden Fetes – and all those important occasions on which you must look your best'. The hats are alps in emerald, tan or 'nigger' fur felt with swathes of ice blue or Sherwood green ostrich feathers and 'appliqued leaves in geranium red suede'. Just the headgear for a Gorbals girl wanting to look her best for the returning, war-weary man in her life. After Mr Churchill's official broadcast message the end of

the war in Europe is sounded by the buglers of the Scots Guards. The rest is all London and Buckingham Palace.

Can this be a newspaper from Scotland's biggest city – even, as they used to call it, in their language, the second city of Empire, the Engine Room of the Commonwealth? Is this what you hope to read at the end of a war from which your husband, your father, your wife, your son or daughter or your lover may or may not come home to Tobermory, Leith or Peebles? Reading this, on the morning of 9 May 1945 wouldn't you have felt stung?

Marshall Walker, *Comrades and Vexations: Some Objects in a Life* (2013)

Today, though, would anyone be stung? There is a powerful seam of Britishness embedded within popular culture and especially in those aspects of mass entertainment – TV, sport, movies, that dominate our daily lives. Film stars, pop stars, comedians, sports stars, celebrities of all kinds are always presented as British. If a couple of English actors and directors are nominated for an 'Oscar', this is reported in the media as a British invasion of Hollywood. The Beatles and the Rolling Stones are great British bands. British design rules the waves and so on. We live in a world where the British brand is all important. The great thing about pop music and sport is that they appear to offer opportunities for everybody. Their popularity rests on an all-embracing vision of participation and enjoyment.

ALAN When the BBC gave up on its Reithian mission to educate many years ago in favour of mass 'entertainment', quality programming was sacrificed and a shallow tabloid culture took over, geared to exploit and boost a fantasy, post-political Britishness. All of this has an enormous impact on people's lives and ways of thinking, so much so the SNP Government felt the need in their white paper *Scotland's Future* to confirm that existing BBC services will continue and current programmes like *EastEnders*, *Doctor Who* and *Strictly Come Dancing* will still be available after independence. For most people the collective identification with their country comes through national sports and other non-political symbols.

SANDY Where does this leave Andy Murray? A Scot while losing, but now with Wimbledon under his belt, a British national sporting hero? We already have to endure scare stories about small Scotland being unable to produce and nourish athletes capable of attaining Olympic standards. Few point out that the fastest human being ever, and the most famous athlete in the world, Usain Bolt, hails from Jamaica, a country with a population of 2.8 million, around half of Scotland's. But the sentimental appeal of British popular

culture is undeniable and will play a part in people's decision-making in September 2014. David Torrance, the journalist and biographer of Alex Salmond, wrote about this in 'Our culture is more than the result of who rules us' (*The Herald*, 16 December 2013). Wasn't he referring to your essay of February 2013, the one which begins this book?

ALAN Yes. He worked it up in his book, *The Battle for Britain* (2013). He quoted from my essay, the opening line: 'There is only one argument for Scottish independence: the cultural argument. It was there long before North Sea oil had been discovered, and it will be here long after the oil has run out.' But then Torrance said that this was a 'rather vague notion' and pronounced that 'such statements don't lead anywhere particularly useful'.

SANDY He'll have to read this book.

ALAN I hope he does. But he did say one thing worth picking up – he said this:

> In terms of the culture with which most people engage, as measured by the pop charts, cinema audiences and best-seller lists, it's difficult to discern differences between Scots and those from the rest of the UK. In high culture too, there is little difference; only when it is boiled down to indigenous Scottish languages can a more convincing case be made.

SANDY Well, there's some sad truth in that, when you think of those people whose main concern is whether independence will mean they can't watch *Strictly Come Dancing* or *EastEnders* any more. But we do acknowledge that technology has transformed the arts, especially the world of popular culture and entertainment and the triumph of the mass market that has induced a kind of homogeneity across cultures. A shared popular culture – music, film – is what means most to many people, more so than politics or democracy. Politics and democracy demand difficult decisions.

ALAN Yes, but think back to what we were saying about Stuart Hood in our First Dialogue, what he achieved, his vision of what popular mass media could do – and then with regard to so-called 'high culture', well, we've talked about London and there's a lot more to be said about money and funding the arts in London. It's horribly obvious to see that Scottish people are not much represented on Scottish television compared to the popularity of *Coronation Street* or competitive game shows. But is Torrance really saying that Scotland has no such thing as 'high culture'? No poets or artists or composers to put alongside Eliot or Goya or Britten? Or is he saying that the 'high culture' snobs don't care about the Scottish writers, artists and composers we could name here?

SANDY The confusion arises because of the legacy of the authority of the British Empire that we've just been discussing, the whole context in which the cultural and educational values of so many people blindly follow the dominant political and financial bias. Instead of questioning this bankrupt authority, Torrance seems to go along with it. He's a decent political journalist, but is obviously out of his depth in cultural waters. Would he be able to discern the cultural differences that inform the paintings of Goya, Jacques-Louis David and Raeburn for example, or a century later, the work of the Scottish Colourists, as opposed to the Bloomsbury group? What would he make of the paintings of Hockney, Bacon and Bellany? Could he identify the profound differences of influence and source material that lie at the heart of their work? I wonder if he's ever thought about the ideas of George Davie with regard to cultural matters? He should have. Isn't it his job to inform his readers of what's really going on rather than produce yet another ill-considered article, more worthy of the *Daily Mail* than *The Herald*? He might be right about the snobs in our midst, though. The story of the last three hundred years of 'high culture' in Scotland is a big one. If you're not aware of that you're in danger of joining the ranks of the philistine journalists already out there demeaning the debate and misleading their readers. You've got to know what it's about.

ALAN Within the historical structure of the Union, British nationalism was strongly supported by all kinds of cultural forms. But the cultural complexity, the human complexity of all the arts, goes far deeper than the distortions of imperial jingo. I tried to track this through in a sequence of poems about the great English composer Edward Elgar, on his various visits to Scotland. I love Elgar's music. He was on holiday in Scotland, with his wife and young daughter, when the First World War was declared, in August 1914. Now, you might think of Elgar as supremely English, or as a composer for whom the British Empire was the world. But when you listen to the music, and understand it in its time and emotional complexity, what you might describe as its symphonic loneliness, you cannot reduce it to that. And so, being critical of the imperial ethos, of the priorities of militarism, you can find a kind of implicit critique of the world of British, German, or indeed any military power, there in the priorities of sympathy and pathos that the music itself requires. Without that sympathy and sense of pathos, without that strength of sensitivity to the musical and artistic expression Elgar delivers in his works, you are at risk of reducing everything to distortions of humanity.

SANDY You have a poem about this.

ALAN Elgar was in Scotland, at the Gairloch Hotel, at the outbreak of the First World War. Just let that sink in for a moment. The year 2014 is an important anniversary for Bannockburn, of course, but also for the beginning of the First World War. Now the question is, how do we remember those events? What do they mean for us now? We shouldn't reduce either of them to over-simplified formulae. They demand a deeper and more thoughtful response. These are two sections of a sequence of poems I wrote about Elgar in Scotland.

At the Gairloch Hotel, 1914: Trio

We journeyed on the 19th of July.
Carice was just a girl, and scared,
the precipice beside us, the driver leaning, 'slightly drunk'
and swaying over the horses. So what was I to do
but smile at her and bring her voice to join mine,
singing nonsense songs, for fun? We knew
a good repertoire, but my eyes went over her head
to Loch Maree, that shining splendour still,
the carriage rolling on, the cliffs below on one side,
the rising rock encroaching on the other.

At the hotel, you can look out
across all Gairloch Bay, over the Minches to Skye
and even, far-off, Lewis.
Alice said she thought it was 'the loveliest place' –
ever. Except Bavaria, of course.
Carice and I went fishing. Alice didn't.

The 4th of August came. The idyll ended.
The guests began to leave. One old couple stayed,
and us. Breakfasts were all crockery,
and cutlery, and heaviness of linen.
I couldn't get the news.
No papers. Post disrupted.
Car drivers gone with their cars.
The steamer had been taken to the islands,
to pick up men for soldiering. The hotel coaches,
broken down, awaited parts from Glasgow.
The locals refused my English £5 notes.

It was 'weird and affecting' seeing these things,
'those dear people bidding goodbye'
 '...the Lovat Scouts rode thro
– were given a sort of tea meal here
& rode off in the moonlight by the side of the loch
& disappeared into the mountain.'

Next day, Achnasheen, and Inverness again,
and Perth and Edinburgh, then back to the south,
vast movements of men to be seen on the way.

All was strangely soundless, as if it were a silent film –

Later I dreamt, of course –

The Dream, 1914: String Quartet

The sounds of iron, horses' hooves –
The clattering on cobbles, young men in the moonlight –
Hundreds and hundreds of young men on horses –
Clean pale blue jaws and officers with big moustaches, gloved hands on
 the reins,
Holding them high. The sounds of horses snorting, riding through
 together,
Solennelle, en masse, a thick moving column riding past the hotel –
I stood on the veranda, watched them go,
The curve of the column, riding –

 The water crashing in on the beach down below
The far loch glittering and still, the high craggy mountains behind us –
And dream-like into the twilight of dawn creeping up, they rode
Into the rising road that would take them –
The men and the horses, into the dark,
As the dawn brought slowly its chorus
of birdsong, the accents of silence,
the voices, again, of women and men,
and the absence –

The absences –

The loss of things to come –

British tradition is so often seen as the epitome of tradition. Historically,
that has meant suppressing the expression of, and suppressing education in,

the distinctive traditions of Scotland. That's nowhere more evident than in the matter of language, literature and the arts. So the end of Britishness is a cultural as well as a political battle. It is a battle between the militaristic priorities of the imperial ethos, the priority of getting rid of anything the soldier cannot turn to use, and the increasing complexity and diversity of sympathy and understanding that is what the arts explore and provide, the full human potential that is truly ours, that is so often taken from us. I hope that's what the poem allows us to see: it's not just Elgar the great English composer, but also Elgar seeing all these young men and horses riding off to the war, from Scotland, and looking at the seas where the ships will be bringing others from the islands, to go to the imperial war. The islands and many towns and villages throughout Scotland lost their young men in hugely disproportionate numbers, compared to the demographics of the rest of the UK. I suspect the sense of well-being in any community bears the cost of that over a very long time. Recovery is slow. So it's the pathos, yes, but it's also the sense of the destruction of human potential. And therefore, if you keep hold of that sense of human potential beyond the tragedy of war, there is also the sense of terrific possibility. Not in any easy way, but what makes the thing tragic is the understanding that this potential has been wasted, the possibilities have been broken. And paradoxically, at a deeper level, that reaffirms the sense that the potential and possibilities are there, intrinsic to humanity.

SANDY You feel it more keenly because you've just gone through the whole process of seeing how they have been wasted.

ALAN Aye. That's what tragedy is. It strikes me, looking back over Scottish literature, how relevant so much of it is, here and now. Sir David Lyndsay has frighteningly sharp relevance. In his play, John the Common Weal is the man for our time, in the 21st century. And Robert Louis Stevenson. As Mary Brodie says to Walter Leslie, in Robert Louis Stevenson and W. E. Henley's play, *Deacon Brodie* (1880): 'It is for every man to concern himself in the common weal.' Though of course, in the 21st century, we have to say, every man and woman. But the point is crucial. Every man and woman, including all the royals. Do they? All these writers I've mentioned, and further back, Robert Henryson, William Dunbar, older Scottish writers – they all have something to say to us now, not only in terms of specialist interest, in literary and academic terms, but to all people, generally, and in Scotland in particular.

SANDY Agreed. And you've just said that the end of Britishness is a cultural as well as a political battle. The fact that cultural production in Scotland is

aligned with independence from the 1920s onwards seems to have escaped
the notice of Unionist commentators. Or perhaps it hasn't, and might explain
why there is so little enthusiasm in high places when it comes to promoting
Scottish art. I wonder if we could look at this from an English point of view
and ask the question: 'Do any of the great English artists and writers of
the past century reflect aspects of Britishness in their work or are they all
resolutely English in their use of source material and aesthetic direction?'

You've already mentioned Elgar and his cycling tours of Scotland, but
is there any evidence of that experience entering into his music? Harrison
Birtwistle spent some time on Raasay in the 1970s and a recent string quartet
The Tree of Strings relates to that period. But as the critic Arnold Whittall
puts it, 'for all his supranational radicalism his music has deep roots in a
profound if uneasy sense of Englishness.' Peter Maxwell Davies, who has
lived on Orkney for the past 30 years presents a more complex case for
'Britishness' but the question remains, is there really such a thing as British
music or art?

If we take for example, those Scottish artists we've already discussed,
McTaggart, Mackintosh, and the Colourists, we can see quite clearly their
aesthetic agendas spring from their surroundings and are very different
from their English counterparts. English Modernism, when it eventually did
arrive in the shape of artists such as Ben Nicholson and Barbara Hepworth,
looked very different indeed from the Colourists. And this is how it should
be. Coming into the present, cultural identity is to be found at the heart of
the work of Douglas Gordon, 'ein Schottische kunstler' as he's known in
Germany where he now lives. Klaus Bisenbach, Curator of Film and Media at
MOMA in New York says this of Gordon:

> As a Scot he had the distance to look at Hitchcock,
> Warhol and Hollywood almost as if they were
> foreign cultures. The foreignness of the known and
> familiar, the alienation from something as intimate
> as the spoken or written word – these seem to be
> recurrent elements in his visual repertoire.

Can we therefore define what British art is, or indeed what Britishness means
in the arts, or what its supporters want it to be?

ALAN Maybe I can answer that question by quoting from an essay I wrote
a few years ago, 'Was There Ever a "British" Literature?' The short answer
is no, but there is a curious period in the 18th century when the idea
of Britishness is explored in different ways – mainly by Scottish writers
confronted with the new situation. Tobias Smollett, in his novel *Humphry*

Clinker (1771), follows a group of people on a journey round Britain and shows what were to become very familiar national stereotypes, before they had become quite as familiar as they are. In the end, it's a demonstration of the failure of the imposition of the fabricated idea of 'Britishness' – though of course, there was certainly a British Empire. The distinctive qualities of writers arise from their own particular identities. You might consider Henry James and T.S. Eliot as Americans who became British citizens, but the complex legacy of that hybridity is very deep in their work, just as one aspect of the greatness of Joseph Conrad is his grasp of the English language, coming to it as he did as a Pole, and there is a Polish aspect to Conrad, it's a key component of his character and writing. But generally, writers and artists arise from the conditions of their nations. British is a totally false category in this respect. Maybe Seamus Heaney sums it up most pleasantly. When he was included in *The Penguin Book of Contemporary British Poetry* (1982), edited by Blake Morrison and Andrew Motion, he famously wrote a poem entitled 'An Open Letter' to the editors. Heaney admits he was hesitant and doubtful whether he should complain, because he knew that since he published in the *London Review of Books*, the *Times Literary Supplement* and *The Listener*, and his books were published by Eliot's publisher Faber and Faber, his readership is inevitably (though not exclusively), 'British': but he insists that he must 'demur' because 'My passport's green': 'No glass of ours was ever raised / To toast *The Queen*.' He immediately qualifies his statement: 'No harm to her', but 'from the start her reign… would not combine / What I'd espouse.'

That's a bit too charming. This gentle, friendly retreat from the flag of the book's title is a lot more deferential than the attitude summed up wittily in Hugh MacDiarmid's poem 'The Difference':

> I am a Scotsman and proud of it.
> Never call me British. I'll tell you why.
> It's too near brutish, having only
> The difference between U and I.
> Scant difference, you think? Yet
> Hell-deep and Heavenhigh!

To British readers, perhaps Heaney's is a more attractive, less challenging attitude. It's worth noting that MacDiarmid's poem was also occasional, prompted by the invitation to contribute to a special weekend edition of the traditionally Unionist Edinburgh-based newspaper *The Scotsman* put together for the Sir Walter Scott centennial celebrations (and was published in it, 14 August 1971, p.3). Examples could be multiplied and ironies abound.

In the 18th century, writing in English, James Thomson (1700–48), in his poem 'The Seasons' (1730), essentially invented the genre of landscape poetry for the British imagination. A little later that century, Boswell and Johnson were visiting the Highlands as if it were a very foreign country. They were silenced when they walked across Culloden Moor. This newly-forged sense of 'British' identity is crystallised in James Thomson's anthem, 'Rule Britannia' – though it was originally written as a song to be performed in a vehemently anti-Jacobite London musical.

SANDY That's a particular moment in 18th-century political and literary history, but more generally, isn't it true that literature and music and all the arts arise from the nation in which they are imagined and created? This is certainly the case with English music, when you come to the end of the 19th century and come into the 20th century.

ALAN Yes, and you might think of Elgar being an inspiration from whom Vaughan Williams would learn, but do different things, and Vaughan Williams himself having that role for Benjamin Britten. But each one in turn is an English composer, first and foremost. None of them are 'British' – except, I suppose, by default, because of the political terminology that we talked about before. The depth of their music and its practice, is English. Vaughan Williams more than any of them talks about this in his collection of essays, *National Music and Other Essays* (1963), where he says that 'the musical style of a nation grows out of its language.' It arises from the 'mother tongue', from the vernacular in poetry and the character of its speech, therefore, he warns, 'English musical history is full of the tragedy of genius withering on barren soil' and:

> Many young British composers have been ruined by abdicating their birthright in their most impressionable years. Before they knew what they wanted to achieve, before they had learned, so to speak, their own language, they went to Paris or Berlin or Vienna and came back having forgotten their own musical tongue and with only a superficial smattering of any other.

Now, Vaughan Williams himself went to Paris and studied under Ravel, but that was where he discovered his sense of himself as an English composer – and in the same way, a little earlier, J.D. Fergusson went to Paris and discovered his sense of himself as a Scottish artist. By travelling there, they both returned to see anew and deeply the national languages each wanted to reaffirm and regenerate in their different arts.

SANDY The status of the arts is aligned with the status of the nation in which they arise. An independent nation has its own independent arts, and this is seen clearly internationally. Ireland is a good example. Irish literature has an international status quite different from that of Scottish literature, although that has been changing because of the enormous range and the quality of critical and scholarly work that has been done and continues to be done on Scottish literature.

ALAN That's true, but it's just as true of England. Vaughan Williams again: 'When Stravinsky writes for the chorus his mind must surely turn homeward to his native Russia with its choral songs and dances and the great liturgies of its church.' He suggests that Stravinsky's 'Les Noces' and the 'Symphony of Psalms' will remain fresh and alive because of that Russian depth of attachment. He also notes this: 'Smetana, the recognized pioneer of Czech musical nationalism, received his first impulse from 1848, the year of revolution, when he wrote his choruses for the revolutionary National Guards.' Vaughan Williams is scathing about the 'misguided thinker' who described music as 'the universal language' when even the most 'universal musician', Johann Sebastian Bach, built up all his work 'on two great foundations, the organ music of his Teutonic predecessors and the popular hymn-tunes of his own people':

> I am quite prepared for the objection that nationalism limits the scope of art, that what we want is the best, from wherever it comes. My objectors will probably quote Tennyson and tell me that 'We needs must love the highest when we see it' or Rossini, 'that they know only two kinds of music, good and bad.'

No, he insists: 'It is because Palestrina and Verdi are essentially Italian and because Bach, Beethoven, and Wagner are essentially German that their message transcends their frontiers.' He elaborates the point: 'Now the musical style of a nation grows out of its language.' He quotes Dr H.C. Colles: 'A people's music grows in contact with the people's mother tongue, from the emergence of the vernacular in poetry and prose literature speech stamps its character with increasing decisiveness in the name of the music of that people.' Vaughan Williams comments: 'The roots of our language and therefore of our musical culture are the same, but the tree that has grown from those roots is not the same.' This is what J.M. Synge in Ireland says in the introduction to *The Playboy of the Western World*:

> I got more aid than any learning could have given me from a chink in the floor of the old Wicklow house where I was staying, that let me hear

what was being said by the servant girls in the kitchen. This matter, I think, is of importance, for in countries where the imagination of the people, and the language they use, is rich and living, it is possible for a writer to be rich and copious in his words, and at the same time to give the reality, which is the root of all poetry, in a comprehensive and natural form.

And this is the story of all major Scottish writers, from Duncan Ban MacIntyre to Fergusson and Burns, from MacDiarmid and Soutar to Lochhead and Kay.

SANDY But you will have people telling you that the only good literature came out of Scotland after the Union, after 1707. You will have people saying that the single greatest achievement of Scottish literary and philosophical culture was the Enlightenment of the late 18th century.

ALAN That simply shows an abject ignorance of the qualities of many, many Scottish writers through many centuries preceding 1707. It also turns the Enlightenment into a post-Union fetishised commodity, without much understanding of what was going on there, how it came about, what its foundations were, and what its limitations were.

British and Scottish?

ALAN And also, you have to take into account the overlapping cultural identities we live in. Scotland is in Britain, Britain is in Europe, Europe is part of Western civilisation and that is multiple, linguistically, culturally, and so on. So if language is a foundation for written culture, we'd have to ask how do these models apply to Gaelic and Scots? An Anglophone world is predicated on English-language identity but Gaelic connects Scotland to Ireland and Wales and Celtic legacies in pre-imperial Europe and the post-colonial world. And the Scots language connects Scotland with dialectal forms of English in the post-colonial world, especially the West Indies, Singapore, and India, as well as the imperial legacy of the Ulster Scots. But the Scots language predates the postcolonial world by a long way. It has an ancient history. And English pre-eminently connects Scotland not only with England but overbearingly with America, the United States, in what some people call a 'special relationship'. Of course it also connects us with what used to be called the Commonwealth, a community

of English-speaking peoples, in Canada, Australia, New Zealand, India, the post-imperial English-speaking former colonies. There is plenty of scope for republican independence there, all right. Post-colonial identities have released all sorts of new ways of thinking about language and art, as well as political self-determination, especially since the 1960s, in Africa, for example. So we're engaged in a different way of thinking about the world as a whole, and in that context, what has developed in Scotland is the opposite of parochialism. It's not a 'narrowing' by any means. It is rather a resituating of relationships and priorities that goes way beyond the Scottish / British imperial paradigm.

SANDY In *The Scotsman* (3 April 2013) the novelist Allan Massie wrote: 'It has always been quite possible to be a political unionist and a cultural nationalist.'

ALAN I don't see that. It's a generational delusion. It was established in the 18th century, after the union of 1707, after the oppression of the Highlands in the wake of 1746, and after the development of the idea of Britishness in the late 18th and early 19th centuries. With Smollett, Scott and right up to Stevenson, being Scottish and British was a cultural and political assumption but it's already breaking down with Stevenson. The First World War begins to demolish that assumption fundamentally. It becomes questionable. The emphasis upon being British – and British meaning English – that is, Englishness is dominant, all else is subordinate – is accompanied by growing self-awareness of national difference. It is established as a question in the 1920s, with the National Party of Scotland in 1928, then almost all cultural production in Scotland is aligned with political independence throughout the 20th century. Now, it is simply not possible to assume Scottish and British identities as coaligned and complementary.

> Growing up in England, school history had taught me that the sea was a defensive barrier, policed by the navy to ensure that Britannia continued to rule the waves. To the explorers, traders and emigrants of Scotland, however, it was predominantly a connection to the world – and crucially one which didn't involve kowtowing to Big Brother over the land border. Water was freedom and possibility.
>
> Nick Thorpe, *Adrift in Caledonia: Boat-hitching for the Unenlightened* (2006)

SANDY There are many in the cultural field who claim that it's misguided to endorse national identity in a plural, international, multinational world but surely, when someone denies himself or herself local or national identities and claims to be 'a citizen of the world' that's just another way of saying, 'I am

not taking any responsibility for self-government or regulating resources and wealth in my own territory.' If someone wants to insist on social priorities appropriate to their own political beliefs, geographical resources and particularities and so forth, while at the same time paying attention to what makes them distinct, different, uniquely responsible to their own place in the world, that would be self-determination. That's what we want. Not politics simply based upon identity but politics based upon the greater democratic possibilities independence offers.

ALAN The aspiration is towards a fairer society, more open, more tolerant, more socially understanding – a departure from the rigorous divisiveness of social segregation evident in sectarianism, sexual discrimination, prejudice against various aspects of human nature and disposition. That sounds like idealism, but why shouldn't we live in hope?

SANDY What's wrong with idealism? We need more, not less of it, considering that in many ways we have moved forwards towards a more, not less, tolerant society in the last 50 years or so. Yet the political purpose of Scottish society is not divided along the same lines as that of English society. The common ground in Scotland between the SNP and Labour indicates a radical difference between Scotland and England, but it also indicates the sad division between the independence and Unionist parties. Maybe you can't have civil society without the glue of financial wherewithal but the priorities of finance create a divided, divisive society. That's where we are. The main achievement of British social democracy, the high level of human welfare established in the aftermath of the Second World War, is now regarded as unaffordable, even though we are as a nation four times better off than we were in the 1940s. The original theorists of capital like Adam Smith and Robert Owen had as a priority social improvement. Their purpose was not to make loads of money for the few but to utilise surplus for social improvement. That is not the case now.

Money and Culture: The Lure of London

SANDY We talked earlier about London as a kind of immoral, impregnable, economic and political monster. It seems to conjure up loads of money for the few but that money is not utilised for social improvement, neither in London nor anywhere else in Britain. The situation resembles London in the early period of the Union, brilliantly satirised by William Hogarth (1697–1764) in his memorable series of prints, 'The Harlot's Progress' (1732) and 'The

Rake's Progress' (1734), with the super-rich and the mass of the poor already in place. The present mayor, Boris Johnson, begs to differ, often arguing that London is starved of public funds and accusing Scotland of being the beneficiary, at London's expense.

ALAN That's just perverse – ludicrous, indeed – but then, BoJo is enjoying a second term of office – he's hugely popular! And who knows what might happen next?

SANDY We have to ask about the relation of money and culture in London.

ALAN London is a massive economic centre but it's also a massive arts centre, and countless numbers of people hoover up the concerts, opera, ballet, art exhibitions, West End shows, the whole arts provision there, and proportionately, you have a much stronger cultural fabric. I don't mean that as unqualified praise or altogether enviable, given its cost. But I mean we have to consider what its value really is. Take a practical example: the books pages or reviews pages of newspapers in Scotland compared to the London press. The extent and depth of the conversation taking place in *The Guardian*, *The Independent*, and so on, compared to *The Herald* and *The Scotsman*. I'm not talking about individuals at all here, but about the whole conversation. Now, on the one hand, you can see the quality, range, depth of engagement and sharpness of perception in, say, *The Guardian* Saturday reviews supplement and they far outstrip anything that can be afforded in *The Herald* or *The Scotsman*. That's not simply about the quality of the reviewers or editors, it's about the sheer extent of the investment, the cultural dominance of London. London doesn't compete with Glasgow or Edinburgh – it's like Everest compared to Arthur's Seat. Which is what I mean by saying that I'm not praising London for this. It's mainly inhabited by a parochial and narrow imagination, much more so than some other places – but if you live there you have access to all this.

SANDY London has always attracted ambitious Scotsmen and women. It's a mecca for all sorts of financial business, top jobs in the art world including the National Gallery, the British Museum and the Tate Gallery, broad-casting and journalism, cabinet ministers, even a few Prime Ministers, not always admirable figures! You name it, the Scots have been there and done it. The 'Scotsman on the make' in London has been the subject of many a hilarious cartoon. Scottish Prime Ministers have usually fared badly. Ramsay Macdonald and Gordon Brown for example, and the very first, John Stuart, Third Earl of Bute, had a particularly difficult time, lasting for only a year, 1762–63. Bute was a man of high principle and a patron of the arts. There's

a magnificent full-length portrait of him by Allan Ramsay, dating from 1758. All of the history books spell out that he was widely unpopular in England, chiefly because of his Scottish nationality. All sorts of rumours and insinuations of bias in promoting Scots to prominent positions forced him to resign. And thinking of Gordon Brown's recent experiences, it seems a residue of that prejudice still persists.

ALAN After the Union, London became a magnet for Scottish artists. Allan Ramsay and David Wilkie had successful careers there and Raeburn thought seriously about making the move south. The lure of money was a big part of the deal but Ramsay especially loved London for the intellectual stimulus and the soirées with the prominent bluestockings who held such events. He was popular among them. A *bon viveur*, a friend of Voltaire – he was quite a catch for an upmarket party. The opportunity afforded by the Union would have been terrifically exciting for Ramsay and others in that stratosphere.

SANDY And 200 years after Allan Ramsay, John Bellany was to experience a similar sense of liberation in London, a city that allowed him to make frequent visits to the National Gallery, the Tate, the Victoria and Albert Museum, the Hayward Gallery, all providing the nourishment he craved at that stage of his life. To truly express what he had to say about the prevailing conformity and self-suppression he came up against in both Port Seton and Edinburgh, whether it be religious, sexual or cultural, meant he had to remove himself from Scotland and it was London, a world city par excellence, that offered him the freedom he needed to prove himself.

ALAN In that sense, London was and is a terrific resource. You could say that it was the closest Bellany at that time could get to the Paris of Picasso and J.D. Fergusson. Great metropolises such as London, Paris, New York, Berlin, Vienna, have been special places for artists, loaded with potential subject matter and full of mystery and wonder.

SANDY I can't think of any Scottish painter who hasn't been inspired by his or her time in London. And the painting culture Bellany found himself in was led by a number of artists who had all arrived in London from elsewhere, Bacon from Dublin, Auerbach and Freud from Berlin, de Francia from Brussels, Herman from Warsaw, Kitaj from Cleveland, Ohio, and Paula Rego from Lisbon, and as with Bellany, none of them fitted neatly into the historical narrative of English art. They were, however, afforded the space and most importantly, the enlightened patronage that enabled them to prosper.

ALAN Take this a bit further. Maybe the relationship between art and money is best illustrated by looking at its effect in a number of great cities: Venice, Florence and Rome during the Italian Renaissance, Antwerp and Amsterdam in the 17th century, Paris and Vienna in the 18th and 19th centuries and today, New York and London.

SANDY And art and artists flourished in all of those cities, in those periods. Great works were created. Venetian merchants commissioned Titian and Tintoretto, Florentine bankers hired Michelangelo and Roman Popes preferred Raphael. In music, Wagner failed in Paris but succeeded in Bavaria, while Beethoven made it in Vienna. From his Amsterdam base the young Rembrandt's main ambition was to emulate the hugely successful Rubens, down the road in Antwerp. I would imagine this is the kind of motivation that spurs on young artists today.

ALAN We could talk about Glasgow in this context as well. In 1900 the Empire's second city was investing massively, both publicly and privately in the arts. The City Chambers in George Square – ten million bricks! – is as stately and sumptuous as any great palace, but built by the civic community rather than an aristocratic landowner.

SANDY That art is apparently attractive to the higher social classes is for some a problem. It implies that art is a luxury item that can only be afforded by the wealthy. Paradoxically, the poverty of artists contributes to the status of art, for the successes should be seen to be picked from a vast pool, and all artists should be seen to risk poverty in a 'winner takes all' economy. Yet there is no question that money has helped artists produce of their best. The Australian critic, Robert Hughes put it bluntly:

> The idea that money, patronage and trade automatically corrupt the wells of imagination is a pious fiction, believed by some utopian lefties and a few people of genius like William Blake, but flatly contradicted by history itself. The work of Titian and Bernini, Piero della Francesca and Poussin would not exist unless someone paid for them, and paid well. Picasso was a millionaire at forty and that didn't harm him. On the whole money does artists much more good than harm. The idea that one benefits from cold water, crusts and debt collectors is now almost extinct, like belief in the reformatory power of flogging.

ALAN But that's only part of the story. Only in visual art is the core business the production of rare or unique objects that can only be owned by the very wealthy, whether they are state museums, businesses or individuals. Other art

forms – poetry, novels, music, films – produce objects that are industrially fabricated in large numbers and are widely owned.

SANDY The way the art market operates, with London playing a leading role, has changed dramatically in the last 25 years, and now resembles a huge multinational corporation with associations of galleries selling the one product in New York, London, Dusseldorf, Paris, Milan. Previously dealers in New York would promote American artists, while Parisian dealers would promote French. That's no longer the case. Hence the phoney 'internationalism' the art world at this level propagates. The 'celebrity artists', 'business artists', 'art stars' of today have to produce large amounts of work quickly, in order to sell simultaneously in galleries across the globe. In fact it's really a distortion of art and culture, but as people are making so much money there are few critical voices. It's all part of the triumph of 'neo-liberal' economic policies.

The effects of the recession on the art market have so far been muted because very low interest rates make art a more attractive investment. If long-term recession is a prospect, due to the vast scale of US and UK borrowing, then the entire character of the art market and its products will once again be open to change. Recently it was reported in *The Scotsman* that:

> The value of art exports leaving the UK for foreign shores has surged to its highest level since the height of the financial crisis five years ago. In a sign that wealthy investors are increasingly prepared to dip into their pockets for lucrative artwork, buyers from abroad paid close to £2 billion for art and cultural exports in the year to 2012 – £5.5 million a day. Massimo Sterpi co-editor of the *Art Collecting Legal Handbook*, said that despite the ongoing economic difficulties, art remained an alluring buy for the well-off. He explained: 'Art is an increasingly important trophy asset for international high network individuals.' Mr Sterpi also believes London's popularity as a second home for foreigners from the Gulf States, Russia and Hong Kong helped drive sales up.

A footnote reveals this latest research is based on data from the Department of Culture, Media and Sport.

ALAN Does any of this affect Scottish art and artists?

SANDY Of course it does. The London art world has tremendous power and influence and uses this to assert control over our ideas of what constitutes important works of art. We can see this clearly in the reactions of those Glaswegian artists who have in recent years won the Tate's prestigious Turner Prize. Very few of them have spoken of themselves as Scottish artists.

Indeed, they have been at pains to play down their Scottish identities. The provocative English curator Lynda Morris, who understands the situation well, describes their actions as 'self-censorship'. Given the role of the Tate as the high temple of British art, a role that defines the ideology of art in Britain, it would indeed be very foolish for any young Scottish artist to challenge all of that. Globalised art production has had a homogenising effect – visit any art school anywhere in the world and you'll see the same kind of work being done. Art world platitudes such as 'art is borderless' and 'art is a zone of freedom' are widely believed by ill-informed students and young artists. If one stops to think, however, it's easy to see the conditions for that freedom no longer exist in the art world: artists sit comfortably in the market's lap; sufficient autonomy is maintained to identify art as art, but otherwise all styles and subject-matter are indulged in; success comes swiftly, or not at all. In his *Aesthetic Theory*, Adorno had this to say about art's freedom: 'absolute freedom in art, always limited to the particular, comes into contradiction with the perennial unfreedom of the whole.' Until that wider freedom is effected, the particular freedoms of art run through the fingers like sand.

As we've noted, very few cities can compete with London on cultural terms, though London has never really had a great period of creativity like Paris in the 1880s, Berlin in the 1920s or New York in the 1940s. The swinging '60s were more about design, fashion and pop music than they ever were about great art. But there was certainly a period of momentous creative endeavour in Glasgow towards the end of the 19th century with the Glasgow Boys, Charles Rennie Mackintosh and Margaret MacDonald, and Alexander 'Greek' Thomson well to the fore. Present-day Glasgow has none of the glamour of major art capitals such as New York and Paris, Berlin or Dusseldorf, but it has nonetheless established a reputation over the last 30 years as a leading centre for the visual arts.

ALAN It has been suggested that the events of 1979, which effectively denied a political voice to the majority of Scots, demanded that our intellectuals, artists and writers become engaged as never before, with the result that the cultural became a surrogate for the political. This is evident in the work of Glasgow's writers, James Kelman and Alasdair Gray, but perhaps less so in the corresponding activities of visual artists?

SANDY There were exceptions. Ken Currie, Steven Campbell, Adrian Wisniewski and others all made powerful statements in their work in the 1980s – both a defiant blast against local conservatism and a brave attempt to take

Scottish painting onto the international stage. It's noticeable that in the big celebrations of Scottish contemporary art planned for the summer of 2014, the National Galleries have come up with a starting date of 1990, therefore excluding the important artists working in the period immediately after 1979. Duncan MacMillan, in *The Scotsman* (30 December 2013) had this to say:

> The biggest project for the year is 'Generation', an exhibition of art in Scotland over the last 25 years, to be spread over the country, a national event. There is, however, no mention of the Referendum in the publicity. You wouldn't expect the National Gallery to take sides, but there is surely a reason to suppose that the artistic energy the show proposes to celebrate might have something to do with changes that have made the Referendum even thinkable, whatever the outcome. A nation that doesn't know its art, doesn't know itself. Thirty years ago, Scottish art was a barely credible notion. Indeed in the south it was a risible idea that the Scots could have any visual culture at all. Now it is universally accepted. That shift marks a profound change in our national self-esteem. We now have grown-up politics and can at least contemplate being a grown-up nation again.
>
> So will 'Generation' reflect this? It is billed as 'one of the most ambitious celebrations of contemporary art ever held by a single country, recognising the huge international acclaim that artists working in Scotland have achieved over the last generation'. I am not sure that 'huge international acclaim' amounts to more than the dubious accolade of a few Turner Prize nominees whose reputation generally represents the triumph of hype over experience. Real national acclaim might have been a more interesting proposition.
>
> Curiously Steven Campbell is included although he did some of his best work in the 1980s, well outside the show's self-imposed (and meaningless) limit of art since 1990, but Ken Currie and Adrian Wisniewski are not, although they are Campbell's exact contemporaries.

ALAN It's difficult to say precisely how much this is calculated exclusion, self-conscious choice, a result of ignorance or indifference or malevolent interference. But MacMillan is surely right to insist that the National Galleries – every national institution, in fact – should be more enlightened and articulate about the changes that have been brought about in what can be contemplated as possible, since, say, 1979.

SANDY: Much has been made of the uniqueness of the situation in Glasgow where in the absence of galleries, dealers, private patrons and collectors, the actions of the artists themselves, in supporting each other by means of

artist-run galleries, studios and various forms of collective and collaborative practices have helped to establish a thriving art scene. So much so, that being a 'Glasgow' artist has assumed a new level of significance in the 'international' art world. The Glasgow 'brand' allowed such artists to evade any questions that being a 'Scottish' might prompt. The city has its own iconography and images that are not 'national' but do stand comparison with other cities or metropolitan art centres. This suggests that the contemporary 'Glasgow' artist, unlike his or her literary counterpart, is determined not to be labeled as 'Scottish'.

ALAN Is this is because contemporary art has set itself apart from the functional character of everyday life, preferring to exist within its own rules and conventions where the immediate concerns of the social and the cultural can be safely ignored? Or is it because being a Scottish artist still retains the tag of provincialism, when set against the glittering successes of 'the young British artists'?

Beyond the Union

ALAN In an independent Scotland there would have to be a much sharper focus on our own cultural achievements. It should not be difficult to come up with new educational priorities that can indicate the range and richness of what our artists do, have done, and are capable of doing. It is the only way to ensure a parity of recognition, dealing nation to nation as equals. Only in that context can one artist be fully comparable to another or the cultural production in one language be of comparable value with that in another language. The political, educational and cultural stature of national identity can help confirm this vertebrate identity. This is where the cultural investment and institutional foundations are required: museums, galleries, libraries, schools, universities, the whole state-organised system which structures cultural appreciation, and helps to provide a sense of self-worth and dignity.

SANDY So if we really believe that, we have to begin by saying that independence is not going to be a continuation of the present. In 50 years, 100 years from now, we want Scotland to be a very different place, and a much better place. I really like the way Owen Dudley Edwards describes a future Scotland in his preface to Stephen Maxwell's *Arguing for Independence*:

> The ultimate cultural case for Scottish independence turns on the inflexible honesty intrinsic to Stephen. Scottish independence is tied to his principles; that a society taking its identity in the ownership of

Alexander Moffat · Portrait of Alasdair Gray · 2010
Democratic Left Scotland (On loan to Oran Mor, Glasgow)

The portrait was commissioned by Democratic Left Scotland and hangs in Oran Mor,
Glasgow, where's Gray's ceiling murals are a feature of the main hall.

Alasdair Gray · Hillhead Subway Wall Decoration · 2012

A mural decoration – using ceramic tiles – in the entrance hall of the subway in collaboration with Nichol Wheatley. The surrounding Hillhead district has long been a special place for Gray and his intention was to bring out his enjoyment of the area in 'a symbolic and humorous way'.

Ken Currie · Portrait of Peter Higgs · 2009 · Edinburgh University

Currie's remarkable portrait of the physicist was commissioned by Edinburgh University. The artist has said that on meeting Higgs 'he struck me as a man of immense dignity, reserve and humility – active in CND in his younger days, interested in art and music and a great lover of the Edinburgh Festival. … At one point he stood up and turned toward me slightly and I noticed his reflection in the great wall mirror in the room. I "saw" the painting immediately'.

David Alfaro Siqueiros · Cultural Polyforum Mexico City · 1971

Siqueiros (1896–1974) one of the three major figures of Mexican Muralism,
gained notoriety after his unsuccessful attempt to assassinate Leon Trotsky in 1940.
His final large scale work, the Cultural Polyforum Siqueiros in Mexico City was completed in
1971. It is the largest mural ever painted and forms an integrated exterior and interior structure,
combining architecture with painting and polychromed sculpture. The interior depicts a
grandiose vision of 'The March of Humanity'.

Juan O'Gorman · House of Diego Rivera · 1931–2

Juan O'Gorman · House of Frida Kahlo · 1931–2

The muralist and architect Juan O'Gorman (1905–1982) designed houses for Diego Rivera and Frida Kahlo in San Angel, then on the outskirts of Mexico City. The two separate colour-coded dwellings contained studios for each artist and were connected by an elevated walkway. Whilst drawing on European Modernism, O'Gorman creates architectural forms that can only be described as uniquely Mexican.

MODERN SCOTTISH
PAINTING

J. D. FERGUSSON

WILLIAM MACLELLAN
240 HOPE STREET GLASGOW
1943

Title pages · JD Fergusson · Modern Scottish Painting · 1943

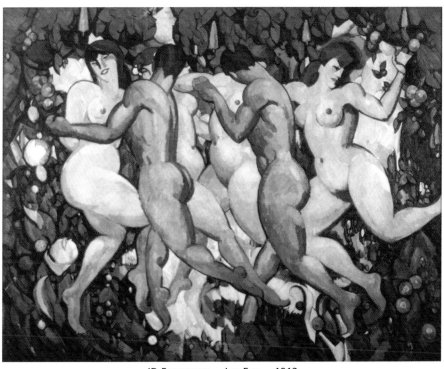

JD Fergusson · Les Eus · 1913
Hunterian Art Gallery · University of Glasgow · Gift from the JD Fergusson Art Foundation · 1990
Les Eus – A Scottish 'Rite of Spring' or 'La Danse'. First exhibited in 1914,
but not seen again in public until 1961.

William McTaggart · Anslem Kiefer

Although a century apart, the 'tragic landscapes' of William McTaggart (1835–1910) and the German artist Anslem Kiefer (b 1945) inhabit similar territories of remembrance, history and myth. Just as McTaggart's paintings are profoundly Scottish, Kiefer's are equally profoundly German. They could not have been made by an artist from anywhere else.

Anslem Kiefer is a German painter and sculptor whose works are characterised by an unflinching willingness to confront the dark past of German history and mythology.

Iona

Will Maclean · An Suilleachan 2013

This cairn, conceived by Maclean in partnership with Marian Leven commemorates the struggles of the Reef raiders to regain the land and celebrates the return of the estate to the crofting community of Bhaltos on the peninsula of Uig.

Photograph: Alistair Pratt

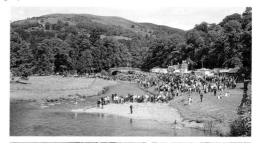

Langholm Common Riding · 2012

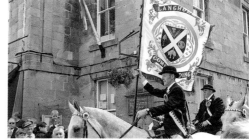

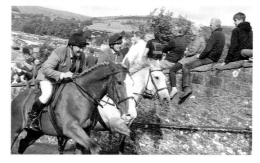

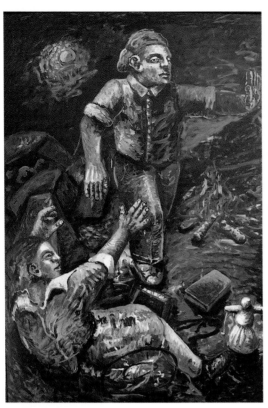

Steven Campbell · Untitled · 1982
Campbell's early monumental pictures,
influenced by Courbet and Picasso,
established his reputation while
working in New York in the mid 1980s.
His success re-vitalised Scottish art and
laid the foundations for Glasgow's
development as a centre for
contemporary art.

Harpa · Icelandic Concert Hall and Opera House Reykjavik · 2011
Designed by the Danish architect Henning Larson in collaboration with
the Danish-Icelandic artist Olafur Eliasson, Harpa's completion represented the determination of
the Icelandic people to re-build their economy after the banking collapse of 2008.
Photograph: Susan Moffat

Douglas Gordon · Confessions of a Justified Sinner · 1995
Collection Fondation Cartier pour l'art Contemporain, Paris (© the artist)
A work consisting of two large-scale screens showing looped sequences excerpted from Rouben Mamoulian's *Dr Jekyll and Mr Hyde* (1932). The loops showed the transmutation from Jekyll into Hyde and back again, and each screen alternated between positive and negative prints of the film.

Duncan Ban MacIntyre Monument · 1859
A granite monument erected in the hills above Dalmally, overlooking Loch Awe. Designed by the architect John Thomas Rochead (1814–1878) who also designed the Wallace Monument at Stirling, the monument was built following a public subscription in 1859.

Ken Currie
The Self-Taught Man
1986

British Council

As a student, Ken Currie assimilated the socialist tradition of painting, learning especially from Léger and the Mexican muralists. In *The Self Taught Man* the central theme is the self-education of the autodidact. The figure of a man labouring over a book promotes the Gramscian vision of the 'organic intellectual' emerging from the working class.

Fiona Hyslop · Gude Cause March · 2009

Fiona Hyslop, Cabinet Secretary for Culture and External Affairs leading the Gude Cause March in October 2009 commemorating the work of Scotswomen involved in the Suffragette movement. The march was a re-enactment of the 1909 Edinburgh Women's Suffragete demonstration.

Alexander Moffat
Portrait of George Davie
1999

George Elder Davie
(1912–2007) was a
philosopher whose seminal
book *The Democratic
Intellect* (1961) deals with
the struggle within Scottish
Universities in the 19th
century to maintain
a generalist form of
education which was
not only philosophical
but scientific, humanistic
and democratic. *The
Democratic Intellect* has
been described as 'the
most important book to
be published in Scotland
during the 20th century'
(Paul H Scott).

Frank Gehry
Maggie's Centre
Dundee · 2003

Gehry's building is one of
several Maggie's Centres
in Scotland completed over
the last decade, including
the extraordinary creations
by Zaha Hadid in Kirkcaldy
and Rem Koolhaas at
Gartnavel, Glasgow.

Jake Harvey · MacDiarmid Memorial Sculpture · 1982–84

Sited in the hills above Langholm, the poet's birthplace, Harvey's sculpture in bronze and steel echoes not only poetry but also the land, reflecting the role that it plays in MacDiarmid's work.

Kenny Hunter
Patrick Geddes Monument 2012

The monument by the sculptor Kenny Hunter celebrates the life and work of Sir Patrick Geddes. It is located within the landscaped garden of Sandeman House, off the High Street in the old town of Edinburgh.

Hunter deploys the traditional format of bust on plinth, but in this case the plinth is a stack of sculpted bee-hives, reflecting Geddes's wide ranging interests in ecological – including zoology – matters.

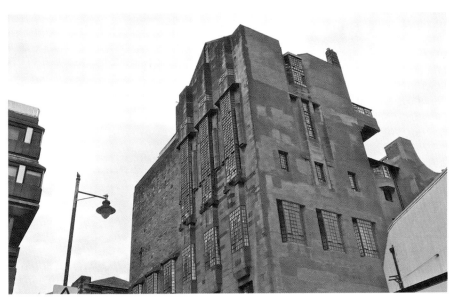

Charles Rennie Mackintosh · Glasgow School of Art · 1899–1909

The Scottish Parliament · 1999–2004

The greatest public building project in recent Scottish history, the Scottish Parliament has emerged as a triumphant monument to its creator, Enric Miralles, and to its champion, Donald Dewar. As opposed to the classical monument, Miralles emphasised a nature symbolism connected to the landscape. 'The parliament sits in the land... Scotland is a land... the land itself will be a material, a physical building material'. Ultimately the building became a kind of fragmented landscape and also the expression of what Miralles called 'a gathering place'.

Alexander Moffat · Portrait of Sorley MacLean · 1980

Above right:
Alexander Moffat · Portrait of Tom Nairn · 2012
Tom Nairn, author of the 'Break Up of Britain' and 'After Britain', is one of the foremost political theorists of nationalism working today. From 2001 to 2010 he was Professor in Nationalism and Cultural Diversity at RMIT, Melbourne, Australia. The portrait, commissioned by Democratic Left Scotland, celebrated his 80th birthday in 2012.

John Bellany · Self Portrait · 2012
Bellany's last self portrait, painted on the day of his 70th birthday, is one of the greatest pictures of human vulnerability ever made.

Allan Bissett
Independence Rally
2013

Elaine C Smith
Independence Rally
2013

Richard Demarco
Scotland House
Brussels

The Scottish
Government marked
the 80th birthday of
Richard Demarco with
an exhibition entitled
'Scotland in Europe:
Europe in Scotland'
in Scotland House,
Brussels in 2011.
Born in Edinburgh in
1930, Demarco's life's
work has centred on
the presentation of
major European artists
in Scotland and the
promotion of Scottish
artists in Europe.

weapons of mass destruction forfeits the allegiance of civilised humans; that a society judging itself on cultural identity handed out by imperial preference or cosmopolitan fashion destroys itself; that a society which perpetually lives by imaging itself at the centre of an empire actually long gone lives a lie it becomes too toxic to inhabit; that a society whose artists cannot think of its own territory as the primary focus for love, for anger, for identity, for sheer self-expression, for disenchantment, above all for truth, is a society twisted into contortions by obsessions with the outsider, market-maker, master. Stephen would never allow Scots to comfort themselves by blaming England. For him, independence always meant telling the truth to ourselves, about ourselves.

Owen Dudley Edwards, 'Preface', in Stephen Maxwell, *Arguing for Independence* (2012)

On Wednesday 5 June 2013, the Scottish Government Culture Secretary Fiona Hyslop gave a speech at the Talbot Rice Gallery at Edinburgh University, entitled 'Past, Present & Future: Culture & Heritage in an Independent Scotland'. I don't know if she wrote the speech herself, but she said things that we want to hold her to, and any Scottish government that comes along later better pay attention, because these are the right things and we want to approve and endorse them. She acknowledged the location in which her lecture was taking place, the Georgian Gallery, a masterpiece by one of our greatest architects, William Playfair, and linked it with her place of work, the Scottish Parliament, the very modern creation of the Catalan architect Enric Miralles. She said that:

> These two buildings tell us much about what is great about Scotland
> – the way that past achievements from the Scottish Enlightenment and
> other great periods in our history mingle with modern successes and
> developments – and the way in which our own artistic achievements can
> be celebrated, along with those from other lands.

ALAN Then she set out five key areas which, she promised, underpin the Scottish Government's approach to culture and heritage in Scotland, and that approach differs from that of the UK Government in each of these areas.

The first was the value of culture and heritage, in and of themselves, because they bind and connect our past, our present and our future and tell the stories about where we've come from, who we are and help us reflect on who we could be.

The second was how culture roots us in place, and helps to empower, enrich and shape our communities.

The third was how culture in Scotland is of us all and for us all, so requires participation and ways to enable all of Scotland's communities to benefit from the great cultural wealth and heritage not only of this nation but of the world.

The fourth was about the wealth of other benefits that culture and heritage bring to our communities, both social and economic.

And the fifth was an attempt to bring all of this together to address the idea of a shared ambition and vision, to build an independent nation where our cultural and historic life can flourish.

She claimed that the present Scottish Government is the most culturally ambitious government that Scotland has ever had, and that it is founded on the belief that public funding of the arts is a fundamental good.

SANDY It's instructive to compare and contrast the content of this speech with an earlier one that Fiona Hyslop herself delivered in November 2012 at a major museums and galleries meeting in Edinburgh. On that occasion she failed to name one single artist, or describe any work of art, even though she was speaking to a conference of museum and gallery people. Emphasis was placed on the role of art in the economy: 'adding to the social value of museums and galleries is the economic value they bring to the nation'. Unable to mention a single painting or portrait, she was able to calculate the return on arts festivals and the so-called 'creative industries'. Instrumentalising the arts for social or economic purposes damages them. It asks them to do what they can't do directly and ignores what they are. And it alienated the arts community who openly challenged the policies of Creative Scotland in a series of letters to the press and media in the spring of 2013. A crisis ensued, but following that, it seems lessons were learnt. The Talbot Rice speech reflects a new and very different approach. For a start, artists are mentioned by name.

I have said before that it is not the Government's job to tell artists what to paint or authors what to write or craftspeople what to fashion. Nor is it the Government's job to tell people what art to see, what books to read or what crafts to buy. It is our job, however, to create the conditions which enable artists to flourish and as many people, groups and organisations as possible to benefit from and enjoy our culture and heritage. I want to talk to you today about how we do this and set out our aspirations for how we could do so much more.

Recently, the Culture Secretary for the UK Government set out a different approach to culture and asked the culture sector to help her make the arguments about the economic impact of culture in the context of economic growth.

I don't agree. That is not the future I choose.

The Scottish Government already accepts the case for the role of government in supporting the cultural sector. We actively support the case for public subsidy of the arts. We understand that culture and heritage have a value in and of themselves.

I don't need or want the culture or heritage sector to make a new economic or social case to justify public support for their work. I know what these sectors can deliver because I see it in action. I visit hardworking artists and practitioners who are exploring new ways of working; and who are creating dynamic and exciting new ways of enjoying and sharing their work and the work of our ancestors. They think in new ways precisely because they are artists.

So, for this Government, the case has been made.

On the 18 of September 2014, the Referendum will give us an opportunity to vote for a future based on choices, predicated on a judgement about what kind of value systems we want to shape our lives and the lives of our children. In culture, the contrast between our approach and attitude to artists and creativity and that demonstrated by the UK Government is fundamental and profound. It reflects a choice of two futures.

The UK Government asks what culture can do for the UK Government's purpose; it asks that cultural bodies, artists and organisations justify public spending by demonstrating – and I quote from the UK Culture Secretary's speech – 'the healthy dividends that our investment continues to pay' and that 'culture is perhaps the most powerful and most compelling product we have available to us'.

What's new and important about this is that she repudiates all previous Scottish government thinking on these issues. When the SNP first formed a government they seemed keen not to talk about the politics of cultural independence – in fact they didn't have a defined cultural policy so they went along with existing New Labour ideas. This is clearly explained in an essay by Philip Schlesinger entitled 'The SNP, Cultural Policy and the Idea of the "Creative Economy"', in *The Modern SNP: From Protest to Power* (2009) where he shows that the SNP government:

> ... inherited a key plank of the Labour-Lib-Dem creative industries policy and ran with it in setting up Creative Scotland. The new body was the unloved child of two ill-matched parents: bureaucracy and intellectual dependency. Why did the Nationalists not think again? Like the Labour-Lib-Dem coalition the Nationalist cabinet had taken up and adopted policy made in London.

At the heart of the official British vision of creativity were the harnessing of culture to the growth of the national economy and a grandiose post-imperial design to make the UK the world's creative hub. The SNP version was the harnessing of culture to the growth of the national economy. Not much difference really, until this speech.

ALAN What she said then is almost in the form of a credo, a manifesto for government. I really hope she means it.

I believe that culture and heritage are both an intrinsic and instrumental good for us all.

Scotland's cultural life and heritage cannot be reduced to a single style or image; rather, they are a wealth of what we might describe as 'stories' that take many different forms, as diverse as the land, peoples and places of this complex country.

There is no one thing that defines us. There are, of course, iconic images, poems, films, artists, writers, performers, compositions, buildings and landscapes that evoke our sense of 'Scotland'. A Scotland that is steeped in meaning and history but which is continually on the move – engaging with its past, looking beyond borders, seeking new and innovative ways to engage with the world.

From the Stones of Stenness, built, we believe, to connect our ancestors to their past, through to the fragility and beauty of the work of Scotland's contemporary sculptors such as Karla Black, whose work is shaped by both traditional materials and the by-products of the modern world, immortalised by the tools of our digital age and renowned far and wide. Our culture and heritage is nothing less than dynamic, nothing less than rich and nothing less than inspiring.

The connections and threads between our past, our present and our future are flexible and fluid; we both take and create meaning when we look deep into the history of our nation, shaped by those who have settled here and those who have left for faraway shores; our connections with other countries, other peoples all linked by these threads connecting people, forms and ideas.

I want Scotland to be recognised as a nation that not only nurtures and is nourished by wonderful songs, poems, stories, drama, dance, paintings, and sculpture but as a nation that welcomes artists and creative practitioners from all over the world to come, to inspire and to be inspired, to innovate and to create.

I want Scotland to be understood not just by *what* we do, but by *how*

we do it. Supporting the process of artistic development is as important as recognising and appreciating the art itself.

SANDY So it seems that the views of artists actually got through to the Scottish Government and this is good news indeed. It shows that in a small country there really is a much greater chance of politicians really listening to what people say. Let's applaud the Culture Minister for having the courage to change her mind and listen to what artists were saying and putting together an arts policy with real vision and substance.

ALAN But so far, all of this is just words. Who will carry out the task of implementation? Creative Scotland? If that is the case there will have to be a profound change of heart within that organisation, which has spent the past several years turning itself into a bureaucratic agency like no other, clearly committed to a market-inflected ideology.

SANDY And we also have to address the status accorded to the role of the Culture Minister in Scottish governments since the parliament began. Culture Ministers have come and gone with the kind of regularity that suggests the job is of minor importance, again closely following the Westminster model. This merely reflects how limited political thinking has become across the UK. And if independence is about change, then the job must become one of the most important in the cabinet. We need a strong Culture Minister at the heart of government if the new arts policy is to succeed. What else did she say?

ALAN She said this:

Art is not always comfortable. It does not need to be easy or 'feel good'. I want us to embrace what's difficult, what's challenging and what's uncomfortable. It is the very measure of the health of our democracy to welcome and embrace the role of artists to challenge our expectations, to nudge us from our comfort zones and encourage us, individually or collectively to reflect on how we could do better and how we could be better.

History is peppered with stories and ideas that define us. Some give cause for celebration, others almost for lamentation, because any nation's story has its darker moments and these are also part of our heritage – urging us all to reflect on acts that both have harmed us and have done harm.

When Picasso painted *Guernica*, he didn't do so to merely adorn a wall, he did so to make a profound and powerful political statement. I know that contemporary audiences confronted with, for example, the National Theatre of Scotland's *Black Watch* also feel that profound sense of contemplation, reflection, raw energy and emotion. It's an

astonishingly powerful and impressive piece of modern theatre that also asks us to reflect on the meaning and impact of war.

SANDY Hold it. I think we should single that out for praise. I can't think of any government minister in London or Edinburgh ever holding up the example of Picasso's *Guernica* in this way. Picasso's political work is always avoided. After all, he was a member of the Communist Party. The profundity of the painting is about humanity and the politics of it are always with us. Fiona Hyslop might have made reference here to the referendum held in 1967 in Basel, on whether the Kunstmuseum should pay six million francs for the purchase of two important Picasso paintings, 'The Two Brothers' (1905) and 'The Seated Harlequin' (1923). There was a vote of 32,118 in favour of spending the money for these works, and 27,190 voted against it. Picasso himself was so moved by this gesture of support that he donated four other works to the museum. They take art seriously in Switzerland, and they encourage and expect everyone's participation. There is no elitist nonsense about this. The message is that great art is for everyone. Fiona Hyslop and indeed any Scottish Minister for the Arts and any Scottish Government, generally, should be following that example. That's democracy and education at work, seriously. We have a long way to go.

ALAN She went on:

> Scotland is more than a nation bound by a border and oceans, it is a nation of ideas and our innovation and creativity is an intrinsic part of our increasingly global lives. A story, a piece of theatre, a stone circle or a song can expand those boundaries and take us beyond borders.
>
> To give you a quote from the Canongate Wall, Hugh MacDiarmid asked, 'Scotland small? Our multiform, our infinite Scotland *small*?'
>
> Our size is only limited by our imagination, our reach as extensive as our desire and capacity to explore.

It's getting a bit general now. That poem has been quoted a bit too often, and the point about it is that it is not a universal cliché about the value of Scotland and the imagination but that it refers specifically to the tragedy of Scotland's human loss, the Clearances, and what might be done if we look at the situation again. He refers to peat-hags not worked in living memory and small black-faced sheep, so he's referring to a local place where people who once lived and worked have been moved on, replaced by sheep. What he's saying is not simply that Scotland is infinitely possible through the use of the imagination, but that the worst aspects of the history of Scotland need to be taken into full account if we're going to do something about the condition that we're in now.

SANDY Yes, but it's still good to see MacDiarmid being quoted there – like Picasso, MacDiarmid was a member of the Communist Party – as well as a founding-member of the National Party of Scotland – so once again what Fiona Hyslop is saying here is that the poets and artists show us how to protest against what's wrong in the world, to want change, to want a better world. That's a brave thing for a Minister of Culture to say so boldly.

ALAN She also said this:

> Culture and heritage are not just the domain, in policy terms, of public agencies and authorities or private or third sector organisations. Culture and heritage are fundamentally about people and places and I believe it is our duty to ensure that everyone has the opportunity to access the arts and cultural experiences, regardless of where they live in Scotland.

SANDY This is the most encouraging speech made by a Culture Minister since devolution. It's particularly important too, given that it's taken the SNP Government several years to get their act together, but putting that to one side, it's been worth waiting for. The critical thinking needed to create a new framework for a long-term plan for the arts appears to be in place. It's now up to the arts community to keep a watchful eye on the delivery of all aspects of the plan. But we're talking politics as well as culture now and here's the question: Will the Unionist parties regard this as an SNP agenda and not as an agenda for the good of the arts in Scotland? In other words, if they were to return to power will they attempt to alter or dismantle what has been put in place?

ALAN And how will we underwrite the necessary arts in an independent Scotland? Will the Scottish Broadcasting Service support an orchestra as the BBC does? Will it support cultural television channels as France and Germany do? Will it have a cultural radio service like Radio 3?

SANDY And if the decline in quality newspaper circulation continues, will there be support for the quality press? If tabloid journalism, sensationalist red-tops and periodicals sustained by commercial exploitation are thriving, what will happen to first-class investigative reporting? How will informed critical opinion and reviewing be sustained in journalism? These are unanswered questions.

ALAN Will the SNP stick to Fiona Hyslop's promises? It's all fine words but it's politics too – and we need to hold all politicians to their responsibilities to the arts. That's our job. And it's the job of every responsible citizen of the new Scotland. And it won't go away. When I was in New Zealand, there

was a visit from the Irish President, Mary Robinson, and she said this, and it has always stayed with me. It should be emblazoned on T-shirts worn by every member of the Scottish parliament: 'The arts are the genius of your country, and education is the key with which you unlock the door.'

PART THREE

The Arts of Independence

Democracy, Education and the Arts in Scotland

THE QUESTION OF democracy depends on education and fair representation of the people in proportion to their number.

Education is important because democracy offers you choices and you need to know what you are choosing between. But the nature of education and the relation between education and democracy has changed since the 1950s. The Irish scholar Declan Kiberd makes this point with regard to that horrible international army of jargon-led, over-professionalised academics specialising in the works of James Joyce, when he says in *Ulysses and Us: The Art of Everyday Life in Joyce's Masterpiece* (2009):

> Many of them reject the notion of a national culture, assuming that to be cultured nowadays is to be international, even global, in consciousness. In doing this, they have often removed Joyce from the Irish context which gave his work so much of its meaning and value... The middle decades of the 20th century were the years in which the idea of a common culture was abandoned – yet *Ulysses* depends on that very notion.

So does all great art. Joyce described himself, Kiberd reminds us, as:

> ... a socialist artist and a believer in participatory democracy – that everyone, whether wealthy enough to have a higher education or not, should have equal access to this common culture. He would have agreed with R.H. Tawney's contention that 'opportunities to rise are no substitute for a general diffusion of the means of civilisation,' something that was needful for all, both rich and poor.

When Joyce was writing *Ulysses*, the world was only beginning to experience the possibilities of mass literacy and the emergence of reading libraries for working people. H.G. Wells's *Outline of History* sold more than two million copies when it was published in 1920. Just after the First World War there was a decline in the authority of church and state and an assertion that working people possessed innate human dignity, and democracy meant that anyone might enjoy Shakespeare. But after the middle of the 20th century, the idea of a common culture was to be generally replaced by the creation of specialist elites and democracy was

no longer seen as a sharing in common understanding and range of reference but rather a provision of access to those elite groups. So, Kiberd concludes, today, the aspiration is usually towards the inclusion of gifted individuals in the dominant part of the structure, rather than the revolutionary transformation of social relations.

This is very close to what was diagnosed by George Davie in his books, *The Democratic Intellect* (1961) and *The Crisis of the Democratic Intellect* (1986). Davie analysed the development and tendency to decline of the educational ideal of being a student of all the main branches of human culture, and the rise instead of categorical specialisation, which would deliver a world in which no-one talks to each other and there is no touching. Specialised expertise is necessary, but it must be grounded, earthed, in a democracy of human understanding, a general sense of what it is to be human. In his appreciation of Davie in *The Herald* (28 March 2007), Lindsay Paterson asked:

> Who, inspecting the details of our educational curricula, or the quality of our media, or the banality of our political discourse, could not feel acutely that Davie was prescient? But, by having taught and having written, he has also ensured that an older and more distinguished tradition would remain available to us – a belief that intellectual rigour, more widely practised than seems possible today, is democracy's only secure basis.

We want to see that tradition realised in an independent Scotland. We recognise the worst of what has been described here by Kiberd and Davie, and this is what we want to change. Because the current situation is exactly what *Ulysses*, and Davie, and all great art, oppose: a corporate stranglehold over universities and other educational and social institutions of all sorts, and a specialist stranglehold over Joyce and so many other so-called 'difficult' writers, poets, artists or composers. That's especially true in the world of the visual arts, where the elite groups are totally commercialised. That's what we would like to see smashed. Let's really blow that up for good.

How do we do that?

The first thing is to act according to your priorities, once you're sure of what they are, but modestly, silently, with cunning, and in exile from

the central powers, or senior management, or whatever authority is in charge. Make it evident to those you are among what these priorities are and how they can be realised in personal and local terms, not through ordination from on high. Use every opportunity the days bring. An open-ness to serendipity allows teachers and artists and writers and anyone, really, to renew styles and themes in every work, and in every generation. 'Cease to strive,' Leopold Bloom advises Stephen Dedalus. Or as Ed Dorn puts it, 'My motto is: / Achieve the inevitable!' It is not through 'growing the economy' or 'striving for excellence' or 'working for progress' that you get anywhere at all. Teaching is asking questions.

Why?

Democracy educates and education democratises. Otherwise, both fail. But education is flattened into league tables, and everyone who has forgotten how to teach goes into administration – in both senses!

Once again, Declan Kiberd reminds us of the relation between social transformation and artistic change, revolutions in form:

> Most writers believe that by changing language and style you may in time alter thought; and that by altering thought you may transform the world itself. The painters who worked alongside Joyce in Paris believed that they might yet challenge other media as exponents of the dominant visual form.

Kiberd says that they lost that battle to film, television and the music video – yet it is not true that they failed entirely. Kiberd says that Joyce issued a similar challenge to newspapers and didn't completely fail, and that is true. In any case, the challenge itself, in the case of any great artist, is not preposterous. Anyone who has been deeply engaged in the works of great artists is changed by that experience, because great art has things that matter to give us. All great art is on the side of humanity. The ideals of democracy in the social structures that give access to the arts must be effected for the arts to realise that gift, and for people to receive it.

And this is keyed to national identity.

Ralph Vaughan Williams, in his book, *National Music and Other Essays* (1963), says that almost all of the great 'classical' composers were essentially German or Austrian, so that actually, 'Mozart and Beethoven [were] nationalists just as much as Dvorak and Greig.' He speaks of himself as benefiting from Cecil Sharp's 'epoch-making discovery of English folk-song' thus aligning his own music with a rediscovered and regenerated

English nationalism. Within this nationalist flourishing of rediscovered traditions, Vaughan Williams says, when you are talking of difficult work, the democratic purpose of your address to all people may be enhanced, if you talk to people with respect for their full humanity:

> The people must not be written down to, they must be written up to. The triviality which is so fashionable among the intelligentsia of our modern musical polity is the worst of precious affectations. But the ordinary man expects from a serious composer serious music and will not be at all frightened even at a little 'uplift'.

This was at the heart of the development of an American idiom in poetry in the 20th century, from Walt Whitman to William Carlos Williams and Allen Ginsberg. Williams shared Whitman's belief, as written in the last sentence of the preface to *Leaves of Grass* (1855): 'the proof of a poet is that his country absorbs him as affectionately as he has absorbed it.' You could test that the other way, though: the proof of a country is that it absorbs its great poets as deeply as they have absorbed it. In Scotland, with (once again) one glaring exception, the country – through our educational curricula, through our mass media, and through our political discourse, has a lot of catching up to do. But said openly, who could resist? To paraphrase Allen Ginsberg's most lovely affirmation in Scottish terms, we might chime with him and Williams and Whitman and all great poets and artists anywhere, affirming a common humanity in any specific nation: 'In any case Beauty is where I hang my hat. And reality. And Scotland.'

But what is the reality of democracy in Scotland?

Even since Ginsberg's time, let alone Whitman's, the saturation of society by technology and mass media has had a transformational effect. It may be that the people of a country are less able now than ever to absorb and enjoy, to take to their hearts, the great works of major poets and artists, simply because they have less access to them through the media. Generations ago this was the case because of mass illiteracy and ignorance. Now there is much more widespread literacy and access to knowledge, but people are blocked from details and value by the mediating wall of conventional and formulaic cliché. Screen media is screening and information technology is misinforming. That's a rather pessimistic thought as regards the arts, but it has a parallel consequence regarding participatory democracy.

Ezra Pound, in his essay 'The Serious Artist' from *The Egoist*, in 1913, says this:

> The arts give us a great percentage of the lasting and unassailable data regarding the nature of man, of immaterial man, of man considered as a thinking and sentient creature. They begin where the science of medicine leaves off or rather they overlap that science. The borders of the two arts overcross.

Now we'd have to insist on 'man and woman' but the essence of what Pound is saying is true. So the question is, as with medicine, how do we make best use of that data? One of the vaunted glories of post-war Britain is the National Health Service. Are we as sure of our provision of the arts? In England in the 21st century, the NHS is being privatised, commercialised, sold off to the market economy. Scotland is trying to keep the egalitarian ideal of democratic health provision as a birthright. Isn't that just as important for the arts? So the question then becomes, at what point did the balance tip from seeing the value of the arts as humanly worthwhile, to allowing them to be at the beck and call of commercial priorities, market forces, the ethic of 'what sells is good'?

That ethic is opposed to democracy because it prioritises making money over human beings as thinking and sentient creatures. It endorses 'material' and denigrates or liquidates the 'immaterial' – to use Pound's word. But the 'immaterial' has value and purpose, it is vital for human well-being.

Michael Fry, in his history of Scotland 1815–1914, *A New Race of Men* (2013), admirably gives significant space to the arts – architecture, painting, literature, philosophy – as well as economics and social history. He sees them as essential in the stories of the people who have lived in this nation. When he comes to the popular fiction of the late 19th-century 'kailyard' writers, sentimental stories of small-town Scotland with inbuilt moral reassurance and sweet nostalgic warmth on every page, he recognises that there are depths and complexities in some of the work in this school, but he makes this important speculation: 'Perhaps for structural reasons, in the nature of the literary market rather than the quality of the literary product, Scotland was already being suffocated by the imposition of British norms,' and he says that this was to be another feature of the 21st century as well. Scott, Hogg, Galt and Stevenson, the major Scottish

writers of the 19th century, were not 'limited by any pandering to their readers.' They 'did not give us a static Scotland', as many 'kailyard' writers did. The great writers made fictions 'that they knew would challenge their readers, so these might out of the encounter change their ideas about their country. It was a high standard for successors to try to live up to, and the general state of Scottish culture did not always favour it – then or now.'

The purpose of writers and artists is not to manufacture comfort. As Pound says, 'the arts give us our best data for determining what sort of creature man is'. Man and woman. That data is valuable. Without it, your health will be bad and your weakness grow profound. So the arts are essential to democracy.

A fair democratic representation of the people depends on the number of people who vote in a constituency. All the constituencies in the United Kingdom deliver the vote for central government. In this structure, Scots will always be outvoted.

If you believe in the democratic unity of Britain, Scots will always be outvoted. Why should we oppose this? Because the cultural distinction of Scotland means that the people of Scotland have their own distinctive priorities. Who cares about these priorities? In the state structure of the United Kingdom, the people who live in Scotland and care most about Scotland and the lives of their families and friends and neighbours will always be outvoted. Always. Because in the United Kingdom there are around five million people in Scotland and 55 million people in England. The vote that put Thatcher in power was a result of functioning democracy. No-one in Scotland has an argument against that unless you believe there should be a separate state in which we can vote for whoever we choose, in Scotland. The vote that resulted in the government of David Cameron in coalition with the Liberal Democrats of Nick Clegg was a result of democracy in the United Kingdom. No-one in Scotland should feel anything but fairness in that unless you want a separate state in which we can vote for a government of our own, made up of people who live in Scotland, who care about Scotland and the people who live in Scotland.

That is where we are, before independence. Scotland will always be outvoted in the United Kingdom. So questions of national representation are crucial. Cultural distinction defines democratic representation. It is for that reason crucial in the education of people.

In a democracy, politics provides society with the most accessible form of that dialogue with itself and the wider world which is the heart of a culture. A vigorous politics, intellectually and morally equipped to identify and analyse the key challenges of the present day and to develop feasible responses, is essential to a healthy culture.

Stephen Maxwell, *Arguing for Independence* (2012)

The conditions of management and money, the gulf between rich and poor, the cult of Senior Management, in the banks, in universities, in art schools, in the National Health Service, in the Westminster government and local councils, in the organisation known as Creative Scotland – all these are a direct result of this 'democracy' of the United Kingdom.

This is not only to do with achievement and geography but also potential and need. The need for an independent Scotland is also the need for democratic representation in Scotland, and this applies in terms of recognition in nine areas of Scotland. Each of these areas has its own cultural distinctions that require sustenance and development.

On the matter of democracy and the value of the independent state, the Cambridge scholar Professor John Dunn has said this: 'the label of democracy' not only affirms the clear duty of the state to provide its citizens with practical advantages:

It also expresses symbolically something altogether different: the degree to which all government, however necessary and expeditious, is also a presumption and an offence. Like every modern state, the democracies of today insist on a very large measure of compulsory alienation of judgement on the part of their citizens. (To demand that obedience and enforce such attention is what makes a state a state.)

He goes on:

What we mean by democracy is not that we govern ourselves. When we speak or think of ourselves as living in a democracy, what we have in mind is something quite different. It is that our own state, and the government which does so much to organise our lives, draws its legitimacy from us, and that we have a reasonable chance of being able to compel each of them to continue to do so. They draw it, today, from holding regular elections, in which every adult citizen can vote freely and without fear, in which their votes have at least a reasonably equal weight, and in which any uncriminalised political opinion can compete freely for them.

John Dunn, *Setting the People Free: The Story of Democracy* (2005)

The United Kingdom is exactly this kind of democracy. As part of the United Kingdom, Scotland is not. In order to become a democracy of this kind, Scotland must govern itself as an independent state.

The Third Dialogue:
21st-Century Kulchur

ALAN Let's start as if from a *tabula rasa* scenario – imagine a society, in its entirety, a good society, all working well, economy active, trade healthy, imagination lively, criticism bristling, festivities regular, public discussions taking place in open and recognised forums –

SANDY All right, but now here comes the question. In this scenario, what kinds of work are important? Who is engaged in what sorts of activity that keeps the whole thing moving and vital?

ALAN There are three overlapping but different kinds of activities that are always essential, throughout and beyond all economic activity, in any society: these are the activities of poets, politicians and philosophers. These are the activities that create everything worthwhile in any society. Neglect any one of them, and neglect the balances between them, and neglect the dialogue and openness and respect that has to be there between them all, and you invite disaster, one way or another. No society has all these things in balance perfectly or in perpetuity, but you have to begin with a working under-standing of how they relate.

SANDY What do you mean? You'd better explain yourself.

Poets, Philosophers and Politicians

ALAN The triumvirate of people whose work matters most is this: poets, philosophers and politicians. There you have the three most essential categories of work that matter in any society. So long as they are not kept separate and exclusive, over-professionalised to the point of mutual ignorance. And so long as you keep the terms open and flexible. Otherwise, you would have total compartmentalisation, and water-tight compartments are only good for sinking ships.

Before you tell me that's ridiculous, that nobody reads poems, nobody likes politicians, and nobody cares about philosophers, hold on and think about it this way.

By 'poets' I mean all artists, what the business people call 'creatives' – writers, painters, architects, people whose creative intelligence is given to

making articulate works of the imagination. But also, more generally, *anyone who can think creatively* in any situation or profession.

By 'philosophers' I mean all the thinkers, deep thinkers as well as strategists, historians as well as new ideas people, *people who think things through*, and can advise accordingly. Insight and inspiration, spur-of-the-moment thinking works here as well as in any of these three categories, but philosophers have to think things all the way through.

By 'politicians' I mean the elected representatives, the government, but also councillors and *anyone involved in putting things into practice*, making practical use of the creative and thinking work that the others are doing. These are the people who make things happen. They take the actual decisions, in the real world, so to speak, or more accurately, in the material world. Politicians have their own professional priorities but it would be utterly wrong to see them as absolutely separate from the work of writers and artists and philosophers who can tell them so much about what their job is for.

The politicians are responsible to the poets and philosophers, not the other way around.

And all three groups are responsible to people generally. All kinds of people, in all walks of life, and in every part of the economic structures that sustain the workings of society.

And *every single person* has some aspect of these three ways of working in their character, and in what they do, for themselves, and among others, to varying degrees. To some degree we are, each one of us, poetic, philosophical, political. And every single person is responsible to everyone else. We are all citizens. No exemption. No privilege. No bonus payments for being a citizen.

SANDY OK, so if it were possible to construct a society from scratch I imagine we would try to include measures that would minimise the huge disparities of wealth that exist at present, try to sort out problems of bad health, sexual and racial and religious discrimination and so on. I doubt if we'd consult Margaret Thatcher's good book on society, but we could do worse than to refer to those old Enlightenment values of freedom and of morality, not handed down by God, but discovered by ourselves, by dint of reason. Regarded by some as old hat, these remain ideas that repudiate inherited wealth, superstition, racism and make possible greater equality for the downtrodden. We need to abandon cynical scepticism when it comes to discussing how to improve our lot. All of this should be at the heart of the independence debate because independence does offer an opportunity to create not only a new nation, but a new society. That's an exciting and challenging project for the future, but it's also one which seems to frighten

and intimidate. Change and the fear of change looms large. Why don't we listen to Paula Rego when she says that 'all change is good because it takes away the fear of change'. If we could do this then the coming together of culture and politics you've been talking about, the combination of the poet with the philosopher and with the politician might really happen.

ALAN It isn't utopianism at all to think of these things as realistic propositions. There are those who have called such notions idealistic or feeble, but I think you're right. Cynicism is the enemy.

SANDY There are huge obstacles of course, given that we seem to have forgotten what a good society is, what good government should consist of. We have all, actively or passively, succumbed to the worship of wealth and celebrity, while endorsing social indifference. Tony Judt described this process as follows:

> Something is profoundly wrong with the way we live today. For 30 years we have made a virtue out of the pursuit of material self-interest; this very pursuit now constitutes whatever remains of our sense of collective purpose. We know what things cost but have no idea what they are worth. We no longer ask of a judicial ruling or a legislative act: is it good? Is it fair? Is it just? Is it right? Will it help bring about a better society or a better world? Those used to be the political questions, even if they invited no easy answers. We must learn once again to pose them.

Is this possible? And if so, how can it be done? Recent evidence suggests that for many Scots, materialism is what counts. Our view of ourselves as upholders of an egalitarian tradition may be a thing of the past. There is a new commonality across the UK as a result of Tory marketisation dogma which since Thatcher has reshaped much of Britain, including Scotland. The public realm has been undermined, the national imagination deadened and with it the idealism needed to re-build social democracy in an independent nation.

ALAN Then we have to learn all this again, starting from the ground, working up. In his book *Windmills in Flames: Old and New Poems* (2010), the English poet Tom Raworth has a poem entitled 'Art is the Farthest Retreat from Boredom' which summarises something essential about the work of art, its value in life and the inexplicable, incomprehensible meaning it gives us. This poem begins to draw to a close with these two lines:

death is so obvious
what does not exist is eternity

Pause on that then consider the imperative last lines of the poem:

any thing can do nothing *but*
prove it because we are now

Maybe it looks like the old cliché – *carpe diem*, seize the day, live for the moment – but it is not simply that. It is rather the sense that your life has value because we are literally history. We can be flippant and share jokes and humour but this is what we are, all we know depends on how we value it. This is crucial: we prove who we are and what we are and everything that we can make possible in the face of inevitable mortality, precisely *because* 'we are now'.

The Machinery of Trivialisation

SANDY Modern technology brings its opportunities along with its risks and liabilities, and we need to discern what the differences are between them.

> The great advances in technology and communications media in our time have, in many ways, led to a general tendency to be satisfied with slogans, which are not just poor substitutes, but aberrations of the ideas they claim to represent. This shorthand version of knowledge, when accepted at face value, can lead to mental laziness. Information is presented on television, and even in many cases on the Internet, in a way that does not allow enough time for reflection and comprehension, thus turning powerful and potentially very positive inventions into the ideal tools for the manipulation of the general public. I sometimes wonder whether a Hitler or a Goebbels would have been able to achieve such popularity without the help of radio and newsreels. Thanks to the development of new technology, it is easier and faster than ever before to find information about almost anything, but this information is accepted in a passive way for the most part and there is no room for educated discussion among all these superfluous facts, even on the Internet. Discussion requires thought – the formulation of ideas – and an idea needs time to be developed and to express itself.
>
> Daniel Barenboim, *Everything is Connected: The Power of Music* (2008)

Daniel Barenboim notes the increasing tendency to be satisfied with slogans. I remember on my first visit to a communist country – the GDR in 1967 – there was no advertising, but instead, everywhere one went, there were slogans. 'Art is every second heartbeat of your life' sticks in the mind.

None were quite on the inspired level of 'Guinness is good for you!' Yet how many times has the phrase 'The War on Terror' been used to browbeat us into accepting unnecessary limitations on our civil liberties and as an explanation and excuse for illegal and pointless wars? Now that we've adopted the bureaucratic mindset of those former communist countries, we too deal in the language of slogans. Art Schools and Universities specialise in them, as does (or did, I hope) Creative Scotland. Universities are 'great places to study and invest in' or they are leading exponents of 'the knowledge economy'. Creative Scotland is none other than a 'Cultural Champion'. Now, just how many people would agree with that? It may well be that most folk can have a laugh at such inanities, but at the same time there are just as many who swallow the lot, hook, line and sinker. What we're talking about is a serious erosion of values, of truth if you like, all replaced by mindless boosterism.

ALAN The trivialisation of the arts in the contemporary world is especially serious in the context of information technology and online communications. There are enormous opportunities of course but the problems are real. The online forum and the nature of what they call internet democracy is massively prominent in all forms of social communication today, for this and the coming generations. The public sphere is the cybersphere. But as Marshall McLuhan said more than half a century ago, the medium is the message – or more accurately, the medium defines what can be said within it. It appears that the thousands or millions of people who are in contact through this medium can be galvanised to go to political meetings, rallies, marches, to learn about a venue, a date, a public event. Or maybe just to find out about a party going on. That's fine. But if you need a medium which deepens respect, extends knowledge and the desire to know, confirms the assets of peace – languages, cultures, differences, and articulates the message in such a way that it demands your respect for these things, insists that you do not take them for granted – then maybe the worldwide web isn't very good at that.

SANDY The extension of information technology is precisely that, isn't it? It's about information – not deep understanding, care, or even love. It's about what you can find out, if you know where or how to look. And it's about self-affirmation, even self-indulgence. It's about spectacle, too, rather than anything like the hard work of learning.

ALAN There was something I read somewhere acknowledged to *The London Morning Post* of 1923: 'The film is to America what the flag once was to Britain. By its means Uncle Sam may hope some day, if he be not checked

in time, to Americanize the world.' Information technology looks like the means by which multinational corporations may hope to globalise the world. The only real defence against that trend towards global conformity is national identity, complex meanings, a defence of difference. Then there is this truth that Edward Dorn came out with in his 'Statement for the Paterson Society' (1960): 'Culture is based on what men remember, not what they do, fortunately.'

SANDY So how does our society encourage us today to remember the things we need to remember? The short answer is not at all. Let's take the example of the Blair/Brown New Labour project – suddenly the past was irrelevant, including the history of the Labour movement. That was an embarrassment, a millstone round their necks. The 'new' had to be cultivated at all costs. A spurious 'modernisation' became the goal, without any reference to history or past experience. Hence the 'own goal' of Iraq, to give only one example of this kind of short-sightedness. This was an elimination of history. Did Blair ever talk about the importance of art and culture, did he ever visit the National Gallery, the National Theatre? What did he leave behind? In his recently-published *The Last Diaries*, Tony Benn comments: 'I feel bereaved that the Labour Party has gone that wrong. It has died. It's been assassinated by Blair and Brown.'

ALAN If the machinery of trivialisation is endorsed by Prime Ministers then that sends out a message – the wrong message! Sometimes, though, you get a surprise that makes you question what most folk take for granted. On 2 January 2014, the morning BBC Radio 4 news programme *Today* invited the popular singer P.J. Harvey to be guest-editor. For the 'Thought for the Day' item, she invited Julian Assange, famous as the initiator of 'Wiki-leaks', an online resource disclosing information that would otherwise have been kept concealed from the public. This is part of what he said, transcribed from http://www.bbc.co.uk/news/uk-politics-25573643:

> 'All men by nature desire to know.' Aristotle, when he wrote this, was saying that the thing that makes human beings different from other creatures, the thing that defines us, is the pursuit and acquisition of knowledge. This is not just to say that we human beings are curious creatures; it is to say that our ability to think about and to act on the world around us is bound up with our ability to know it. To be alive as a human being is to know in the same way as it is to have a heart that beats.
>
> We all understand this in mundane ways. We understand, for instance, that part of being a fully independent adult, making choices about life, is

learning about the world around us and informing our choices with that learning... The powerful throughout history have understood this. The invention of the printing press was opposed by the old powers of Europe because it spelled the end of their control of knowledge and therefore the end of their tenure as power brokers. The Protestant Reformation was not just a religious movement, but a political struggle: the fight to liberate hoarded knowledge through translation and dissemination... Knowledge has always flowed upwards to bishops and kings, not downward to serfs and slaves. The principle remains the same in the present era.

Now, that's a general truth, and there are immediate practical applications in terms of the choices people have access to through what we remember or what we can discover, and that's always relevant to the idea of a working democracy. But that general truth also has applications in terms of the many ways the arts give us knowledge of humanity, the value of our cultural life.

SANDY This is how the English novelist Jeanette Winterson views such a diminution of our cultural life. In a lecture she gave on the subject, 'What is art for?' in 2011, she describes how society today responds to art:

Nobody doubts that hospitals and schools must be paid for by all of us. Mention art, and the answer seems to be that it should rely upon the marketplace: let those who want it, pay for it. Art is specialised, particular, elitist and probably bogus. In Britain, a few old masters, Shakespeare and Dickens, Mozart and Puccini, are enough to feed the general interest in the arts. Modern art has become a media circus: a money-driven, prize-hungry extravaganza, dependent on marketing and spin, which may leave the public with a few extra names it recognises, but that makes everyone cynical about the product. The word gives it away: product. Art is being treated as a commodity. We doubt that it is special. Dead artists belong to the heritage industry. Live artists belong to the PR industry. It may be that capitalism will be as successful with art as it has been with religion, absorbing it to the point of neutrality. We can muzzle the power of art in all sorts of ways – destroying or banning it is too obvious. A favourite gag is to familiarise it so that we no longer see it (Constable), or to sentimentalise it, so that we read it but do not allow it to read us (Dickens). Even better if we can just watch an adaptation on TV.

I presume she's not just speaking about conditions unique to the England of today, but addressing what we might find elsewhere in the UK and beyond. I know this is part and parcel of a general malaise that we can't entirely

escape from, but are we to be stuck forever within this view of culture, or can we do better in Scotland? You've described a 'democratic strain' in Scottish literature for example, which might help people to engage with art and culture in a much more positive way.

ALAN Aye. Maybe the most obvious example of recent years is Irvine Welsh. The popularity of *Trainspotting*, the book in 1993, and then the film in 1996, and the whole writing career that followed that, made Irvine Welsh probably one of the most widely-read Scottish authors since Burns, or at least since Nigel Tranter or A.J. Cronin. And Welsh's work both in fiction and in his engagement with social morality and the political culture of Scotland is undeniably left-wing, democratic, socialist or egalitarian in a broad sense, and most recently, out-and-out in favour of independence. There's a lovely television interview from 20 April 2012 where he's introduced by the English TV *Newsnight* front man Jeremy Paxman, who's well-known for his various Scotophobic asides, describing Burns as 'no more than a king of senti-mental doggerel' (quoted in *The Telegraph*, 14 August 2008), and Paxman introduces him as 'Irvine Walsh' as if, it seems to me, trying to provoke a response. Welsh simply ignores that, with total equanimity, and goes on in a completely cool demeanour to dismiss all the pretentions of the British imperial legacy as well past their sell-by date. Paxman's opening question, again, trying and failing to be provocative, is: 'Now, are you surprised to find yourself a nationalist?' Welsh replies:

> Yeah, I don't really see myself as a nationalist, I see much more the Union as being in a kind of secular decline. The Union was very much conceived to facilitate British imperial expansion, British industrial expansion, sustained by a kind of welfare state and the *ésprit de corps* of two world wars. All these things no longer exist. They've gone. So I just don't actually see what's driving the Union, what's holding it together.

Challenged by the Labour MP Tristram Hunt, Welsh says that he does not think that the cohesive whole of Britishness is served by the political Union any more:

> People feel in Scotland now that it's not so much Britishness that they're against but it's the actual concept of the UK and the actual Union. The two political cultures have become very divergent... England's a multicul-tural, post-imperial nation and it's trying to work out this identity, this very complex identity. Scotland is much more mono-ethnic. It's a very different society that's developed in a very different political culture. I just don't see any kind of connection there.

Paxman refers to the famous diatribe from *Trainspotting* about Scots being colonised, with the main character Renton declaring that he hates being Scottish; he then asks Welsh: 'Supposing that Scots decide not to go for independence, that self-loathing is going to get really acute, isn't it?' Welsh replies: 'I think it will. I think people realise that it's not really an option now.' When Hunt says that one of the strengths of the Union is the stature of the United Kingdom on the world stage, Welsh responds: 'When you look at some of the decisions we've made in foreign policy, if you look at Afghanistan, where so many people were against that war, I don't think you can pick these things as being pluses.' Hunt admits that he thinks English people themselves need space to consider the complexities of Englishness. Welsh says he doesn't think that's possible within the political construct of the United Kingdom: 'People have moved on from that in Scotland. I just sense that people have rejected that model.'

SANDY That interview may have been a rare example of two opposed views being equally balanced.

ALAN Except that the bias of the medium itself is also necessarily part of the story. Welsh's demeanour was cool, but the patrician tones of Paxman and Hunt were favoured by the medium itself. If you were going only by the surface, they would seem to have been on the winning side. Generally, television, with its front men and front women, announcers, and editors, the way programmes are presented and put together, what you see and hear at any time of day or night, are not impartial. There are other examples from television programmes like *Question Time* and comedy panel shows where prejudicial contexts and declarations and decisions that arise from and endorse the Anglocentric establishment are very evident. But there is something more important than any of that. In the context of the dialogue I was just quoting there, Irvine Welsh's argument arises from a tradition in Scottish literature that goes right back to David Lyndsay and further. This is a distinctive theme in the whole story of Scotland, described by Marshall Walker as 'the democratic strain':

> Other symptoms of the democratic strain include the socialism of Lewis Grassic Gibbon in a 'world rolling fast to a hell of riches'; 'the dispensation of the poor' in the mind of Sorley MacLean and his redefinition of Calvary in terms of 'a foul-smelling backland in Glasgow' and 'a room in Edinburgh, / a room of poverty and pain'; Bill Bryden's sympathy for a moderate shop-steward in his 'Red Clydeside' play, *Willie Rough*; the 7:84 Theatre Company's attack on capitalist exploitation of Scotland in John McGrath's *The Cheviot, the Stag and the Black, Black*

Oil; the copies of the *Daily Worker* and the dove of peace, and the poster of Paul Robeson, which a pregnant woman thinks she had better hide when a social worker calls to check her suitability for a housing waiting list in Jackie Kay's poem-sequence, *The Adoption Papers*, 'Chapter 3: The Waiting Lists'. A democratic manifesto is implicit in the Scots of Robert Garioch and in Tom Leonard and James Kelman's use of Glasgow *patois* to cut through to the real lives of ordinary people and in doing so to protest, as Gaelic could never quite do, against the bending of a country's mind by 'a police *régime* of the signifier', to co-opt a phrase of Edward Said's, that is, by the undemocratic authority of a language whose artificial and ossifying 'correctness' derives from the bullying power of a remote parliament and a chimerical throne.

Marshall Walker, *Comrades and Vexations: Some Objects in a Life* (2013)

That is what's behind Irvine Welsh's sense that people in Scotland inhabit a very different political culture from people in England.

SANDY But democracy isn't easy. Egalitarianism isn't easy to bring into effect. Throughout the 20th century, both the far right and the far left despised democratic procedures. Despite all the terrible crimes of the Stalinist period, work and security were preferable to democracy for many people in the Soviet Union. And I would guess that in China today, millions will be delighted to set up a business and make a profit without worrying too much about the absence of democracy. It's not easy to export either, as the US has been reluctant to admit and slow to understand. The 'Arab Spring' raised hopes for the furtherance of democracy, but these hopes proved illusionary. In Europe, we can say that it took until 1945, and two disastrous wars, before Germany became a democracy. In 1945 there were only 11 democracies. There are now 105, which suggests that democracy is a process too. A hundred years ago, women were denied the vote, London was the imperial capital par excellence, and many Scots hoped that a Home Rule Bill would pass through parliament. Aye, it's not easy.

The Work of Democracy

ALAN Making democracy work is difficult. The world of the business model is the here-and-now and succeeding tomorrow. In the business world, the past is only important for utilitarian purposes. But this is false economy. If you don't know your history, as has been said time and time again, you

repeat your mistakes. Think of Afghanistan. Think of so-called innovation that business trumpets and that really doesn't exist. Innovation in business doesn't really exist. It's simply new forms of cheating, breaking the law for selfish gain, left, right and centre. And there is also the question of a modern constitution, a written constitution for a democratic Scotland. How will an independent Scotland put together a new constitution? Will the government take charge and appoint a body of lawyers and former politicians to carry this out? That would certainly be the way things were done in the past, but is that good enough for the future?

SANDY We need to move beyond the committees of the great and the good. We need to both imagine and put into practice new ways of political participation and there are many different examples to draw upon. The Icelandic constitutional model saw a small country rebuild its democracy post-banking crash, with the people of Iceland taking part in the writing of a new constitution and using the internet to do so. There is the Australian National Convention which saw 1,000 citizens meet and deliberate on ten national priorities which the government had to respond to. It seems reasonable to suggest an independent Scotland would offer opportunities of this kind, enabling individual citizens to make meaningful contributions to the national good. What better way to involve the people of Scotland in such an important national project?

Lesley Riddoch's examples from the Nordic nations are useful here. She points out that the average tax-raising Norwegian council is truly local with just 11,500 residents (162,000 in Scotland) – that's why one in 80 Norwegians stands for election (there is one in 2,701 in Scotland). In Switzerland, they have national referendums on important issues. These are held regularly, and voting is compulsory. Once again, this is one of the more positive virtues of a small nation. And we still cling to the notion that British democracy is way ahead of the rest of the world!

ALAN Perhaps the central defect of modern democracy, the price we pay for its virtues, is the fact that much of the electorate is largely unacquainted with anything more than the elementary workings of modern societies and political systems. In the absence of knowledge, people tend to fall back on folk wisdom and urban legend, nearly all of which is conservative. There's a wonderful, obscure little book called *Them and Us in Literature* (1975) where Paul O'Flinn remembers his kids bringing home a book from the library. He settles down to read to them. It's about a goldfish. He's bored out of his mind in a garden pond swimming round the same cement gnome every day. So one night he pops into the overflow pipe, down the drain and

out to sea in search of adventure. His mum and dad are against it and prefer to stay at home watching *Coronation Street*. The sea is a disaster: cold, dark, salty and full of miserable crabs. Tears roll down the goldfish's face. Then one day he finds himself swimming past the end of a familiar drain. Up he goes, along the overflow pipe and pop! Back into the old familiar little pond. Mum and Dad are overjoyed, the goldfish never grumbles about boredom again and lives happily ever after. Harmless in itself, maybe, but how often have we heard the same message: Your world and your position in it might seem dismal but they're as good as you'll get so there's no point in doing anything about it. If you do try and improve it then either you're wasting your time or you'll only make matters worse. So leave things as they are, be grateful for what you've got, do as you're told, and in the end you'll learn to love it all. P.S. Don't think too deeply about anything – and do not vote for independence!

SANDY In the UK, the absence of knowledge and self-confidence makes the construction of rational policy on, say, crime, immigration, welfare, or the EU, almost impossible, not to mention constitutional reform, or new relationships between nations. This helps to explain why so many Scots are unable to make up their minds about the future – why they might 'play safe' and vote NO. And all of this is food and drink to the 'popular press' and something that all of the mighty 'Barons' from Beaverbrook to Murdoch have ruthlessly exploited. That's why Prime Ministers and Leaders of the Opposition are so keen to get into bed with them.

ALAN But the arts – literature, painting, music – all the arts enhance knowledge and self-confidence about our humanity, and the potential we have for changing things for the better. John Berger talks about this at the end of an essay called 'The Moment of Cubism', but he describes it as the time of precipitation, just before the start of something we cannot imagine, like the orchestra at the beginning of the first movement of Beethoven's Ninth Symphony. Imagine listening to that for the *first* time. Berger says:

> The moment at which a piece of music begins provides a clue to the nature of all art. The incongruity of that moment, compared to the uncounted, unperceived silence which preceded it, is the secret of art. What is the meaning of that incongruity and the shock which accompanies it? It is to be found in the distinction between the actual and the desirable. All art is an attempt to define and make this distinction *unnatural*. Art helps us to refuse the inadequacy of the given, and to want better... The only inspiration which exists is the intimation of our own potential.

SANDY So the question is how do we recognise that potential more widely and help to realise it? How do we increase participation in a modern democratic society? We have to try to understand how politics work because we can't leave politics to the politicians. They won't do anything that really needs to be done especially if opinion polls suggest it will be unpopular. But how can we make an effective intervention in political matters? How do we gain access to politicians, for example? Is it really possible for any of us to challenge the Chancellor of the Exchequer on economic matters? Is it possible any more for a working-class man or woman to be a leader of the Labour Party? This has high costs in terms of time and effort, trying to get to grips with mountains of legislation, specialist committees and all the rest of the machinery of government. It's a tall order, but more of us need to try.

ALAN Is there any kind of cultural dialogue that ordinary people take part in across the board? I wonder if there is a difference in this respect in England as opposed to Scotland. If there is, maybe the difference is in a sense of intellectual responsibility. In Scotland, the relations between people, artistic arbitrageurs and artists and writers and educationalists are intrinsically different from those relations in England. As we noted, one theme that persists in Scottish literary history is that of the idea of a common humanity beyond economic hierarchy or political manoeuvring. It may be a myth and seem hopelessly idealistic or fanciful, but it is grounded in realities of social expectation that are real and worth trying to keep in mind.

SANDY There is a continual clash between conservatism and stagnation and experimentalism and the new. The dead hand of oppressive authority is always descending upon the imagination.

ALAN It's the old conflict between chaos and order, isn't it? Shakespeare's comedy affords the most familiar example of this. When Statesmen and Officers of Law make their attempts to rule and order a world of unpredictable desires, we know the course of love will overturn their pious assertions. Shakespeare's festive comedy is a happy recognition of holiday in nature and release from the 'workaday' world. Spring becomes Summer. But it goes deeper. In the comedy of *Twelfth Night, Love's Labours Lost* and even in *A Midsummer Night's Dream*, the most wonderful celebration of love and love's victories, there is always a sense that *if* the wrong road had been taken, *just* underneath or above what's happening, a much more dangerous and probably hostile nature is waiting to erupt in volcanic upheaval or torrential downpour. The comedies are never too far away from the tragic potential inherent in them. In *Julius Caesar*, Brutus notes the lack in himself of Antony's 'quick spirit' and 'gamesomeness'.

This alerts us to qualities that are essential in the full, human universe Shakespeare's plays inhabit. You need this flexibility and openness. You need to be aware of ambiguity and relativity, and these things are always opposed by the necessity of ordering. And yet, the quest for order and the reach beyond the single, solitary self, are equally essential. Such complex contradictions might lead to festive comedy, but they might also lead to tragedy. High summer's plenitude *must* give way to autumn's withering and the darkness and death of winter. So the arts, in all their various ways, engage us in and celebrate our way through the human truths just noted. Without them, we are too easily tricked into the extremes: Apollo's ordered universe, stultifying, suffocating, dead, or Dionysus's drunkenness, dance, chaos, tearing us all apart. Here's the task: find a way through. In Joseph Conrad's novel *Lord Jim*, a character named Stein notes the ambivalent closeness of comedy and tragedy and offers his answer and advice:

> 'Yes! Very funny this terrible thing is. A man that is born falls into a dream like a man who falls into the sea. If he tries to climb out into the air as inexperienced people endeavour to do, he drowns – *nicht war?* No! I tell you! The way is to the destructive element submit yourself, and with the exertions of your hands and feet in the water make the deep, deep sea keep you up.'

This is not simply surrender: great exertion is required. But a kind of submission must also take place, a recognition of the ambivalence of destruction and creation. As Milton's Satan puts it, 'All is not lost'.

SANDY Thus arises the idea that all artists have got to be creative troublemakers, trying to make it new and destroy the old. Yet we know this is a false dichotomy. Art is living, and in its life it conserves the best and most vital in the business of being human. There is a radical failure of imagination in the idea of impossibility, in the lack of optimism in the cynical sentiment. No, we can't do that. This is what we oppose. When Nicola Sturgeon says we can overcome child poverty, the optimism of possibility, the determination to change things for the better, is present and clear and held between the real and the imaginary in the most practical of promises. In this promise, the Union can only deliver and redeliver the past. Independence is about what we can do in the future. Yet in Scotland today, this promise is met with disbelief, with incredulity. That a government can think in such terms and with such positivity has become alien to us. 'They're lying, that cannae happen here!' will be the knee-jerk reaction of many.

ALAN Can we prove this? How can we demonstrate potential in actually changing things, create a world of better architecture, better social conditions, better health and education. Such things cannot be grounded in free market capitalism but arise from social vision and the inter-relation of the hierarchies of power.

SANDY There's plenty of evidence. There is a lot we can prove. Think back to the Scottish Enlightenment when a new set of questions were asked of nature and science leading to real improvements in agriculture, transport, medicine, engineering, the development of industrial technology. The list is endless. And let's look at examples from elsewhere. In the newly independent republic of Finland, for example. The Finns couldn't have chosen a worse moment to declare independence. There was a civil war, accompanied by famine in the aftermath of the First World War. When Alvar Aalto began his career as an architect the country was unstable both politically and economically, with the building industry at a low ebb. Aalto was quick to grasp that the timber and forest industry could supply the materials for an architectural revolution. From the mid-1920s to the mid-1950s he designed a series of buildings – worker's clubs, hospitals, town halls, churches, newspaper offices, pulp mills, university campuses – which transformed Finland and placed Finnish design and architecture on the world stage.

ALAN Yet many people persist in denigrating the Scottish Parliament building – one of the most significant new architectural structures in 21st-century Europe – because of an over-run on the initial budget thanks to incompetence within the civil service. Putting this into perspective is rarely considered and the notion is now widespread that Scotland is somehow or other incapable of realising anything big and important. In other words we won't be able to govern ourselves.

SANDY Again, we should look elsewhere to try to gain a better understanding of the difficulties involved. The new Wembley stadium in London didn't appear on time or on budget. There's a problem right now in Berlin with renovation work on the Staatsoper, two years behind schedule and with an over-spend of nearly 100 million euros. Not to mention the Amsterdam underground project which has been 'frozen' after the collapse of an entire street of historic buildings. The cost of completing the job has risen by hundreds of millions as a result. And it should be added that both the Germans and the Dutch have unrivalled reputations as constructors and engineers. Big engineering and construction projects the world over are always susceptible to unseen events, no matter who's in charge.

ALAN But there are exciting examples of positive change all over Scotland where better architecture, imagination and social vision combine.

SANDY Let's take what are called 'Maggie's Centres', the wonderful legacy of Maggie Keswick, who after her depressing experiences as a cancer patient attending NHS clinics, felt compelled to act. Her friendship with several of the great architects of our time has resulted in a unique concentration of Maggie's Centres across Scotland. She insisted that the Centres be places where people feel at home and are cared for. Frank Gehry, who designed the

Dundee Centre, said he had a dream in which Maggie chastened him for being too fancy. His building, which some think resembles a small Scottish croft, proves that cultural imagination, combined with individual initiative – the Centres are all fully independent of their sister hospitals – can make things better.

Here's the evidence. This is only one of hundreds of examples, large and small, that offer proof of the potential of culturally inspired change across Scotland. Dundee will be transformed in the next decade and the Commonwealth Games in Glasgow will surely prove inspirational for years to come. If we can demonstrate potential then others will follow.

Think about the current debate around our abandoned city centres. Lots of talk but no action. There are dozens of unused buildings everywhere. Why don't we establish Houses of Culture in every town centre in the land, open to everyone, from nursery children to old age pensioners? There they would meet with artists, writers, composers, dancers, actors, and so on, on a daily basis. Classes would be held and participation encouraged at all levels. Everyone would have a real introduction to culture and the role of the arts and if we really believe that art can transform lives and help with the development of human beings, we should make this a priority.

ALAN There will be those who say, 'Why don't we do this now?' Independence is merely a distraction, an excuse for putting things off. But the kind of lasting transformation and change that Scotland needs is long term, spanning the next century or so. The case for independence isn't the same as some short term election pledge. It's way beyond that.

SANDY The English philosopher Roger Scruton has defined English nationalism as something very separate from the European Union, but ironically enough, in doing so he provides an excellent theoretical case for Scottish independence.

ALAN I doubt whether he was aware that what he was doing could actually be applied to Scotland.

SANDY Perhaps not, but the family, or the clan, provide a basis for a larger unit, such as a nation. It also links the work of democracy with nationalism. That's the crucial thing.

> Should countries be more like families?
>
> In families, people often get together to discuss matters of personal concern. There will be many opinions, conflicting counsels and even factions. But in a happy family everyone will accept to be bound by the final decision, even if they disagree with it. They have a shared investment in staying together. Something is more important to all of them than their own opinion, and that is the family, the thing whose welfare and future they have come together to discuss.

For Scruton, the family is an essential component of identity. It's the vital human structure that supplies a relatively stable equilibrium, even when opinions change and conflicts happen. The model of the family creates a kind of equilibrium that can supply the necessary give-and-take of argument, so that the foundation creates the possibility for compromise and rational engagement in discussion. It defuses the tendency to dictatorship – or at least it makes sure that dictatorial power is not the norm. He goes on to say that this applies in politics as well. Freedom of speech, dissension or disagreement are all based on the idea of a shared identity, what Scruton calls 'a first person plural, a "we"' and it's this plural identity that helps us to accept each other's opinions or desires, even when we might disagree with them. He goes on:

> Religion provides such a first person plural. I might define myself as a Christian or a Muslim, and that might be sufficient to bind me to my fellow believers, even when we disagree on matters of day-to-day government. But that kind of first-person plural does not sit easily with democratic politics.
>
> In particular it does not accept the most fundamental disagreement within the state, between the faithful who accept the ruling doctrine and the heretics who don't. Besides, modern systems of law are defined by territory and not by doctrine. In Egypt it is the law of Egypt that you are bound to obey, not the law of Turkey or Greece.
>
> Hence the need for a national rather than a religious 'we'. A nation state is the by-product of human neighbourliness, shaped by an invisible hand from the countless agreements between people who speak the same language and live side by side. It results from compromises established

after many conflicts, and expresses the slowly forming agreement amongst neighbours both to grant each other space and to protect that space as common territory. It depends on localised customs and a shared routine of tolerance. Its law is territorial rather than religious and invokes no source of authority higher than the intangible assets that its people share.

All these features are strengths, since they feed into an acceptable form of pre-political commitment. Unless and until people identify themselves with the country, its territory and its cultural inheritance – in something like the way people identify themselves with a family – the politics of compromise will not emerge.

ALAN Scruton is especially fastidious and perceptive when he goes on to ask why the experiment in 'federal government' led to 'an unacceptable empire in Europe' but also led to 'a viable democracy in the United States' and speculating on this, he says that he thinks the answer is really simple: 'American federalism created not an empire but a nation state'. Now that's the crucial thing for us in Scotland. America went through massive disputation about the rights of the state and there was a bloody civil war in the 19th century, but the American settlement had established what Scruton calls 'a secular rule of law, a territorial jurisdiction and a common language in a place that the people were claiming as their home'. In that settlement, people could treat each other as neighbours. The point is that they were not connected through race or religion or class, but as 'fellow settlers in a land that they shared'. Scruton concludes:

> Their commitment to the political order grew from obligations of neighbourliness, and disputes between them were settled by the law of the land. The law was to operate within territorial boundaries defined by the prior affections of the people, and not by some trans-national bureaucracy.
>
> In short democracy needs boundaries and boundaries need the nation state. All the ways in which people come to define their identity in terms of the place where they belong have a part to play in cementing the sense of nationhood.

Roger Scruton, BBC *News Magazine* (30 August 2013)

SANDY The thing is, the USA is a nation of different states, the fact of immigration includes the history of different national identities in the 'united' states. It's different in the United Kingdom. To gain citizenship here, you have to pass a test which basically confirms your Englishness. Isn't there a question about cricket? I doubt if there's a question about the Declaration of Arbroath.

ALAN We would have to qualify Scruton's idea that one language makes one nation or one literature, as well – Scotland is distinct in having literature pre-eminently in three languages: Gaelic, Scots and English. Switzerland is another country with more than one language.

SANDY Kenya has 42 languages, for goodness sake! There must be many countries which are multilingual.

ALAN New Zealand has English and Maori, of course. And how many tribal languages are there in Australia? And as well as the indigenous languages, being an immigrant nation, Australia has considerable numbers of the population speaking Italian, Greek and so on. In Scotland, according to the last census, there are more Polish speakers than Gaelic speakers.

SANDY The point is, these languages are all tools for writers to use. It remains for these languages to be deployed by writers to represent the experiences of people in these places.

ALAN Aye. And that would contribute to the sense of a national identity shared by its component identities that Scruton is talking about there. By and large Scruton's description of national identity and democracy is pretty impressive – even if it was not intended to apply to Scotland, it's a pretty good description of the kind of Scotland we'd like. Or as the great American poet Robert Frost put it more succinctly, 'Good fences make good neighbours'.

SANDY For James Joyce, Ireland at the turn of the 19th to 20th centuries was a laboratory nation where he could experiment simultaneously with the archaic and the avant-garde, the cosmopolitan and the local. In this he was doing exactly what Picasso and Stravinsky were doing in painting and music. For Joyce, the characteristics of Ireland were intrinsic to any meaning he could make in his own writing.

ALAN Back to Declan Kiberd again. Ireland was his nation, and the nation, as Kiberd puts it, was itself exactly what created 'a sense of responsibility for the fate of others in the community'. A sense of collective identity not boosted by self-directed hype to the point of overwhelming aggression, not fascist at all, but generating a sense of civic participation. The erosion and decline of nations and the unthinking aggression towards nationalism in an era of global economic forces is part-and-parcel of the collapse of this civic ideal and the deliberate growing of consumerism, throughout society. The working class, or erstwhile working class, are as susceptible to this as the middle class – or to be less class-focused, whatever amount of money you have to spend on a

regular basis, what you choose to spend it on is presented to you within this social context. The idea that you might have a right to produce rather than consume, and that certain things should not, definitely not, be privatised, has been very badly broken.

SANDY And yet that's what allows for civic and social investment in institutional education, public libraries, museums, all designs for domestic and public architecture, and parks. And that's what created the greatness of cities like Barcelona, Bombay, New York, Dublin, Glasgow, Edinburgh – as places in which people live and work and recreate themselves.

> The tragedy of the 20th century was the replacement of a public spirited bourgeoisie, not with a fully enfranchised people, but with a workforce now split between overpaid experts and underpaid service providers. The world so lost turns out to have been far better than that which replaced it. The world of pub, café, civic museum and national library produced social democracy, modernist painting and *Ulysses*. The world which supplanted it can generate only the identikit shopping mall, the ubiquitous security camera and the celebrity biography. The middle class has no real public culture or artworks which critique its triumph, because it has assimilated all the oppositional forces of modernism, by reducing them to mass entertainment. Now the streets are places not of amenity but of danger, through which nervous people drive in locked cars from one private moment to another.

> Declan Kiberd, *Ulysses and Us: The Art of Everyday Life in Joyce's Masterpiece* (2009)

ALAN Kiberd confirms that *Ulysses* and all Joyce's work is part of the literature of the Gaelic revival: Joyce saw the best essence of that revival as 'a return to a vibrant medieval world in which sacred and obscene stood side by side.' That's essentially what MacDiarmid was endorsing in the 1920s, in his appraisal of Gregory Smith's idea that in the best of Scottish literature, there was an implicit understanding of the rightness of the grinning gargoyle there beside the saint, carved out in the cathedral's stone. He called this appropriate juxtaposition of the sacred and profane, the 'Caledonian Antisyzygy', and I've heard more than one self-styled sophisticated Scottish critic since then bashing MacDiarmid for coming out with such a mouthful of pretentiousness, but in fact as Kiberd says, it's exactly what you find in Joyce. Joyce maintained that the medieval was the essential spirit of Europe and that Ireland at its best was in touch and in tune with that. If Chaucer rewrote Boccaccio, and Milton rewrote Dante, and Shakespeare got what he did from his sources (which was probably just as much as MacDiarmid got from his), the problem really set

in when the English acquired the Empire and a literature devoted to manly individualism and cruel-to-be-kind self-conscious dominion, from *Robinson Crusoe* on. This is Joyce, quoted in Kiberd:

> Had we been allowed to develop our own civilisation instead of this mock English one imposed on us, and which never suited us, think of what an original, interesting civilisation we might have produced.

Ulysses reconnects with the Ireland before colonial occupation. And that's exactly what we need to do in Scotland: reconnect with what's best here through and back and beyond and before the centuries of being caught up in the Empire. Declan Kiberd also noted this:

> Walt Whitman said that the greatest writers were only at ease among the unlearned, and that Homer, the Bible and Shakespeare were great precisely because they tapped the energies of the common people.
>
> Joyce, like Whitman, Milton and Shakespeare, derived inspiration from the idea of the nation. All four men were in a real sense inventors of their nations, because of their willingness to open their art to despised or discarded oral traditions among their people.

SANDY How truly that applies in Scotland, to the Border Ballads, to Barbour and Dunbar, to Fergusson and Burns –

ALAN And to Mary Macpherson, Mary MacLeod, Duncan Ban MacIntyre and Alasdair MacMhaighster Alasdair, to Hugh MacDiarmid and William Soutar and Violet Jacob and Marion Angus and Tom Leonard and Liz Lochhead and James Kelman and Irvine Welsh. It is a collective epic.

SANDY And national epics give people ideas about where they come from, and what they might be.

ALAN Homer, Virgil, Joyce, MacDiarmid. All you have to do is read them honestly.

The Virtues of Nationalism

SANDY Nationalism is a word that makes a lot of good people queasy. The playwright David Grieg says he has a 'profound distrust' of nationalism, but believes independence offers a way for the country to shake it off. It's an interesting thought that after independence there will be less need to stress the national. It's easy to see why he distrusts nationalism. A mere mention of the atrocities which took place only a few years ago in the various post-Yugoslavian territories or the awful example of Nazi Germany demand that we ask serious questions of what went so wrong in these situations.

ALAN But it would be very wrong to stigmatise the word categorically. Atrocities of awful magnitude are also committed because of tribal or ethnic or religious authority – think of Rwanda, of Darfur, or of Palestine or religious fundamentalism of any kind. There is more than one way for people to betray their own humanity.

SANDY Nationalism may have been a child of the Western Enlightenment with Western-model states like Britain, France and the USA inventing their own forms of political nationalism, but this was never the case in the East, in the Austro-Hungarian Empire and the Balkan states. A different kind of national spirit persisted there – resentful, backward-looking, detesting the Western bourgeoisie even while trying to imitate it. It was this situation which generated a genuinely narrow nationalism. As Tom Nairn explains:

> Though originally drawn to the West, the Germans had ended by succumbing to an Eastern-style package. Developed into a form of eugenic insanity, it was their blood cult which threatened to drown the Enlightenment inheritance altogether after 1933. This was mercifully (though only just) defeated in 1945. However, out of it came the experience which stamped a lasting impression of nationalism's meaning upon both the Western and the community mind. Nazism may in truth have been a form of genetic imperialism – in its bizarre pseudoscientific fashion universal (or at least would-be universal) in sense – but its nationalist origins were undeniable. So its sins were inevitably visited upon nationality politics as such. Since the largest, most important ethnos in Europe had gone mad in that particular way then the ethnic as such must remain forever suspect.

ALAN Maybe the simplest way to put it is that there is good nationalism and bad nationalism. The French Resistance was good, French colonialism in Algeria was bad. Uber-nationalism or imperialism and colonialism, the imposition of one national imperial power over another, the belief that one is comprehensively superior, another comprehensively inferior – that's obviously bad. But if you're the David in this David and Goliath scenario, your resistance to the bullying authority trying to lord it over you is good. So far, so very, very obvious. But of course it's always, everywhere, more complex. Still, when I went to work in New Zealand in 1986, the French had been testing nuclear weapons at Moruroa Atoll in the South Pacific. Friends told me you could tell if the orange sunsets were glowing in a certain way. The Greenpeace ship the *Rainbow Warrior* had just been blown up by the French in Auckland Harbour, with murderous loss of life, not long before I arrived, and New Zealand was refusing to allow any development of nuclear power

and in fact refusing to allow any nuclear-powered ships to come into New Zealand waters. That meant refusing to give way to pressure not only from America but also from Australia. It was a courageous thing to do and it was a government decision clearly backed up by the vast majority of the people of the country. Now, the thing is, you can only do that in a nation-state with autonomous authority. I bet if Scotland had been independent in 1986, we would have taken the same position.

SANDY We did show courage of this kind, when the Justice Secretary for Scotland Kenny MacAskill released Abdelbasset al-Megrahi on compassionate grounds, standing up against massive pressure from reported public opinion in the media. That pressure was clearly coming not only from the government of the United Kingdom but also from the USA. The Scottish Government made the difficult decision in its own right, not giving way to international pressure. That's something we should all be proud of. It must have been very tempting to appease the USA, as the British Government most surely would have done.

ALAN And there are many, many examples of new nation-states coming into existence in the wake of the declining imperial power that was the British Empire, and in the wake of what was the Soviet Union, and in other parts of the world entirely. India in 1947, Nigeria in 1960, Sierra Leone, Tanganyika and southern Cameroon in 1961, Jamaica, Trinidad and Uganda in 1962; Sabah, Sarawak, Singapore, Zanzibar and Kenya in 1963; Nyasaland, northern Rhodesia and Malta in 1964; Gambia and the Maldives in 1965; Bechuanaland, Basutoland and Barbados in 1964; Aden in 1967; Nauru, Mauritius and Swaziland in 1969; Tonga and Fiji in 1970. Armenia and Lithuania in 1990; Uzbekistan, Kyrgyzstan, Tajikistan, Turkmenistan, Moldova, Belarus, Kazakhstan, Georgia, Ukraine, Azerbaijan, Latvia, Estonia and Russia itself in 1991. There are now 50 nations in Europe. All are independent except Scotland, England, Northern Ireland and Wales. I mean, what are we waiting for? There is no reason why Scotland could not take its place as an independent nation-state in the world of the 21st century. There is simply no reason not to. And the value of such independence is suggested when you think of the political decisions that can only be made in such a state of independence.

'Scotland' is not simply what you want it to mean. It is a complex theatre of memory in which different ways of 'being Scottish' are interpolated and handed down, constructed and mobilised by social and political forces which seek to naturalise them. There is a complex interaction of social process and cultural meaning... Identity is not a 'thing' which

can be treated as real or unreal, but a social space in which matters of structure and culture come together. What it means to be 'Scottish' is far less important for the answers than for the terms in which the debate occurs. Identity politics, then, becomes a sphere in which history, society and culture interact. It is a debate about different versions of being Scottish, which seek to mobilise process and iconography.

David McCrone, *Understanding Scotland: The Sociology of a Nation* (second edition, 2001)

SANDY Evidently the nation-state has its virtues. There are obvious paradoxes and contradictions, though. Many of the Highlanders who were cleared out of Scotland went to Australia and proceeded to clear the native Australian aboriginal people off their ancestral homelands. There's a similar situation in Palestine, where the Israelis, many of whom are sons and daughters of victims of the holocaust, have pursued a policy of colonisation similar to that of the colonising Scots in Australia.

ALAN It's pretty horrific. We need to face up to the bad history of our own people, but we shouldn't wallow in it.

SANDY The bad things of history are common property, too. There is more in common between the British and Soviet empires, both gained by military muscle, than is often thought. And the British example is often taken from the idea of the Roman Empire – conspicuously absent from most references to historical pedigree is the notion of Greek or Athenian democracy. The Roman Empire inspired the idea of the British Empire – you know the kind of thing, 'on which the sun never sets'! This was also an inspiration for fascism, for Mussolini in Italy, and so forth. This is not the American example at all. That's a very different kind of Empire, a cultural Empire, in positive and negative ways.

ALAN The small nations of the world can be a necessary defensive structure against the overwhelming power of imperial, Goliath-states. When I was in New Zealand in the early 1990s, I attended a lecture by Noam Chomsky in which he said exactly that. He was clearly very self-conscious about the *Rainbow Warrior* and the Greenpeace presence there, and the fact that as a pastoral, farming country where the economy is so closely connected to home-grown produce, the value of self-determination and statehood is primary, its meaning obvious to everyone. I admit though, as soon as he said that I was thinking about Scotland in the same terms:

Nationalism, as an idea, can no longer be regarded as something obsolete. In Europe, at least, it is now clear that it forms the future.

The next few decades, and perhaps longer, will be shaped primarily by the development of nationalism – by the struggles of population groups to establish their identity through institutions of government, and by the relationships between existing nation states and minorities at home and abroad. Shaped, that is, for better or worse. The better will come from those who associate national liberation with responsibility, who know how to use the powers of independence to create both a sensitive and authentic democracy and a new type of partnership in Europe as a whole. The worst will be provided by leaders who exploit the dark and reactionary phenomena which nationalism can evoke: xenophobia, tinpot authoritarianism, obsession with symbols, mistreatment of ethnic minorities.

The resurrection of nationalism has come as an appalling, disabling shock to much of the 'liberal establishments' in Western Europe. But the Cold War decades were deceptive, creating an illusion of an international, and indeed super-national order which had transcended old diversities. In those decades – for intellectuals in both East and West – a certain socialist or social-democratic orthodoxy held that the so-called 'Balkanisation' brought about by the Versailles settlement had contributed, even caused the Second World War, providing Hitler and his lesser imitators with all the grounds for inflammatory nationalism and fascism. As time passed, almost all understanding was lost for truths well understood at the other, less fortunate end of Europe: that a nation without a state – without its own institutions of government – will be dominated and brutalised by another state, and that the nation remains the imaginary vehicle onto which most of humanity loads its hopes for the journey towards a better future.

Neal Ascherson, 'Scotland's Place in the New Europe' (1992)

SANDY So your experience of New Zealand matches exactly what Neal Ascherson is saying there, doesn't it?

ALAN Sure. And Scotland could take this example. And not get too hung up on the British imperial questions, like the military question.

Czechoslovakia was created in 1918, not only as a political entity – as a country – but also as a word. In the past, the Czechs and Slovaks were linked mainly by the nearness of their languages... it was only in the 19th century, during the period of national revival movements, that the Slovak 'awakeners' – the scholars, writers and linguists who attempted to resist the harsh Hungarianisation policies – began to look to the Czechs

for support, since the Czechs were closest to them, linguistically. Thus originated the image of the Czechs as the older, more experienced Slavic brother from whom the Slovaks sought advice, support and protection.

Even when the First World War was reaching its climax, the idea of a common state of Czechs and Slovaks was almost unheard of at home. When the war was over the idea of a single Czechoslovak nation was supported by the victorious powers as part of their policy to weaken the defeated Austro-Hungarian Empire.

In the eyes of the world, there has long existed the idea of Czechoslovakia as a unified and essentially prosperous country, particularly compared with most of the countries around it. This view from the outside, however, did not take into account all the inner tensions, all the ups and downs and difficulties of co-existence. In reality, there were few periods during the 74 years of Czechoslovakia's existence that could be called peaceful or happy.

ALAN That's Ivan Klima writing about the problems of Czecho-Slovak relations. He says that those problems arose out of both economics and culture. Those two aspects of what makes a coherent identity in a nation are always crucial. Because of geography and history, the Czechs came into this union as 'the stronger partner'. What does that remind you of? The Slovaks, Klima says, were 'just starting off in all fields, and suffered from feelings of inferiority'. So a lot of Czechs were pretty snooty and disdainful of the Slovaks. As Klima says, they 'looked down their noses at them'. Knowing about Czech culture was always going to be essential for well-educated Slovaks, but with a few exceptions the Czechs would have no equivalent interest in Slovakia. Isn't that a familiar story? Klima tells us that the Czech 'sense of superiority was reflected in practically every sphere of life'. So there was no surprise that the Czechs considered the country as theirs. For many Slovaks, that sense of ownership or belonging was a lot more complicated. Klima tells us this:

> What first appeared to the Slovaks as friendly assistance soon became, in the eyes of many, a rather unpleasant form of patronage, and unfair competition for the newly emerging Slovak intelligentsia, bureaucracy, or entrepreneurial class. It was not long after the initial euphoria over their newly-won freedom that the first signs of nationalism and separatist tendencies began to appear in Slovakia, and these intensified from year to year, becoming an explicit desire for a country that Slovaks could truly consider theirs, and theirs alone.
>
> Ivan Klima, *Czechoslovakia: A Premature Obituary* (1992)

SANDY In 2012, the diplomatic editor of *The Times*, Roger Boyes, visited Slovakia to gauge the mood 20 years on from what has become known as the 'Velvet Divorce'. He spoke with Milan Knazko who was a leader of the Slovak anti-Communist movement Public Against Violence in the 1980s, and for a while was advisor to President Vaclav Havel. In the new Slovakia, he became Slovak Foreign Minister and the Culture Minister. Knazko pointed out that Slovakia had no diplomatic representation in Bratislava before 1993, but now has a busy diplomatic life.

ALAN Edinburgh too could soon be packed with ambassadors.

SANDY Until independence, Bratislava was a backwater but is now a vibrant, bustling capital. 'You will see Scottish cities change in a similar way.' The Slovaks and the Czechs quickly shifted from being each other's main trading partners. Fiscal independence gave the Slovaks freedom to compete aggressively for foreign investment. A flat income and corporate tax of 19 per cent, no dividend tax, liberal employment rules, and a well-educated young population has led to an influx of international businesses. Advice for the Scots comes thick and fast in the bars of Bratislava: 'Don't let yourselves be bullied just because your population is smaller,' growled a carpenter. Mr Knazko warned the English and the Scots to guard against future recriminations: 'When I lectured in France, I was asked, "Who was to blame for the collapse of Czechoslovakia?" I replied, "No-one. Don't search for the guilty party. No crime was committed."'

ALAN So what we're experiencing in Scotland is nothing new, really. It's just that we don't ever get to hear about these stories.

SANDY No, we don't get to hear those stories, but we urgently need to know how others have achieved independence because learning from the experience of other countries is not part of the British establishment's way, which has always regarded foreign examples as irrelevant. Therefore the 'Better Together' tactic is simply to present Scottish independence as an abnormal and risky notion, doomed to certain failure. As a result, we have to provide alternative versions of how nations all over the world have asserted their independence and dealt with issues of currency, borders, pensions, and so on, taking heed of the numerous examples that have occurred across Europe in the past twenty years, for a start. We seem to have forgotten that the entire Commonwealth is made up of countries that began the 20th century as British colonies and ended it as independent states. And Ireland, which left the United Kingdom in 1922 and became an independent republic, but nonetheless negotiated free travel and a currency that remained pegged to

the pound sterling for more than 50 years. And there are many, many other examples we can learn from, from all over the world.

ALAN I attended a talk given by the Irish critic and columnist Fintan O'Toole at the Glasgow School of Art in January 2014, where he was discussing the differences between Ireland and Scotland in this context. He began by saying we have two major advantages in Scotland: we do not have violence or sectarianism to the same extent as Ireland. The whole history of the movement for Irish independence has been fraught with violence. And sectarianism there has been existential, that is, any group defined by its faith might believe it was fighting for its very existence, so that connects to the violence. Things are simply not as extreme in Scotland, and that's an advantage.

SANDY We have spent 100 years discussing questions about independence and now with the referendum, a peaceful democratic process invites us to change political reality.

ALAN O'Toole also gave a valuable example of two aspects of nationalism in the Irish experience. In 1926, he said, on the tenth anniversary of the Easter Rising, the National Theatre, the Abbey Theatre, staged Sean O'Casey's *The Plough and the Stars*, a great play, indeed, but one that presented the events of 1916 from the perspectives of women and the working class, and asked, has anything changed? And answered, not much. The protests were intense. Among the audience were people who had fought or lost loved ones in the struggle, not only in the rising but in the even more violent, protracted, civil war that followed. They wanted something that would tell them it had been worthwhile, and O'Casey was not giving them a celebration. The play honours the dead and gives respect to Ireland by tearing apart myths of purity and exceptionalism. But the audience was outraged. W.B. Yeats responded to this by elaborating the idea that national identity might be characterised in two ways. One is by national vanity (nothing could be better than us), the other is by national pride (in which we can take all the criticism that comes, and not feel anxious about it). Yeats advocated a state where pride is a fragile, vulnerable thing, and the anxieties that go with vanity are superseded by that sensitive confidence of maturity. Confidence is not arrogance. In other words, you neither cringe and say, we're just not good enough, nor do you vaunt your ego and say, we are incomparable, and always right, but rather, you think about it, seriously.

SANDY So the best nation state we can imagine would be one in which people were at ease with their own plurality. This is what we were talking about in

terms of the diversity of identities, languages, geographies, that make up this nation called Scotland.

ALAN People grow into their culture, learn it, remember it, but then with maturity, their culture is chosen, selected. You choose what you want to be. It is a fundamental process in all education. So it's what you might call an 'elective affinity', it is not imposed upon people – either by their own authorities in national government, or those from outside its borders, either by shamrocks and shillelaghs or tartan and velar fricatives. Ideally, the national culture would be a place where identity is multiple, and where, without anxiety, people can choose in full knowledge of what their choices mean. That realisation of independence has consequences. Nationalism itself is negated as soon as the independent state is achieved. You're not striving for it anymore. You're getting on with it. You might call that the failure of success. But a mature national culture is not anxious about itself. Independence endorses pride, but a pride that is vulnerable, fragile, self-conscious and aware of itself through the arts. Self-confident, but always open to dialogue.

SANDY So independence would be only the beginning. That's what we're aiming for. That's what we want.

ALAN But in these different contexts of nationality, what is the role of the artist? Is she or he simply an independent voice, critical or festive, or one of a company, politically engaged? Is he or she working in ways that most people don't understand or want to understand? The examples of Yeats and O'Casey here are important. Is the artist or writer taken to heart by the people, and doing things people can learn from, be helped by, in the most vital ways?

SANDY Thinking about the work of the artist in the context of any society, the writer Meaghan Delahunt, born in Australia but resident in Scotland for more than 20 years, had this to say in an essay published by the Saltire Society:

> It is a process. Might it be that some of what artists face every day – uncertainty and risk – making connections between disparate things and finding a way to negotiate fear – might these creative qualities be exactly what Scottish society needs in the transition to independence? Such quali-ties are also inherent in the process of migration. A situation of flux and transition demands a creative response. Scotland has traditionally seen itself as an emigrant nation. But for the country to go forward, it seems to me that it must embrace these qualities as a reserve for facing the future. To go forward and create and keep an open mind as to what the

end result, the new society, may look like. To embrace uncertainty and the creative possibilities it offers, rather than to fear it.

Meaghan Delahunt, *The Artist and Nationality* (2013)

ALAN It is a process. That's the key point. Whatever happens, the arts are essential in the process of education, in the process of democracy, in the process of people changing their minds and taking things forward. Whatever happens, when all the votes are counted, it is not an end of anything, but a further part of the process. Wole Soyinka has an essay called 'The Fourth Stage' where he drives this right down to its deepest meaning. For his people, he says, in their cosmogony, their understanding of what humanity is in the cosmos, there are three worlds: the worlds of the ancestors, the living and the unborn. You can see how in the western world, commercial priorities are dynamic because they are pre-eminently about the living, resources are exploited and the future can look after itself; and you can see how conservative, moribund societies like some parts of Scotland can be dragged down by doing things the way they've always been done in the imagined world of the ancestors; but the world of the unborn needs a bit more attention, I think. We can learn from this. Soyinka then goes on to say that there is a fourth stage, the realm of transition, when things change, and human beings enter onto this fourth stage, or into this fourth space, to risk transition, to bring about change. This is the space of tragedy, but it is also the space where change does happen, transition can take place. In the whole cosmos of creative and destructive being, Soyinka says, according to the wisdom he acquired in his own upbringing in Nigeria, offences against humanity and even against nature 'may be part of the exaction by deeper nature from humanity of acts which alone can bring about a constant rejuvenation of the human spirit'.

That's what we want to happen in Scotland.

The Origins of Modernity

ALAN When you think about the art of Modernism, what makes it so difficult for so many people is simply the fact that the artists and writers were helping us find a way into the modern world. And because earlier moments of transition, periods of conflict and social change, are so deeply historical, they have become more familiar and perhaps we don't consider them as difficult as they must have been. Yet the literature and art of other times, from many different periods of history, can speak to us directly about these difficult 'origins of modernity'.

Think of the Celtic stories that cross from pre-Christian times to the coming of Christianity, with Ossian in dialogue with Christian saints after the Fianna, his warrior family, had gone from the earth.

Think of Columba, arriving in Scotland, keeping his native Ireland out of sight and defending himself and his companions from the threat of Vikings and violence, and creating the *Book of Kells* on Iona.

Think of the struggles for Scotland's independence in the stories of Wallace and Bruce, and how those stories came to be written down by Blind Harry and John Barbour. Think of the *Declaration of Arbroath*.

And through the realms of James III and James IV, the great makars of Scotland, Robert Henryson, writing *The Testament of Cresseid*, a proto-humanist proto-tragedy that transcends the orthodoxies of its own time and touches a human nerve that still brings us anger at inhuman disasters and grief at the tragedy that comes. Think of William Dunbar.

Think of Sir David Lyndsay, writing on the edge of the Reformation, and entering into modernity of the most revolutionary kind. In fact, you might say that the Reformation was the greatest revolution of the western world, from which all the others developed – the American Revolution, the French Revolution, the Communist Revolution, all attempts to change the world and break the authority of corrupted powers.

And think of the way in his own time Allan Ramsay tried to regenerate an awareness of the Scottish literary tradition for a new generation, or how Robert Burns supported the American revolution and welcomed modern ideas about democracy and social justice.

SANDY Hold it there a moment. For many people all over the world even today, social justice and democracy is imagined through the words of Burns, in songs and poems. His popularity carries this message. And Burns inspired action in the cause of liberty and freedom. There's a small bronze plaque in the centre of Berlin commemorating an incident which took place during the 1848 revolution. The inscription reads:

> Here on the 18th March, 1848, barricade fighters defended themselves against troops of the 2nd King's Regiment. These troops a few hours later refused orders to launch further attacks.

> For a' that, and a' that,
> It's coming yet for a' that,
> That man to man the world o'er,
> Shall brothers be for a' that!

> (Ferdinand Freiligrath 1849 from Robert Burns 1795)

So forget about all those tedious annual Burns Suppers! Would that we find some of this Burns-inspired courage when our moment of truth arrives in the autumn of 2014!

ALAN Or think of the great, neglected figure of John Murdoch and his commitment to land reform in the Highlands. He was the Highland, rural counterpart to John Maclean bringing socialism to the working people of the industrial cities during the First World War. Hugh MacDiarmid learned from both Murdoch and Maclean, and Edwin Morgan learned from MacDiarmid. These are all ways of encountering and engaging with modernity. We needed them at the time and we can learn from them now.

SANDY The 19th century was the golden age of Scottish architecture. An extraordinary amount of building stimulated by the great wealth accruing from the Empire erupted all over Scotland. Edinburgh's New Town took shape while Glasgow, the nation's Victorian power-house, became associated with an architectural eclecticism, epitomised by the unique classicism of Alexander 'Greek' Thomson. In their introduction to *Scottish Architecture*, Miles Glendinning and Aonghus MacKechnie explain that:

> of all the meanings conveyed by the styles of the 19th century, the most direct and elevated was that of national identity. Scotland's aspiration to special status within Britain and the Empire was a constant concern of the age. The 20th century and the arrival of Modernism saw a violent reaction against the Victorian age. The Modernist world-view took several decades to emerge with its two most important Scottish pioneers, Geddes and Mackintosh, coming at the beginning of the process.

ALAN They were the great pioneers of modernity in Scotland.

SANDY Indeed. Patrick Geddes (1854–1932) was a Scottish polymath, Celtic Revival activist, a thinker and visionary who spent almost half of

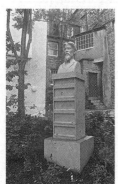

his professional life in Edinburgh, with the remaining time spent abroad. Although Geddes was not an architect but a biologist and city planner his work stressed the way in which art could enhance the health of individuals and communities. He aimed to foster a renewal of urban culture, using Edinburgh's Old Town as a laboratory of 'renascence'.

Geddes was a social reformer and educationalist, setting out the need to reform educational systems and learning methods. In 1885 he helped to found the Edinburgh Social Union, an organisation imbued with Arts and Crafts, social

and aesthetic concerns. He was also a patron of the arts (his magazine *The Evergreen* was a visual manifesto of the Celtic Revival) and was linked with many of the important artists, designers and architects of his time including Phoebe Anna Traquair and Charles Rennie Mackintosh. According to Murdo Macdonald, 'Geddes admired Mackintosh, seeing in his work a clear-sighted and creative understanding of the past and the present which at the same time showed a way forward'.

ALAN Mackintosh is a lot more familiar to most folk, though.

SANDY The story of Charles Rennie Mackintosh (1868–1928) has been often told in recent years. Blockbuster exhibitions in the Met in New York and in the County Museum in Los Angeles in 1996–97 revealed his genius to the world. Special pleading is no longer necessary but we know that was not always the case. Recognition of his standing as one of the greatest of 20th-century architects took time. His masterwork, the Glasgow School of Art, completed in 1909, received its first recognition in a professional journal in 1924. No published plan of the building appeared till 1950. It wasn't until the Edinburgh Festival exhibition of 1968 that his extraordinary genius began to be fully appreciated in Scotland where he had been seen as a failure, as a man who would drink too much and therefore got what he deserved.

It's refreshing to recall Nikolaus Pevsner's radical appreciation, first published in 1936 under the title *Pioneers of the Modern Movement*. Pevsner, one of the many refugees from Hitler's Germany who brought much new thinking and expertise to the British scene, was really the first to define what might be termed as the 'Englishness' of English art. Under another title, *Pioneers of Modern Design,* published in 1960, he emphasises that Mackintosh worked 'in contrast to the reckless repudiation of tradition among English architects of the time. Among English, not among British architects. For in Glasgow there worked during those very years a group of artists as original and as imaginative as any in Europe.'

> In design and decoration the first appearance of the Glasgow school at an exhibition in Vienna in 1900 was a revelation. The centre of the group was Charles Rennie Mackintosh with his wife Margaret MacDonald and her sister Mrs McNair (Frances MacDonald). In dealing with him, we are able at last to link up the development in England with the main tendency of Continental architecture in the '90s, with Art Nouveau. Before he was 28, Mackintosh was chosen to design the new building for the Glasgow School of Art, a remarkably bold choice due largely to the Principal Francis H. Newbury. Not a single feature here is derived from

period styles. The facade is of a strongly personal character and, in many ways, leads on to the 20th century. The rest of the front is extremely simple, almost austere in its bold uniform fenestration. This row of metal lines reveals one of Mackintosh's principal sources and at the same time one of his most characteristic qualities. The source, particularly telling in the strange balls at the top of stalks, with their intertwined tentacles of iron, is clearly the Celtic and Viking art of Britain, as it became familiar beyond the circles of scholars just at this time. They are, it seems certain, Mackintosh's way of admitting national tradition, though his links with

the Scottish baronial past are perhaps more evident in his country houses than in a public building such as the School of Art.

Nikolaus Pevsner, *Pioneers of Modern Design* (1960)

ALAN In other words, Mackintosh remembered Scotland's story, and was building on history.

SANDY Exactly. And he was also building on Viennese art nouveau, the Italian Renaissance and classical Japanese building methods. On re-reading Pevsner's account I was reminded of a meeting with the distinguished Czech art historian, Jiri Setlik, who had the misfortune to be imprisoned by both the Nazis and by the Communists. He told me, 'what really lifted my spirits during those dark times was thinking about Mackintosh and his beautiful creations...'

ALAN In the 21st century the work and ideas of both Geddes and Mackintosh are now part of a better-informed discourse in Scotland with regard to green issues, conservation, planning, city centre regeneration, and ongoing architectural practice.

SANDY Their legacy is best seen today in the new Scottish Parliament building at Holyrood. In his designs for the Parliament, the Catalan architect Enric Miralles produced an anti-monumental structure dominated by natural shapes, reflecting a Geddes-like concept 'of carving in the land... a gathering

place'. Miralles and his partner Benedetta Tagliabue gave us a wonderful building that speaks of Scottish cultural distinctiveness as well as acknowledging the influence of both Geddes and Mackintosh.

If you don't know your own history, you fail to understand what's possible.

Geddes and Mackintosh, giants of the modern age, 'disappear' for a half century or more. They are remembered and revered in central Europe but forgotten at home. How could this have happened?

ALAN And there is this to consider. Since the 1980s and '90s, modernity has arrived in the form of a technological revolution that was unimaginable before then. We've noted this already, how the technology can so easily make the work of art – the work of understanding art – trivialised and unimportant in a universe where instant gratification is the normal expectation. Walter Benjamin's great essay 'The Work of Art in the Age of Mechanical Reproduction' has an awful relevance today. You think of that essay from 1936, then as it was brought to an enormous viewing public in the television series and the book *Ways of Seeing* by John Berger in 1976, and since then has passed into public provenance as a kind of modern gospel. The essence of the argument is that the stillness, space, quiet and thoughtful attention required by the work of art, that you engage with when standing before an actual painting, or sitting listening to an actual performance of music, or reading a book or listening to a story, is necessary for understanding and appreciation. The age of mechanical reproduction – print, postcards, and later film and television and now new media – break that down and make the work of art a commodity for infinite transmission. That's good, in that it democratises the work of art, takes it out of the arbitration system of commodity-fetishism, and makes it available to the widest number of people. But it's also bad, because it breaks down that silence, that space for thought and looking, studying, contemplation, critical thinking. And we need that more than ever today. We need the artists and writers who address this situation intuitively and self-consciously, critically, more than ever in the present world.

SANDY The age of mechanical reproduction has also allowed access to the history of culture, the history of art, as never before. Blockbuster exhibitions, museums, books, colour reproductions, the internet, open up to everyone thousands of years of art and culture from all over the world. It's almost utopian in scope, giving us the opportunity to see the work of great artists at the click of a mouse, but it also presents a challenge, the challenge of how to make sense of so much information. For many young artists, especially those without focused cultural bearings, the experience is one of extreme disorientation. The endless barrage of immediacy destroys perspective and erodes the individual's ability to formulate a point of view. This is why most young artists are in flight from the past, and at the same time, overwhelmed by the present. Yes, there are many questions we need to ask of modernity, or perhaps, what has become of modernity.

In our Second Dialogue you made a key point about writers from further back, Robert Henryson, William Dunbar, older Scottish writers – that they all have something to say to us now, that they remain vital and alive. And you just noted that they in their own times were harbingers of modernity as it was for them and their contemporaries. It should be obvious that the cultural traditions of Western art remain hugely important with a great deal to say to us. If we consider the significance of just one work – Grünewald's 'Isenheim Alterpiece' (1515) and its influence since its rediscovery in 1853, with artists as diverse as Beckmann, Picasso, Matisse, and Jaspar Johns all making work that derived from the altarpiece at varying times throughout the 20th century – we can appreciate not only the historical meaning of the work, but also that the theme of suffering and death is of fundamental importance to the art of our own times, and to each one of us now.

ALAN This has always been understood by artists.

SANDY Yes. Why did Picasso maintain a life-long dialogue with Velasquez and Goya? Why did Mahler return to Bach in his final symphonies? But we live in a time when people have become so dislocated from the past they find it hard to imagine that it is of importance. The message we continually receive from the gurus of contemporary culture is that the past is simply the past and not relevant to us now. That's a terrible mistake. All of the artists we're talking about have things to say to us. It doesn't matter whether they lived 100 years ago or 500 years ago, they still count. Many of them worked at a time when it was possible to achieve a truer integration of art and life in their work. That's why we need to keep returning to them. Not only do they show us where we've come from, but they also show where we might go in the future. And when you say we need that more than ever today, that we need the artists and writers to address this situation intuitively, and critically, more than ever in the present world, we have to ask, do we actually have those artists today? Do we really have the equivalent of a Picasso, a Mahler, right now? And where today are the equivalent in Scotland of Mackintosh and Geddes?

ALAN This is to do with the deliberate eclipse of libertarian ideas. Feminism, the role of the public intellectual, the moral force artists made verbal in the 1960s and '70s, pretty much died out with Picasso, Britten, Shostakovich. Gorecki perhaps was the last, in the 'Symphony of Sorrowful Songs'. But he was unusual in the context of commercialism.

SANDY I think there's a lot more to this than commercialism. There's a view that Modernism was the emergent culture of an age when modernisation

was still incomplete with a backdrop of tradition against which a cultural vanguard could project the idea of the work of art as a monument to the future. This vanguard was political, dedicated in many cases to the overthrow of the old order. But in the second half of the 20th century, Modernism began to run out of future. Its cult of endless innovation hit a dead end of sterile elitism: its ideas were being both canonised by the establishment and co-opted into the mainstream. Modernism's themes of authenticity and meaning gave way to pastiche and a fascination for the surface image. The links between innovation and politics were broken. Avant garde-ism became nothing more than the latest fashion.

All of this is much more pronounced in the visual arts and musical worlds, less so in literature, perhaps because writers don't attend academies or conservatoires. Walk into any art school these days and every student will be pursuing their version of the current trend, unaware of the history of Modernism and unaware of any period of art before that. So there's a failure from within as well as from without. As you've said, there is now serious confusion about radicalism and value, the question of what is worthwhile. And there is generally a failure of the critical sensibility. Things are seen, not in terms of quality, but rather of novelty.

ALAN That's why we're finding it difficult to identify who the really important artists are right now. There are these cultural battles to fight as well.

SANDY Just think how many works of art that have been produced, say since 1945, that have no content to speak of, where representation has given way to presentation, where the 'art object' exists as autonomous and self-referencing, denying content and celebrating its independence and irresponsibility. All of these art objects are sustained by the way capitalism turns everything into a commodity to be marketed and sold. This in turn inevitably leads to cultural activity and production being broken up into various kinds of what might be termed niche interests. By creating a series of well defined niche markets to target their products and maintain their market share, the main players in the art world consolidate their power. Likewise cultural scenes may initially grow up as mutually influencing trends, but increasingly they become self-contained ghettos defined by a spurious sense of identity resulting in works of art made only for a supposed cultural elite rather than an immediate communication between men and women.

ALAN The artists and composers of recent times we've identified as great – Britten, Shostakovitch – refused to accept any of these divisions. They looked beyond the limitations of Modernist elitism, stood apart from the

worst excesses of avant-garde irresponsibility, to make works of art that connect with ordinary human values and needs, just as art has always done in the past.

SANDY What their works contain is, in the words of Richard Taruskin:

> ... conducive to political and moral debate; and the more we can get used to thinking about high art – and classical music in particular – in such terms, the better. Except for the little aestheticist and formalist detour of the past 70 years or so, the traditional way of thinking about art and talking about art has always emphasised the political and the moral.

Taruskin, often described as America's 'public' musicologist, is quite fearless in his questioning of the 'critical orthodoxies' surrounding contemporary culture. As an exchange student at the Moscow Conservatory in 1971–72 his preconceptions of what constituted serious music were shattered when he attended a performance of Shostakovitch's Seventh Symphony, a symphony often lampooned in western Modernist circles. Educated as an undergraduate to believe that art was insulated from social reception he was flabbergasted to find that the Russian audience actually took this particular work seriously. This experience was repeated when he went to hear Rostropovitch play the Second Cello concerto:

> The same electric atmosphere pervaded the hall, but this time it was an atmosphere not of patriotic nostalgia but of risk. It was then that the idea of Shostakovitch's doubleness struck me, and with tremendous force. It was not just Shostakovitch's unique stature amongst Soviet composers that I sensed. His stature was unique amongst all the artists I could name. It was a backhanded fulfilment of the old Socialist Realist ideal – and the older Tolstoyan ideal – of an art that would speak with equal directness and equal consequence to all levels of society, from the least educated to the most educated.

Of a further concert, the premiere of the Fifteenth Symphony no less, Taruskin says this:

> But the outpouring of love that greeted the gray, stumbling, begoggled figure of the author, then 65 and beset by a multitude of infirmities, was not just an obeisance to the Soviet composer laureate. It was a grateful emotional salute to a cherished life companion, a fellow citizen and fellow sufferer, who had forged a mutually sustaining relationship with his public that was altogether outside the experience of any musician in my part of the world.

For Taruskin there, the artist is an exemplary figure.

ALAN But also, a citizen, a fellow citizen, a companion for life.

SANDY We should expect more from our artists. We should demand more from them. We should teach people to demand more from them.

ALAN But then, science has changed the world we live in forever. It is not as it always was. And we can see this if we bring together two of the greatest artists of the last 200 years, Gustav Mahler and Sorley MacLean. When Gustav Mahler composed his cycle of songs, 'Das Lied von der Erde', he ended with one called 'Das Abschied' – 'The Farewell' – and in this long, beautiful song we hear the voice taking leave of the world – death is approaching, but the beauty of the world is perennial, it seems to say. And in the sketches that have been recovered and worked up into his Tenth Symphony, there is a deeply haunting sense that, once again, death is approaching.

SANDY You have to explain this further.

ALAN When he wrote this, Mahler was very self-conscious of his own mortality and how little time he had left. He wrote this, his last symphony, with a profound sense of the beauty of the world as something that would be there after he had gone. Yet this assurance is no longer available to us. Science has brought about the existence of nuclear weaponry and power, with its incalculable legacy for future generations, the poison that it leaves in the earth. Whether by intention or by accident, the possibility is with us now of a vast destruction of nature and the natural world.

SANDY Yes. And this is simply a truth of the world we live in today that was not there in Mahler's time. Shostakovitch understood this. And Sorley MacLean?

ALAN In his poem 'Hallaig', MacLean describes the ruins of the township on the island of Raasay, near Skye, where he was born and grew up and lived as a boy. Hallaig was in ruins when he was a boy, but he recollects its beauty and memorable, haunting presence in the poem, and at the end he tells us that as long as the poem lives and has its effect, the memory of what was once there, living in Hallaig, the people and families themselves, will also remain alive. Their loss will measure the value of whatever remains in the world we inhabit. Later, though, in another poem, 'Screapadal', MacLean describes another location and confronts the presence of nuclear weapons on the submarines that patrol the waters nearby.

The factor in charge of the people who forced the evictions from Screapadal and other townships was called Rainy, and the historical reference underpins the actuality of what MacLean is emphasising here. Rainy, he says, left Screadapadal beautiful, even after it was cleared of its people. But it is not possible to be confident about such beauty being present in perpetuity any longer:

> Rainy left Screapadal without people,
> with no houses or cattle, only sheep,
> but he left Screapadal beautiful;
> in his time he could do nothing else.
> A seal would lift its head
> and a basking-shark its sail,
> but today in the sea-sound
> a submarine lifts its black turret
> and its black sleek back
> threatening the thing that would make
> dross of wood, of meadows and of rocks
> that would leave Screapadal without beauty
> just as it was left without people.

SANDY You say it is no longer possible to be confident about such beauty being present in any perpetuity. This reminds me of Adorno's statement, 'To write poetry after Auschwitz is barbaric' and the idea that art should not be permitted at all in the aftermath of Auschwitz. His view was that Auschwitz and art are on the same level, both belonging to the same culture, a culture that had failed dismally, not least as a result of absolute materialism. The genocide perpetrated at Auschwitz made use of scientific, technological methods. And we know too, that the music of Beethoven and Bruckner was used in the service of totalitarianism and war. Sorley MacLean volunteered to fight against Nazism as soon as war broke out in 1939. He was aware of Adorno's accusatory rejection of art and culture but continued to write poetry in the full knowledge that war and Auschwitz did and do exist. What are we to make of this?

ALAN That takes some time to answer. I've heard recordings of Bruckner symphonies performed as if they were accompaniments to marching fascist armies – that's a horrific travesty of everything Bruckner and his music wishes for. How could he be the Nazis' favourite? I know how Wagner sounds like power and maybe it's a cliché to say he appealed to Nazism in the hunger for power that characterised that force. But again, the intrinsic liability, the

intrinsic potential in the music is ambiguous – it can be hijacked and put to ends for which it was not intended. Humanity, any individual person might be caught up in this way. There is a horrifying play by the Scottish playwright Cecil Taylor (1929–81), *Good* (1981), which was made into a very fine film in 2008, which tells this story. Things can be made to work in ways they are not truly aligned with. And pleasure can serve any political purpose. Comfort is a liability. I hear that power thing in Wagner – how he shows off – but then *The Ring* is about the failure of all that. After about 20 beautiful opening seconds, the river, the forest, a kind of Eden, you have the opera beginning and the long, awful trajectory of the whole cycle. It is not triumphalist. That's what the Nazis always wanted to be. Wagner is not triumphalist. Even the end of the first opera, 'Das Rheingold', when the gods cross the rainbow bridge to Valhalla, well, that might sound like triumph – but it is all going to end in disaster, and you know it. Like any great work of art, the more you read it or listen to it or look at it, the better it gets. And Strauss – well, I love Strauss, that wonderfully rich and generous, poignant, touching, nature of his – and yes, he was a member of the Nazi Party – but you have to look at the circumstances. He had to be a member. So was Schindler. He was protecting others, literally. And Strauss's music speaks of other things, German, sure, but as much as Elgar is not imperialism, Strauss and Wagner are not Nazism. So listen to the Strauss Oboe Concerto, written at the end of the Second World War, and find out and remember how it came to be written, and think of what it's doing, to reconnect with Mozart, to breathe clear air once again. Not to evade, but to write the alternative, the answer to that nihilistic proposition, the answer to fascism.

SANDY You have a poem about this.

ALAN Yes, most of the first part of it I found in the biography by Bryan Gilliam, *The Life of Richard Strauss* (1999), and he kindly gave me permission to make a poem of it. The last part is about the Oboe Concerto, and what I think it means, the resistance to fascism enacted by the celebration of life.

The Confrontation

'He said that the great offensives of the future would be psychological, and he thought the Governments should get busy about it and prepare their defence… He considered that the most deadly weapon in the world was the power of mass-persuasion.'

– John Buchan, *The Three Hostages*

'The essence of propaganda consists in winning people over to an idea
so sincerely, so vitally, that in the end they succumb to it utterly and can
never again escape from it.'

– Goebbels

'No-one can say what will be "real" for people when the wars which are
now beginning come to an end.'

– Werner Heisenberg

Richard Strauss went to Berlin in 1941,
to discuss the matter of royalties and the rights of composers
of classical music, as opposed to popular music.
As president of the Reichsmusikkammer,
Strauss had declared in 1934 that composers of 'serious' music (*ernste
 Musik*)
should get a higher percentage. Goebbels overruled that directive.
Strauss responded that the Propaganda Minister had no right to interfere
in the affairs of composers. He went to see Goebbels about it.
He was taken up directly to Nazi high command,
where he received a tongue-lashing loud enough to be heard
well beyond the closed doors. Goebbels ordered that a letter
that had been written by Strauss should be read aloud:
'As for the authorized statute concerning royalties,
 we ourselves shall decide the question of distribution,' Strauss had written.
'Goebbels has no right to interfere.'
Goebbels slapped at the letter and screamed:
'Herr Strauss did you write that?'
Strauss said, 'Yes.'
'Silence! You have no idea who you are and who I am!
You dare to call Lehar a street musician?
I can feed this impertinence to the press...
Lehar has the masses and you don't!
The art of tomorrow is different from the art of yesterday.
You, Herr Strauss, are from yesterday!'
Strauss left the meeting shaken and on the edge of tears.
He now knew that fame and humiliation were sharply placed together,
that he had no way to protect his own family
and that even shut off in his mansion at Garmisch,
reading Goethe, writing memoirs and essays and music,
the realities of politics would keep invading his world.

In 1941 he was seventy-seven years old.
Goebbels was forty-four.

At the end of the war, American soldiers arrived in Garmisch
by 30 April, the day of Hitler's suicide. The larger villas were being taken over
and used for the quartering of troops. The old composer went out to his
 front gate
and said, 'I am Richard Strauss, the composer of *Der Rosenkavalier* and
 Salome.
Please leave me alone.' But as luck would have it, sitting in the jeep
 was an American officer who knew Strauss's music.
They declared the villa off-limits and safe.
And one of the American soldiers who visited him there
 was a 24-year-old musician named John de Lancie,
 principal oboeist with Pittsburgh Symphony Orchestra,
 and the shy, young de Lancie asked whether Strauss had ever thought
 of writing a concerto for his instrument.
'No,' was all Strauss said.
But the oboe concerto was then begun
 and first performed in February, 1946.
It has none of the horrors of war.
It breathes the clear air of Mozart.
It speaks of the things of the past
 that but for the work of the artist
 the future might have destroyed.
It speaks of the act of giving.
It is one of Strauss's gifts to us,
 and the soldier who asked the right question.

But there is an even deeper answer for Adorno. We must not stay in the 20th
century to make that answer, despite the extent of its engagement with death
and holocaust and what must seem like unprecedented awfulness. Adorno
thinks his own life experienced something that changed the world forever.
That is so. But that does not make him special. It is much longer, much
deeper than that. It's about the limits of what we understand as human.
Other people, at other times in history, have experienced things that changed
the world. And each one of us must know this, surely. Human knowledge,
and every single human life, you, me, whoever, in whatever generation.

SANDY I think that's the answer we need to repudiate Adorno's despair.
Every one of us, and every generation, has to find out about these things

for himself or herself. Any young artist or writer might find themselves in a horrific crisis, personal, social, global, and think the arts are redundant in the face of this. But the arts are never redundant.

ALAN And that process of discovery is never ended. There is a bigger map. This is the deeper answer. In his little book on Melville, *Call me Ishmael*, Charles Olson proposes that the story of a great historical era can be read to its final end in the 19th century, in three great odysseys: 'The evolution in the use of Ulysses as hero parallels what has happened in economic history.' Homer's Ulysses pushes against the limits of the known world, the Mediterranean, and in this way he projects the archetype of the West to follow, the search, to reach beyond the self. By 1400, Dante finds Ulysses in Hell, among the evil counsellors. He has become an Atlantic man. In the *Inferno* he speaks to his crew like Columbus, urging them further forward: 'O Brothers! who through a hundred thousand dangers have reached to the west, do not deny yourselves experience of that unpeopled world beyond the sun.' He bends the crew to his purpose, and drives them west. After five months on the Atlantic, they see the New Land there on the horizon, but a terrible storm blows up and they are drowned and destroyed before they reach land. Olson concludes:

> The third and final odyssey was Ahab's. The Atlantic crossed, the new land America known, the dream's death lay around the Horn, where West returned to East. The Pacific is the end of the UNKNOWN which Homer's and Dante's Ulysses opened men's eyes to... Ahab is full stop.

SANDY So sum it up.

ALAN It's like this. Olson's map of history shows us the globe and we can recognise the truth in what he's saying. We cannot repeat those journeys. We cannot do what has been done. But this is the earth. Each one of us is on a single journey. Every setting out is a new beginning. Every new generation sets out once again, and because human beings are remembering animals, the curse of forgetting means that all these things need to be learned again and again. And as we've said, this is nowhere more evident in recent history than in the present time, when the technology of forgetfulness is so prevalent. And whatever we can gainfully keep with us, around us, a language or two, companionship, a family, friends, the arts, literature, paintings, music, a nation, will help. And it stays open. The open complexity of all journeys is intrinsically the domain of the arts, and understanding this is a form of resistance. It is to resist the vanity of all efforts to bind and contain imaginative

life, it is to resist the mechanical excess of systematic meaning. It is to teach that intelligence and sensitivity reside with an irreducible openness, never with the closed.

SANDY This is to say that we – all people, everywhere – need to learn something about this story, how to read the story in the map, and that the arts are essential to this learning.

The History of the Future

SANDY We've been discussing the origins of modernity, and I imagine if asked about the history of the past 200 years most people would think that the main issue was the rise of industrialisation, leading to modernity, and to Modernism. It's slightly alarming to note that the founder of the Bauhaus, Walter Gropius, that great propagandist of international Modernism wrote to the President of the Reichskulturkammer in June 1934, emphasising the genuine German character of architectural Modernism – and yes, he did have the good sense to depart Nazi Germany a few months later. This raises yet another question about the past 200 years: whether we like it or not, it's pre-eminently about the history of nationalism.

In an essay entitled 'On Studying Nationalism', Tom Nairn grasps this particular bull by the horns citing Ernest Gellner's famous 1964 essay *Nationalism* as the decisive advance in understanding why this is so:

> For those concerned with understanding nationality politics, that was the Eureka! cry which founded the social-scientific theory of nationalism. So, he demonstrated how industrialisation produced modern political nationalities; yet he did not go on to suggest that the true subject of modern philosophy might be, not industrialisation as such, but its immensely complex and variegated aftershock – nationalism.

Nairn is emphatic:

> The true subject of modern philosophy is nationalism, not industrialisation; the nation, not the steam engine and the computer. German philosophy (including Marxism) was about Germany in its age of difficult formation; British empiricism was about the Anglo-Britons during the period of Free-trade and primitive industrial hegemony; American pragmatism was about the expansion of the US democracy after the closure of the Frontier; French existentialism manifested the stalemate

of 1789 Republicanism after its 20th-century defeats – and so on. What philosophy was 'about' in that sense has never been just industrialisation, but rather as specific deep-communal structures perturbed or challenged by modernisation in successive *ethnics*, and experienced by thinkers as 'the world'.

The realisation that nationalism cannot be left out of any proper discussion about art and culture has prompted a certain amount of revisionism from Pierre Boulez for one. In a recent interview, the arch-proponent of musical Modernism – a Modernism sited beyond history and nationality – conceded that Schoenberg did indeed belong to the Austro-German tradition, and Stravinsky to a Russian one.

So much for Modernism and nationalism.

ALAN So let me get this right. What you're saying is that Modernism *is* nationalism.

SANDY What I'm saying is, the deeper we dig, the more we discover how Modernism takes on different shapes and forms across nations and continents. French and German modernists pursued diverging paths as did the Russians and the Italians. There were no German painters comparable to Bonnard or Vuillard. That type of sensibility is only to be found in France, whereas the German masters of Expressionism, Kirchner and Nolde use paint in a way that no French artist ever considered. We can grasp this most clearly in music where so many of the leading modern composers took their inspiration from folk sources: Janàček, Stravinsky, Bartók, Kodaly, Ives, Mahler, Vaughan Williams, Chisholm – all these immediately spring to mind.

And also, if we look a little more closely at architecture, often regarded as the most truly international statement of Modernist principles, we find significant cultural differences between the great pioneers, the Germans, Gropius and Mies van der Rohe, Le Corbusier from Switzerland, Alvar Aalto from Finland and Oscar Niemeyer from Brazil, not to mention the Austrian Adolf Loos, the American Frank Lloyd Wright and the Scotsman Charles Rennie Mackintosh. All were deeply influenced by their own cultural backgrounds as well as the possibilities of 'the new'.

ALAN And yet it's still said that the global world we now live in has all but eliminated national difference and distinctiveness.

SANDY Perhaps in terms of business and economics, it has – but not in cultural fields. Modernism in football – and here we should remind ourselves

of Albert Camus' statement that 'everything I know about morality and the obligations of men, I owe to football' – demonstrates that despite the increasing globalisation of the sport with star players from Africa and South America plying their trade in the big money European leagues, national teams still retain their indigenous qualities. Spain, currently world champions, have developed a unique method of passing, 'tika-taka', instilled in their players from the age of fifteen onwards by means of elite national training programmes. Interestingly, no other national team has attempted to emulate this style of play which speaks strongly of its special Spanish origins, untranslatable, as it were, into other languages.

Football fans the world over understand that the great footballing nations – Spain, Italy, Germany, Russia, Argentina and Brazil – all have their own distinctive playing styles, based upon varied cultural roots. And small countries have played important roles in the modernisation of the sport. Hungary in the 1950s and Holland in the 1970s developed new tactical concepts which revolutionised the game everywhere. Until recently, Scotland also excelled at football, with a number of brilliantly-inspired individual players who regularly enabled the national team to qualify for the World Cup. That's one of the reasons why Alex Ferguson, the demonic former manager of Manchester United is taken so seriously in England. And from the very beginning in the 1870s, the Scottish national team has enjoyed independent status, recognised as such by both the European and World governing bodies, the equivalent in football terms to the EU and the United Nations. Separation in the case of football proved crucial.

ALAN I have heard that Mr Salmond has written letters to all of the recent Scottish team managers to encourage them and wish them well, revealing the he's an aficionado of the game. If we in Scotland were to lose our international status as a football team, and were rolled into the one football team-UK, there would probably be an instantaneous revolution from every football fan, an open declaration in favour of independence!

SANDY It would be an absolute clincher!

ALAN Maybe other representations of what nationality can do could take that as a model. But it's time to discuss what independence will mean in practice, the mechanics of the thing. What the SNP seems to offer is a kind of confederation with close ties to the rest of the UK, England, Wales and Northern Ireland. The Queen would remain, as would the pound. Incredible nonsense has been uttered about the currency question. Alistair Carmichael, Secretary of State for Scotland, was asked in an interview in November 2013

if an independent Scotland would be excluded from sterling, and he simply replied, 'Yes.' Michael Fry had an excellent article in *The Scotsman* the following week (25 November 2013). He said this:

> Sterling is a fully convertible reserve currency, just like the US dollar and the euro. Any country in the world can, if it wishes, make use of such a currency for both domestic and external transactions. Even Communist Cuba in effect utilises the US dollar, as a hard currency in parallel to its own soft peso, and it certainly does not ask permission from Washington to do this. Montenegro has adopted the euro, without being a member of the European Union or of its eurozone.

He pointed out that Alastair Darling, chairman of 'Better Together', said that for Scotland to retain the pound would reduce the national economy to the level of Panama. 'He should know, as the man who brought Britain closest to being a banana republic. More likely, canny Scotland would save sterling from chancellors like him.' He went on:

> If independent Scotland wants to use sterling it can do that too, without even asking the English. Ireland did exactly the same during the period of currency union with the UK that came to an end when it joined the European exchange rate mechanism (forerunner of the euro) in 1979. Dáil Éireann had adopted the pound by its Currency Act of 1927 and, as far as I can discover, this unilateral legislation was the sole legal authority for the move. At any rate, I do not think Irish governments of those days were in the habit of asking permission from Westminster to do whatever the newly independent country, recently liberated by violence, wanted to do. Again, the English should count themselves lucky that what the Scots propose instead is an agreement. But if they spurn it, Scotland can continue using sterling anyway.

Essentially, he's saying that the English Government cannot stop the Scottish Government using sterling as long as it remains a fully convertible reserve currency, even though George Osborne and all the Unionist parties say that a fiscal Union is out of the question.

SANDY What is being proposed, then, is practical and admirable, up to a point. It shows that the SNP has a fluid, flexible understanding of the changing nature of statehood within an international context. The Scottish Government is clearly aware that there are degrees of independence, crudely categorised as 'heavy' or 'lite', that the European Union is now in a state of flux and that greater economic integration within the EU needs careful consideration. But in effect this means that the SNP has yet to define what

independence will look like and that poses a problem. Michael Keating has described the SNP as:

> ... a rather traditional nationalist party. It has neglected nation-building and failed to develop a narrative around identity, collective action, economic development and social solidarity, indeed neglected to exploit precisely the cultural advantages that small nations possess. It presents a vision in which the attainment of statehood itself will resolve all its problems.

We've already talked about the SNP's failure to really engage with culture, therefore throwing away what could have been its most powerful weapon. So let's keep it to the front of our attention when we ask the big questions. How could democracy work in Scotland? How would it be different from the abject failures of its operation in the United Kingdom?

ALAN I love that dour, flamboyant nationalism of the Welsh poet and clergyman R.S. Thomas. His poems are characteristically bleak and tough, but he was a magnificent example. In the introduction to his biography, *The Man Who Went into the West: The Life of R.S. Thomas* (2006), Byron Rogers says this:

> Curiously, he is a Welsh nationalist to the lengths of not supporting the Welsh Nationalist Party because it recognises Westminster. 'Britain doesn't exist for me, it's an abstraction forced on the Welsh people. I'm just critical of any country that belongs to another country.' He paused, then said mildly, 'Even a one-eyed country like this, that's lost its self-respect.'

I wonder how much of the argument rests on this matter of self-respect. A great deal more than most people feel comfortable talking about. And yet, it's absolutely crucial. The fundamental purpose of the independent nation is to be the foundation of a collective dignity.

Thomas was a poet whose vocation in the church I think was deeply characterised by his vocation as a poet. In a 1972 television interview for the BBC, according to the Rogers biography, he said this:

> The message of the New Testament is poetry. Christ was a poet, the New Testament is a metaphor, the Resurrection is a metaphor, and I feel perfectly within my rights in approaching my whole vocation as priest and preacher as one who is to present poetry...

Asked what sort of God he believed in, Thomas once replied, 'He's a poet who sang creation, and he's also an intellect with an ultra-mathematical mind, who formed the entire universe in it'. Evidently that was what he meant by

'metaphor': the whole thing can only be understood through the imagination, but the imagination is vitally connected to actuality. Thomas was linked to the Welsh nationalists protesting against the imposition of the English language and the purchase of homes in Welsh-speaking areas by English people, and talked about this publicly, insisting that he was advocating non-violent protest: 'The burden of my talk was that, since to adopt the methods of Owain Glyndwr was out of the question, how could we meet the English threat to our identity non-violently? I did not express hatred of the English, nor did I urge attacks on their property.' He emphasised that he was not going to advocate anything he was not prepared to do himself. It seems to me that we in Scotland might pay more attention to what went on in Wales, with R.S. Thomas, and before him, the remarkable poet and playwright Saunders Lewis (1893–1985), a scholar, political activist, and one of the founders of the National Party of Wales, Plaid Cymru. But how many folk are familiar with their names and their significance as cultural protectors?

SANDY The Scottish position, though, is not the same as that in Wales, or in Ireland.

ALAN No, that's right, but we can learn from all these positions, and we can start with common cause, shared purpose, the priorities of humanity. That's what the arts help us to do. Let's say that the essential qualities of Scotland are as they are in almost any country: diversity and depth. We noted this before, in our first dialogue. To call a nation a land of contrasts is a familiar cliché but the contrasts that are to be found in Scotland have their own particular distinctions, historical, geographical, political, linguistic, and we can say that all these together generate the distinctions we call cultural. So, briefly, if we took Scotland as a nation made up of its different constit-uent parts, and considered them one at a time, and kept the cultural history of the nation in mind, what would we have?

SANDY We might have good reason to emphasise the value of further devolution from Edinburgh to regions or territories well beyond the capital. There has to be central government but equally there has to be local government, and in the centres of local government, what would be the essential co-ordinate points local councillors must remember?

ALAN Let's think of Scotland as one nation of nine major territories. Let's start with the northern archipelagos. Already we're thinking of Shetland in terms of language, music, the poetry of J.J. Haldane Burgess and Stella Sutherland and Hugh MacDiarmid's poem 'On a Raised Beach' – a major poem in all 20th-century literature, for my money. And if we move to

Orkney, George Mackay Brown, Eric Linklater, Edwin Muir, Stanley Cursiter, Peter Maxwell Davis.

SANDY And if we travel to the western isles, we want to encounter Will McLean's memorial cairns and Sorley MacLean's poem, 'Hallaig' –

ALAN Another major poem of the 20th century. But then in history, consider the relationship between the authority of Lord of the Isles and the rule of the kingdom, the authority of the King or Queen of Scots. Consider the relation between Orkney and Shetland and Norway, between the Outer Hebrides and Canada, between Argyll and Ireland, between Edinburgh and Aberdeen and the low countries, between Glasgow and America. These territories we're talking about have their distinctive identities in literature, art, music and politics but they are open and bridges exist to other places, other peoples, other relations of power.

SANDY So come back to the mainland, the far north and the north-east. And we would have to read Neil Gunn's *Highland River* and *The Silver Darlings*, Willa Muir's *Imagined Corners* and Violet Jacob's *Flemington* and the poems of Marion Angus, just to begin with.

ALAN And in the Highlands, in the west and centrally, Duncan Ban MacIntyre's great poem, 'Praise of Ben Dorain' and the play by John McGrath and the 7:84 Theatre Company, *The Cheviot, the Stag and the Black, Black Oil* – you can watch it on YouTube – and so much Gaelic poetry and story and song that most of us know almost nothing about –

SANDY Then travel east, to the coast there, and touch down at Arbroath, and read the *Declaration* once again, and then visit Joan Eardley's Catterline, the Mearns of Lewis Grassic Gibbon and John Bellany's Port Seton.

ALAN Stop a while. John Bellany read more deeply in Scottish literature than any modern artist, didn't he? The work of poets, writers and artists, in their expressions of understanding of human potential and tragedy, the waste, pain and horror of human life in its most cruel and terrible forms, and against that, the human potential for joy, communities of sympathy and co-operative will, people living and working together. That's what his work is about. It can be pretty uncomfortable, or discomforting indeed. It can be reassuring but as with the work of all the great artists, this reassurance is profound, not superficial. The tragedies of Aeschylus, Euripides and Sophocles, of Shakespeare, Ibsen, Brecht, the

writings of Céline, Döblin, von Horvath, for example, direct our attention to irrefutable horrors and offer no easy consolations. John Bellany's reading of Scottish literature is centred in this intuitive understanding that the work of the artist is to help people to live, and that writers and poets like Hugh MacDiarmid, James Hogg, Robert Louis Stevenson, George Mackay Brown, Sydney Goodsir Smith, were engaged in activities similar to his own, in their commitment to bring their own genius to the sympathy of others and to be constantly critical of the inhumanity so evident in the 20th century.

SANDY And just as Wilkie has given us Pitlessie, John Bellany has given us Port Seton as an essential point of reference in the whole story of Scottish art. But come further into the heartland of Scotland, and keep an eye on the historical depth of things with Blind Harry's *The Wallace* and in Dunfermline, formerly the capital of Scotland, we can read John Barbour's *The Bruce*, remembering that Bruce is buried there, though his heart is buried in the Borders, in Melrose, and Robert Henryson was a schoolmaster in Dunfermline, and his poem *The Testament of Cresseid* – recently translated into modern English by Seamus Heaney – is one of the greatest poems in any language.

ALAN So let's head for the south-west and the homelands of Robert MacBryde from Maybole and Robert Colquhoun from Kilmarnock. While we're there we can follow the tracks of William McIlvanney's great characters Docherty and Laidlaw, in the fictional 'Graithnock', modelled on Kilmarnock. We'll pay our tickets to visit the Robert Burns museum and after that, let's head east to the borders and visit Walter Scott at Abbotsford and have good look at his portrait by Henry Raeburn and think of how those great modern artists, William Gillies and William Johnstone, saw their border landscapes, and inhabited that terrain imaginatively, in visions we can all share. And we should read the novels of Allan Massie, Selkirk man and great champion of Scott.

SANDY And think then of Scotland's cities, all of them to be considered in their context and hinterland, and also in their connection with each other as centres of population. What do they have that is different? What do they have in common? Each needs distinctive theatres, and every city or town council should be matched by a theatre in which contemporary political satire presents local and international events in the public arena.

ALAN In Glasgow we'll meet the works of Charles Rennie Mackintosh and Margaret MacDonald, the under-rated John Quinton Pringle, whose paintings can be seen in the Kelvingrove Art Gallery, then over to the People's Palace for the murals of Ken Currie, where we can see John Maclean, a key figure in

the working-class struggle in the first two decades of the 20th century, who refused to sell out to capitalism, unlike so many Labour people of the time. And then we could encounter Edwin Morgan and Liz Lochhead and so many others. And the crime writers, who write more about humanity than police procedures, such as Denise Mina and Louise Welsh.

SANDY And in Edinburgh, Phoebe Anna Traquair's magnificent murals in the former Catholic Apostolic Church (1893–1901) in Broughton Street, known as the Sistine Chapel of Edinburgh. And we should have a good close look at the building itself, by the architect Robert Rowand Anderson (1834–1921), who also designed the Scottish National Portrait Gallery, the McEwan Hall of Edinburgh University, and indeed the extraordinary Mount Stuart House on the Isle of Bute – not to mention the Central Hotel at Glasgow Central Station. If we're in the Scottish National Portrait Gallery, we might take in the Processional Frieze over the grand staircase, depicting over 150 heroes from Scotland's history, painted by William Hole (1846–1917). That's not to mention more familiar Edinburgh writers like Robert Louis Stevenson, William Dunbar or Robert Fergusson and Muriel Spark. Then we should go up the Royal Mile to the esplanade and look at the statues of Wallace and Bruce at the entry arch to Edinburgh Castle and the flag that keeps flying there, the Union Jack. Now, when we get an independent Scotland, do you think the Saltire and the Lion Rampant will be up there again, at last?

ALAN Of course. Now let's go to Perth and call in on the film-maker Douglas Eadie, who made a wonderful film, almost a dramatised documentary, about the life of one of the finest Scottish poets of the 20th century, William Soutar, called *A Garden Beyond* (1978). When is that going to be shown again on BBC Scotland or STV and given the appropriate publicity? You know, I was at the Saltire Society Book of the Year awards event in November 2013, which was a great occasion with writers of all kinds – poets, historians, novelists, and a research award given to major, groundbreaking work by doctoral students in the universities – and there was no coverage whatsoever on BBC or STV, and I heard nothing from Radio Scotland. I don't know what press coverage there was, if any. Think of the publicity given to the Booker Prize, by comparison. We're still suppressing knowledge of the best things in our own culture! That's got to change.

SANDY If we go over to Dundee, we'll see that in a different way. Let's say hello to the poet James Young Geddes, far and away the most radical Scottish poet between Burns and MacDiarmid. Is he being taught in all the schools in Dundee? And there's Stuart Carmichael, a fine artist, and like Geddes, terribly neglected. And of course there's the far-from neglected publications of D.C.

Thompson and his greatest artist, the Englishman, Dudley D. Watkins, who definitively settled in Scotland, and whose incarnations of *The Broons* and *Oor Wullie* are embedded in the national memory. And let's read the works of our great contemporary A.L. Kennedy, Alison Kennedy, whose novels and stories are dark, meditative, intensely imagined and diamond-sharp, yet who once said that she never learned anything about Scottish literature in her schooling. She was given no idea that as a writer, the writer she was to become, she was coming from a tradition or hinterland of major work which was her birthright. She had to rediscover her own country.

ALAN And in Aberdeen, we'll become very familiar with Byron, who came from here and wrote his most wonderful song, 'Dark Lochnagar', thinking of his childhood, but there are also the less familiar figures of the painter William Dyce, born in Aberdeen, and the composer Ronald Center of Huntly, whose magnificent 'Dona Nobis Pacem' is a choral work for minimal musical resources with settings of Walt Whitman. It is a tight, intense, and deeply felt masterpiece that is not diminished by comparison to Britten's large-scale War Requiem.

SANDY In every part of Scotland, the richness and diversity of the work of these writers and artists and composers comes up at you.

ALAN And we could make that journey again and again, different routes, calling at different places, and the whole vast history of the arts of Scotland would rise up to us. But right now most of it is underground. Archaeology is the necessary thing. When we were travelling around Scotland to festivals and other events when we were launching the last book, *Arts of Resistance*, in 2009 and 2010, we found that many – maybe most – of the people in our audiences did not know about the arts and artists that were native to the places we visited. One of the most moving poems of W.S. Graham, 'Loch Thom', is about a lonely freshwater loch up above Greenock. When I was there at a Burns Club meeting in 2013, so many people who knew the loch but did not know the poem were astonished and grateful when I introduced it and read it out. It's all there, right on your doorstep.

SANDY Greenock should have an entry of its own. Think of Alan Sharp and George Wyllie, both eccentric, even bizarre characters, whose writings and art remain deeply memorable. But Greenock was a point of departure, a port to the wider world – that always activates the imagination and makes possibilities real.

ALAN Alan Sharp started here but his last work was the screenplay for one of the best films I've seen in recent years, *Dean Spanley* (2008). It's about

a Dean of the Church who in a previous life was a spaniel. You wouldn't believe imagination could travel so far as Sharp's does in this film. Peter O'Toole, Sam Neill, great actors, and no reference to where Sharp came from literally, but it's about what the imagination can do to help you in this life. That's the thing.

SANDY There's knowledge and there's fantasy. Pause for a moment with fantasy. Imagine a thriving, prosperous, dynamic Scotland – as opposed to what the 'Project Fear' people tell us, that Scotland will be in a condition of total economic and social meltdown. Do you know that hilarious film by the director John Carpenter, *Escape from New York*, from 1981? It's set in a future 1997 and the United States has become a crime-infested inferno, the economy has broken down completely and the island of Manhattan has been turned into a maximum-security state prison. But the President's plane has crash-landed there, and the hero, Kurt Russell playing '"Snake" Plissken' is given 22 hours to go in and rescue Donald Pleasance as the US President. So, imagine David Cameron has crash-landed when he's flying back from a G7 conference, and he finds himself held prisoner by a gang of criminal Scots in a devastated independent Scotland, and Andy Coulson is sent in to rescue him. 'Project Fear' right enough.

ALAN What's happening in the field of popular culture as regards the independence campaign?

SANDY At one independence rally, the brilliant life-force that is Elaine C. Smith was MC, and thanks to the iconic roles she has played on television she's very well known – a living example of popular culture at its most contagiously good-humoured. When you think of that, English and Scottish popular culture are very clearly not the same thing. Elaine is a very Scottish personification of what comedy can do, and that's very different from Morecambe and Wise or Jo Brand. The English popular comedians epitomise English types, their humour arises from the resources of England. The Scots comedians do the same thing but from very distinctively Scottish resources.

ALAN So to go back to David Torrance for a moment, we were quoting him earlier saying that there's not much difference between Scottish and English popular culture. I guess he's only thinking about the Scots who like *Coronation Street* – he's

not thinking about the differences between, say, David Mitchell and Kevin Bridges.

SANDY Exactly. Think of Rikki Fulton, Duncan Macrae or Sanjeev Koli. At the rally, Elaine introduced Alan Bissett, who launched into a reading of one of the most ferocious polemical poems written this century, 'Vote Britain'. It brought the house down! Alan has no problem at all with crossing between high and low culture, to use those terms. This polemical poem moves through very serious issues indeed and uses extreme scorn and satire and ferocious comedy to reconsider them. That combination of humour and seriousness is a literary skill, an approach or technique that runs back through MacDiarmid to Burns and Fergusson all the way to Dunbar, and is another example of the democratic strain we've already talked about. This is how 'Vote Britain' begins:

> People of Scotland, vote with your heart.
> Vote with your love for the Queen who nurtured you, cradle to grave,
> Who protects you and cares, her most darling subjects, to whom you gave
> the glens she adores to roam freely through, the stags her children so
> > dearly enjoy killing.
> First into battle, loyal and true. The enemy's scared of you.
> That's why we send you over the top with your och-aye-the-noo Mactivish
> > there's been a murrrderrr jings! crivvens! Deepfriedfuckinmarsbar
> > wee wee dram of whisky hoots mon there's a moose loose aboot this
> > smackaddict
> Vote, Jock. Vote, Sweaty Sock. Talk properly.
> Vote with those notes we scrutinise in our shops.
> (might be legal tender but looks dodgy to me)
> Vote for the Highland Clearances. Baaaaaaaaaa.
> Vote for nuclear submarines in your water.
> Vote for the Olympic Games you didn't vote for
> (but you'll pay for it, you'll pay for it).
> Vote Conservative. Vote Lib Dem. Vote Libservative. Vote Condabour.
> Vote with the chip on your shoulder.
> Vote Labour. New Labour. Old Labour. Scottish Labour.
> (Get back in line, Scottish Labour, HQ in Solihull will issue their
> > commands shortly,
> Just keep the vote coming in from up there thanks goodbye,
> Subsidy junkie).
> Vote for any argument you construct in your defence being 'anti-English'.
> Vote for Scots who make their career in Scotland being 'unambitious'.

Vote for enjoying your own culture being soooooooo parochial.

Vote God Save the Queen and that bit about us crushing you all.

ALAN About 50,000 people have been reading that poem or listening to it online. That's a big audience. If people are to open up to the questions and have some fun talking about them, the discussion needs to get snappy and sharp, and the whole world of popular culture and entertainment is the location in which the debate should take place. If you think about politics and culture in Scotland as dull, serious issues for sombre discussion by serious women and men, that puts everything into the ghetto of the articulate evaders of direct questions, the organised and impenetrable self-congratulators of the chattering classes and the unapproachably affluent classes. Radical thinking needs a different politics, one informed by fun, irreverence and imagination. When you're mapping out the destination of a different Scotland, more democratic and less institutionally dominated, you need dreams. And even if the maps are wrong, at least they show that the land is there. So that whatever *actually* happens, or *can be made* to happen, change starts happening in the way you think about what *might* happen.

SANDY There are comic approaches, such as this, prepared by the National Collective, a network of over 1,000 young artists and designers, all committed to independence. This is a 'spoof' top secret document by HM Treasury marked restricted only to Cameron, Osborne, and a small number of others:

> An independent Scotland would be a celebrity-free zone. There would be no Michelle Mone or Billy Connolly to take just two examples, nor Sean Connery as he will still be in tax exile. Instead Scottish people will be faced with a daily diet of earnest writers and thinkers constantly proclaiming that Scotland is living through a cultural renaissance.

And as with all good comedy, what is being made fun of reveals certain basic truths – that we are obsessed with celebrities and think that Scottish literary folks are too dull and 'earnest' for their own good. Yet, if we take the example once again of Irvine Welsh, we can see that a serious author can get through to lots of people. As you've said, we need to dream more, about all sorts of things, about a future Scotland that elects a writer as President. Is that really such an impossible scenario? How many Czechs imagined, let's say in the mid 1980s, that they would have a writer, a former prisoner under the old regime, as their President within five years? Someone once said of Schubert that in his tumultuous imagination – the imagination of a very young man – his thinking was always at the frontiers of the possible.

ALAN The work of the artist is to make public an understanding of human difference that recognises, respects and takes pleasure in diversity. This happens effectively in public art. This might be an area where art and social work coincide, valuably. Without the aesthetic priority of art, the public engagement is lessened, and if that sense of human difference is only engaged in private communities, then it's easy to see how quickly it can become not diversity but dividedness. This is pre-eminent in the work of Shauna McMullin, who invited 100 Scotswomen to contribute 100 valuable short sentences or phrases in their own handwriting which she then made into a collective work entitled 'Travelling the Distance', a ceramic sculpture commissioned for the walls of the Scottish Parliament building. The distinctive handwriting of each contributor, the meaning of each aphoristic phrase, from very diverse sources, the aesthetic pleasure of the overall work, the look of it, and its actual location, all these come together in a celebration of diversity that requires that public space to be understood. Since then, Shauna has worked on the 'Albert Drive – Who is my neighbour?' project, beginning with one of Scotland's most diverse streets, Albert Drive in Glasgow, and exploring what it means for people of different ethnicities to live alongside each other. It was a collaborative project with a team of multi-disciplinary artists, Arpita Shah, Basharat Khan, Janice Parker, Nic Green as well as Shauna McMullan herself, and the project quickly captured the imagination of the local community.

The point is that while the different ethnic, linguistic and cultural enclaves in Albert Drive might be divided from each other in private, when they were brought together in this participatory work of art, that dividedness became a visible diversity. The opportunity to enquire into and begin to understand each was enhanced. That's exactly the kind of work the arts can do, engaging in a continuing dialogue with the dynamics of identity.

SANDY An endless flowing dialogue stands at the heart of the work of Richard Demarco, artist, gallery director, educator, promoter of theatre and much else, whose worth is recognised the world over. The observation that 'art begins in the meeting of friends' has often been associated with Demarco and the long-term associations he has built indicate that art and life are not separate – art for him does not begin or end with an object.

For the past 50 years Demarco's mission has been to unite the cultures, histories and arts of both Western and Eastern Europe. As he himself says,

'I am painting a picture of Europe which is beyond the politicians.' His approach means he has never sought to function as an exhibition curator as the term is commonly understood. Through his exhibitions, conferences, journeys, and other events from the 1960s onwards, there is the desire to try to change the way people discuss and interpret art, society and politics, in both post-war and post-Cold War Europe. Talking about his life's work recently he described it all in the following terms:

> It is a total work of art which has come into being over six decades as a result of the contributions made to it by generations of artists, all inspired by the physical reality of Scotland, its history, and its cultural heritage. I am grateful that I can regard it as the latest development in an on-going, living work of art.

In contrast to the National Galleries of Scotland, Demarco's pioneering work has always sought to place Scotland within a wider European context. OK, his unconventional and sometimes contradictory methods have meant he has operated outside the usual channels of patronage in Scotland. Hidebound by stuffiness and bureaucratic rules and regulations, our educational institutions have been unable to accommodate his challenging demands. But he was rightly honoured in 2010 by the Scottish Parliament in a special session. And once again, we have an example of culturally-inspired change that does impact on how we might see our future as an independent nation.

ALAN What about the dynamics of identity in terms of Scotland's increasingly diverse population, its growing number of new citizens from all parts of the world? That's another good reason for having an independent Scotland with its own foreign policy and an ability to deal with other countries on equal terms.

SANDY Edinburgh has been enhanced in recent years by the arrival of thousands of Polish immigrants, 13,000 at the last count, the largest concentration in Scotland. Leith Walk has been transformed with new delis and restaurants, and of course there is a long history of Scottish-Polish connections, well before the Union and the Empire. During the 17th century it's estimated there were between 20,000 and 60,000 Scots living and working in Poland. So the Polish presence is a welcome reminder of an earlier period of Scottish Internationalism. It also shows Scotland moving from its former status as a country of emigration to a country of immigration, an important change of direction for all sorts of reasons. That so many want to come here is a huge vote of confidence for Scotland's future both in terms of economic growth and of further cultural diversity.

In 2008 I curated an exhibition for The Royal Scottish Academy entitled 'New Scots' which was a response to the growing number of artists who have come to live and work in Scotland during the past 25 years. There was a time, especially in the mid-20th century when it seemed that ambitious Scottish artists had to leave in order to pursue successful careers and this vacuum was rarely filled by the arrival of artists from elsewhere. The notion that Scotland was either too distant or too unreceptive to art and artists persisted. But the re-emergence of Glasgow as a city with strong international links in the visual arts has changed perceptions and encouraged artists to make the decision to base themselves there. The artists selected came from the USA, Canada, Belgium, Norway, Ireland and England. Make no mistake, they are all 'settlers' and all committed to the long term in Scotland because they believe this is the best place for them to make their work.

ALAN Settlers – not colonists. I see what you mean.

SANDY After the Ullapool event in November 2012, that sparked off your essay, Alan, that begins this present book, Sam Ainsley, David Harding and I received a letter from the American artist Timothy Collins and his Japanese partner Reiko Goto-Collins with their thoughts on the weekend, which they had attended, going to every talk and lecture. They were reflecting on some ideas that had arisen, on the questions of culture and independence. This is some of what they had to say:

We come away from the past weekend with much to consider. As an American who still tosses a teabag into the nearest body of water early each morning on the 4th of July the Scottish independence movement holds some fascination. But more to the point for both Reiko and I are the values that Scotland has brought to us. This land has made us both think deeply and in new ways about our relationship and the responsibility for living things and the environment. Talking to Ken Neil and Davie Laing Saturday morning we found ourselves explaining our presence in Ullapool, and as we did so, we stumbled into a list. Scotland has:

1 Established the newest national parks in the world.
2 New Laws protecting public access to all land and water.
3 A national referendum on marriage rights for all.
4 Free university education for all.
5 Leadership on environment that is recognised globally.
6 A radical re-forestation plan for the most de-nuded landscape in Europe.
7 And last, but by no means least, the bid for independence.

Oh – and a point that only an American can fully appreciate – a tradition of national health care!

Whether the independence initiative results in independence and/ or devolved rights and responsibilities, Scotland continues to move forward into the future. A number of people talk about a second Scottish Enlightenment. It is an inspiring time to be here. To have an opportunity to experience some small bit in the dialogue is a privilege.

This has value in that it comes from a recently arrived American artist with a fresh and unbiased view of the country. It is a wonderfully positive assessment of where we are and where we might go.

ALAN It's terrifically encouraging when someone comes from beyond the borders of Scotland and sees all these positive virtues so clearly.

SANDY Yes. In an interview in 1996, the composer Hans Werner Henze was asked the following question: 'An impossible question to close with. If you could project your vision to see how music had developed by, shall we say, 70 years from now, what would you like to see? Can you foresee the survival of the kind of culture (orchestras, opera houses, and so on) you have lived in? What would you like to see change in the relationship of composers and audiences?'

This is what Henze said:

Having worked with young people a lot for many years, and having gained an insight into their aesthetic worlds, in their stupendous variety, I cannot be but highly optimistic. There is such quality, so much creativity and energy! From this I take the courage to foretell that the first half of the next century will be blessed with beautiful new music of all sorts. This, more than anything else, will make it impossible for the authorities to shut down theatres and concert halls and send musicians on the dole. Composers and their audiences will grow together with more and more conviction and love. Music has made enormous progress in this century, as an art of the soul, as social refinement, as something important for people, as important as the air we breathe.

An unusually optimistic answer from the left-leaning composer and offered well before the events of 2008 when the western part of the capitalist world almost crashed and burned to the ground. Does it still stand up as a realistic assessment of the good of the arts? Can we be inspired by such thinking as we ponder the future of Scotland and the role culture might play in shaping that future?

ALAN Even if we can't immediately identify a Britten or a Shostakovich or a MacDiarmid working today, Henze reminds us that we have no reason to be pessimistic, no excuse for cynicism. The future will bring its own answers. The point is that nothing we've been talking about goes away. It's there, in our past, and if we remember it, all the questions remain for every new generation to be asked and ask themselves. We've been asking ourselves questions, in our own terms, in these dialogues, and we've been trying to give some answers we believe. But they're questions everyone needs to find new ways of asking. And everyone will need to find the right answers. Everything that we've been talking about, all the questions that we've been asking, all the answers that art and artists deliver, they won't go away. The urgency is political. But these questions are permanent. They are never done.

SANDY Taking our cue from Hans Werner Henze, there should be a way of offering a vision that is hopeful, something that can be imagined in the future and something that can be realised, actually. Henze's thoughts on the future can hardly be dismissed as facile or naively optimistic. Conscripted into the German army, aged 18 in 1944, he experienced National Socialism and war at first hand. His view that Germany was still contaminated by fascism led to his exile in Italy. He faced up to his avant-garde critics in the early 1950s who accused him of allegiance to outmoded ideas of beauty and melody. His subsequent visits to Cuba in the late 1960s encouraged a powerful engagement with contemporary reality. Yes, I think we can be sure that his views of the future of music were based on long experience and a proper and deeply considered appraisal of the evidence. When he says that music has made enormous progress as an art of the soul, as something important for people, as important as the air we breathe, he's spelling out the transformative power of art and the fact that more and more people are experiencing this. He's talking about the power of music, the sense of communication and purpose it brings, and how it gives people courage to go on with their own lives. He's saying that art is essential in society, because it represents a conscience and ethos, a moral presence that everybody needs.

ALAN As we've already said, remembering is important. Social habits and conventions encourage us to remember certain things, sometimes fabrications and false things propagated by interested parties. Sometimes national identity is fabricated in this way and imposed upon people as caricature. Yet we can go further and deeper than these things. There are more important things to find out about and remember – not the immediately obvious things. In art we don't talk about instant results, but about working your whole life as an artist. It takes time to release the beauty,

grandeur, hope and danger that is present in the making of art. Equally so to remember what we can make of the nation. We've also already talked about Vaclav Havel who knew this and who knew that building a new democratic nation would take time.

SANDY We haven't yet talked about Nelson Mandela, who, like Havel, eventually was able to form a government with the people who tried to kill him.

ALAN The whole context was changed in that process. The 'long walk to freedom' was not only Mandela's walk, Mandela's story, it was also the story of all the different parts of his nation, South Africa.

SANDY Mandela's story shows us how to talk to your enemy, how to engage your enemies. He initiated and maintained a dialogue that was crucial to social change, so that the fixed relations of the oppressors and the oppressed might be brought to an end. And this is also what all the arts do. How do you communicate across lines of communication that are already closed? Through the literature and music and painting that cross all borders, all barriers. Their passport is humanity.

ALAN And that's why the borders are there. They give depth and focus to the distinctions of locality, they heighten our awareness of difference, within and beyond what they delineate, and they nourish the expression that transcends them.

> A people who free themselves from foreign domination will not be free unless, without underestimating the positive contributions from the oppressors' culture and other cultures, they return to the upward paths of their own culture. The latter is nourished by the living reality of the environment and rejects harmful influences as much as any kind of subjection to foreign cultures. We see therefore that, if imperialist domination has the virtual need to practice cultural oppression, national liberation is necessarily *an act of culture*.
>
> Amilcar Cabral, 'History is a Weapon: National Liberation and Culture' (a lecture delivered 20 February 1970 at Syracuse University, New York), quoted in Wole Soyinka, *Art, Dialogue and Outrage: Essays on Literature and Culture* (1988)

Everything Nelson Mandela did was in terms of his nation, South Africa. He could not have done what he did outside of South Africa. What the racists never understood, until de Klerk, was that Mandela was already the leader of the nation, this multi-faceted, 'rainbow' nation. Mandela is the ultimate nationalist. He is the best example of what a leader might do to reform and

regenerate a vision of national identity. What the future will bring to South Africa remains to be fought for. All these good things remain to be fought for. But what visions we might have for whatever that future can be, we owe in large measure to Mandela. Let him be too our example for Scotland.

Conclusion

MOST GREAT ART of the last 200 years has been on the side of the people – not the ruling class, or the church, or senior management. Humanity. There is the giving voice through art to the experience of working-class people, industrialised workers, farming people, then there is the rise of the voices of women in articulating in artistic forms their own experience.

The work of writing actually begins to gain wide ground in the 17th century, in diaries and travel writing and accounts of experience that otherwise would never have been written down. And as soon as these things are written down, the possibility of imagining the experience of others is triggered at once. So then in the 18th century, literature really comes into a major place as a medium through which our experience of humanity enlarges and relativises itself. In the 19th century, the experiences of working people become increasingly articulate and in the 20th century, the experiences of women. So in this process of increasing self-representation and political emphasis, there is a growing sense of the democratisation of the world. It is increasingly available to us, to be selective about these matters of value.

You can see it long before that, of course, in Gilgamesh, in Homer, Herodotus, or in Shakespeare's characters, Rabelais's giants, in Dante choosing to write in vernacular Italian rather than church Latin. Dante's choice of language itself places him on the side of humanity. And it's there in painting and music as well as in literature. Rembrandt, Velasquez, El Greco, Goya, and Mozart, Beethoven, Britten, all the way through. The arts are the most serious arena where the battle for humanity is unending. But in history, after the French Revolution and the American Declaration of Independence, as we come into the modern world, there is the rise – or the return – of this idea of democracy, and what we've been arguing is that democracy, the arts and education are inter-related in the most fundamental ways. Democracy educates, education democratises. Of course. But in that formulation, the arts are essential, because only through the arts can education and democracy really work. It's a matter of co-ordination, of agreeing on critical value. And that's what has been so desperately absent from the evolution of politics in Scotland in the last 300 years. Or even 400 years.

After the unions of 1603 and 1707, famously, the Scots were insistent that matters of church, law and education would retain their distinctive national character, yet what have they done to help Scotland to flourish?

In the absence of politics, in the absence of a self-determining political culture, the potential significance of each of these vocational and professional areas of work and commitment are distorted, diminished or exaggerated. Belief in the life of the spirit that made the clay grow tall, that inhabits and animates the very fabric of society, can so badly turn sectarian; belief in the laws that help people to live by first principles and ultimate ideals, can so badly close itself off from the partial, compromised, hesitant nature of folk as they are; belief in the value of learning so badly turns to commitment to education made superior according to the economic rewards in the south, vouchsafed by a hierarchy of language and attitude, disdainful of the local. Scotland needs politics because politics is what people do. People are the polity. Polis is this.

Imagine for a moment if all the churches in Scotland declared their support of independence.

Imagine if all the lawyers and judges in Scotland did the same.

Imagine that all the Principals of every university in Scotland, every Head Teacher, and every teacher of English, History, Art, Music, every subject, told us in an open public forum that they were in favour of an independent Scotland.

In the event of these people failing to do that, we do not have to imagine the reality of the artists of Scotland, writers, composers, painters, film-makers, high calibre people in every art form, who have demonstrated again and again for centuries, the distinctive culture of the nation we call Scotland, and the character, diversities and depths, of the people who live here. They are the outlaws.

If not for such works as Wilkie's 'Pitlessie Fair', Mackintosh's Glasgow School of Art building, Peploe's Iona paintings, Fergusson's 'Les Eus', MacDiarmid's 'Drunk Man Looks at the Thistle', Spark's *The Prime of Miss Jean Brodie*, Lochhead's *Mary Queen of Scots Got Her Head Chopped Off*, Eardley's Catterline paintings, Burns's 'Tam o' Shanter', Dunbar's 'Dance of the Seven Deadly Sins', David Lyndsay's *Satyre of the Thrie Estaits*, Duncan Ban MacIntyre's 'Praise of Ben Dorain', and countless others, Scotland would be no more than a geographical region to be exploited. There would be no argument for Scotland at all. There would

be no value in arguing or fighting for an independent Scotland. But these works and artists are there, they exist, they can help us to live in our relation to Scotland, and they can help us to understand ourselves more comprehensively in the human universe we are given to inhabit. In their different fields there are surely equally great achievements in medicine, economy, science, and biology, but none of these speak openly and give freely of their virtues as do the works of art. That is the crux of our argument and that is why we endorse so strongly the value of an independent Scotland.

Index

Arts of Resistance: Poets, Portraits and Landscapes of Modern Scotland

Alan Riach and Alexander Moffat, with contributions by Linda MacDonald-Lewis
ISBN: 978-1-906817-18-3 PBK £16.99

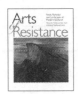

The role of art in the modern world is to challenge and provoke, to resist stagnation and to question complacency. All art, whether poetry, painting or prose, represents and interprets the world. Its purpose is to bring new perspectives to what life can be.

ALEXANDER MOFFAT and ALAN RIACH

Arts of Resistance is an original exploration that extends beyond the arts into the context of politics and political change. In three wide-ranging exchanges prompted by American blues singer Linda MacDonald-Lewis, artist Alexander Moffat and poet Alan Riach, discuss cultural, political and artistic movements, the role of the artist in society and the effect of environment on artists from all disciplines.

Highly illustrated with paintings and poems, *Arts of Resistance* is a beautifully produced book providing facts and controversial opinions.

... an inspiration, a revelation and education as to the extraordinary richness and organic cohesion of 20th-century Scottish culture, full of intellectual adventure... a landmark book.
TIMES LITERARY SUPPLEMENT

All Art is Political: Writings on Performative Art

Sarah Lowndes
ISBN: 978-1-910021-42-2 PBK £9.99

Since the 1990s, performative art has been increasingly accepted into the cultural mainstream, becoming a familiar and popular feature of art galleries and museums, as shown by the Tate Modern's recent 'Collecting the Performative' project. But what is performative art? What about its radical origins? How does it remain politically engaged?

Writer, curator and lecturer at the Glasgow School of Art, Sarah Lowndes, takes us through the world of performative art, using five care studies spanning from the 1960s to the present day. A series of essays and conversations, *All Art is Political* explores the work of art-musicians Mayo Thompson and Keith Rowe, Berlin-based artist Thea Djordjadze, Glasgow-based Turner Prize winner Richard Wright, American conceptual artist Susan Hiller and German-Swiss artist and writer Dieter Roth.

What is a literature sausage? How do you transform reading coffee grinds into contemporary art? How do you incorporate live radio broadcasts into a musical performance? What does it mean to draw attention to the marks accidentally left behind by previous uses of the exhibition space? How do you bring out the latent brutality of Punch and Judy shows? For the answers to these questions and many more, turn the pages of *All Art is Political*.

Blind Ossian's Fingal: Fragments and Controversy

Compiled by James Macpherson, Introduced and Edited by Allan Burnett and Linda Andersson Burnett
ISBN: 978-1-906817-55-8 HBK £15

 James Macpherson's 18th-century translations of the poetry of Ossian, a third-century Highland bard, were an instant success. These rediscovered Ossianic epics inspired the Romantic movement in Europe, but caused a political storm in Britain at the time and up to recently have been denounced as one of the greatest literary hoaxes of all time.

Editors Allan Burnett and Linda Andersson Burnett take a fresh look at the twists and turns of the Ossian story. This volume includes *Fragments of Ancient Poetry and Fingal* along with contemporary commentary.

They contain the purest and most animating principles and examples of true honour, courage and discipline, and all the heroic virtues that can possibly exist.
NAPOLEON

Burnsiana

Rab Wilson and Calum Colvin
ISBN: 978-1-908373-91-5 PBK £12.99

 Combining art and poetry to form a beautiful new alternative to current Burns related titles, Colvin's photographic artworks go hand-in-hand with Wilson's witty and insightful poetry to provide a daring take on the world of Robert Burns.

Employing the unique fixed-point perspective of the camera, Colvin creates elaborate narratives from manipulated and constructed images so as to comment on aspects of Scottish culture, identity and the human condition in the early 21st Century. Wilson in turn, responds to these images, giving a deeper alternative meaning to the artworks and dwells on who we are, where we have been, and towards what we may become.

Rab Wilson is one of the best poets now working in Scotland. In the interest of his language, subject matter, form of address, development of style and perspective and tone, he is far more curious and willing to take risks than almost all of his contemporaries.
ALAN RIACH

Luath Press Limited

committed to publishing well written books worth reading

LUATH PRESS takes its name from Robert Burns, whose little collie Luath (*Gael.,* swift or nimble) tripped up Jean Armour at a wedding and gave him the chance to speak to the woman who was to be his wife and the abiding love of his life. Burns called one of 'The Twa Dogs' Luath after Cuchullin's hunting dog in Ossian's *Fingal*. Luath Press was established in 1981 in the heart of Burns country, and now resides a few steps up the road from Burns' first lodgings on Edinburgh's Royal Mile.

Luath offers you distinctive writing with a hint of unexpected pleasures.

Most bookshops in the UK, the US, Canada, Australia, New Zealand and parts of Europe either carry our books in stock or can order them for you. To order direct from us, please send a £sterling cheque, postal order, international money order or your credit card details (number, address of cardholder and expiry date) to us at the address below. Please add post and packing as follows: UK – £1.00 per delivery address; overseas surface mail – £2.50 per delivery address; overseas airmail – £3.50 for the first book to each delivery address, plus £1.00 for each additional book by airmail to the same address. If your order is a gift, we will happily enclose your card or message at no extra charge.

Luath Press Limited
543/2 Castlehill
The Royal Mile
Edinburgh EH1 2ND
Scotland
Telephone: 0131 225 4326 (24 hours)
Fax: 0131 225 4324
email: sales@luath.co.uk
Website: www.luath.co.uk